# PILGRIMAGE

The ~~steaming woods~~ think it queer

To ~~~~ horse must ~~~~

The ~~~~ ~~~~ to think it queer

To We stop with not a farm house near

the woods an frozen
Between a ~~forest and a~~ lake

The darkest evening of the year

She ... her
He gives harness bells a shake

To ask if there is some mistake

The only other sounds the sweep

clowny
Of easy wind and ~~falling~~ flake.

The woods are lovely dark and deep

But I have promises to keep

~~That bid ... in my ... And there are miles~~

And miles to go before I sleep

And miles to go before I sleep

For Sarah, Susan, and Samuelle

"Stopping by Woods"

# PILGRIMAGE
# ANNIE LEIBOVITZ

INTRODUCTION BY DORIS KEARNS GOODWIN

RANDOM HOUSE NEW YORK

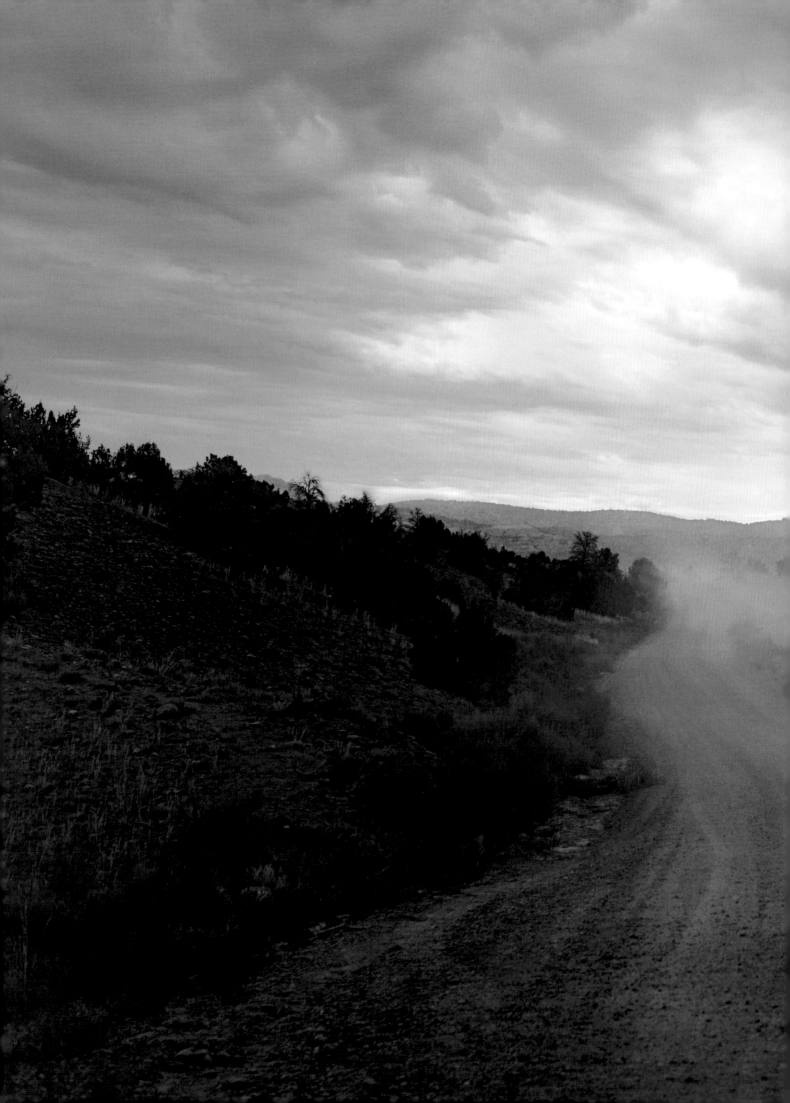

# INTRODUCTION

As a historian, nothing matters more to me than the chance to wander through the rooms where my subjects lived and worked, to imagine them coming down the stairs for breakfast, writing steadily at their desks, entertaining guests at dinner, settling down in their favorite chairs to read. The people may be gone, but the houses remain. The landscape may have changed, the furniture, rugs, and draperies may be only the best representation of what was thought to have existed at the time, and yet, somehow, as one moves from room to room, the people who lived there are brought to life.

Indeed, I believe that my fascination with the presidency began with a visit to Franklin Roosevelt's home in Hyde Park when I was nine years old. The president's cigarette holder and his pince-nez glasses were on a small desk in the study, exactly where he had left them at the end of the day. On a chaise longue in Roosevelt's bedroom, I saw Fala's leash resting on the plaid blanket where the little dog liked to sleep. I realized that day that I could play an inner game with history. I could close my eyes and imagine Roosevelt returning to his study, picking up his cigarette holder, putting on his glasses, and sitting down to read, his beloved dog at his side.

When I began doing research for my book on Franklin and Eleanor Roosevelt, I spent many hours at the Big House, as the Hyde Park home was known. That this house, furnished and decorated by Franklin and his mother, Sara, never truly belonged to Eleanor was abundantly clear. A guide explained the seating arrangement at the dining table. Franklin sat at one end, Sara at the other. Eleanor sat somewhere in between. On the second floor, there are two large, comfortable bedrooms. One belonged to Franklin, the other to Sara. The room Eleanor slept in was small and Spartan.

The sleeping arrangements, the guide explained, most likely followed Eleanor's discovery of her husband's affair with a young woman named Lucy Mercer. When Franklin promised never to see Lucy again, Eleanor agreed to stay with him, but their marital relations came to an end. Ironically, the catastrophe proved to be a liberating force. It opened up a new path for Eleanor. No longer tied to her old world in the same way, she became involved with a circle of feminists dedicated to abolishing child labor, passing protective legislation for women workers, fighting for the minimum wage. She learned that she had a whole range of talents—for public speaking, for organizing people and inspiring them to common action. She found her voice and became one of the most influential women of her age.

Annie explores this independent phase of Eleanor's life with photographs of Val-Kill, the fieldstone cottage Franklin built for his wife on the grounds of the Hyde Park estate. "The peace of it is divine," a grateful Eleanor told her husband the first summer she spent there, in 1925. From that time forward, though she stayed at the Big House whenever Franklin and the children were at Hyde Park, Val-Kill was Eleanor's home—her first home of her own. The management of the household was

much less formal than the regimen at the Big House. "There wasn't a lampshade that wasn't askew," one guest remembered, "and nobody cared if the cups and plates matched." What mattered most were the cheerful atmosphere and the comfortable living arrangements that pervaded every room.

Eleanor finally had her own chair, surrounded by a sofa, several tables covered with family photographs, and a number of easy chairs of different dimensions, selected for the comfort of people short or tall, thin or fat. A tea set stood ever ready in the corner. Lunches and dinners were served family style. Dormitory rooms on the second floor could accommodate dozens of her friends. Eleanor's favorite place to sleep was a porch open to the stars, a delightful space in stark contrast to the spare bedroom in the Big House. Here at Val-Kill, without the ghost of Sara Roosevelt hovering about, Eleanor could enjoy the camaraderie of her own circle of friends.

After Franklin died, Eleanor turned the Big House over to the government and made Val-Kill her permanent home. In the years that followed, she and Fala became inseparable. Fala accompanied her on walks through the woods, sat beside her chair in the living room, and greeted her at the door when she came home. "No one was as vociferously pleased to see me as Fala," she proudly noted after a trip to New York. Still, Fala missed the president. When General Eisenhower came to Hyde Park to lay a wreath on Roosevelt's grave, Fala heard the sirens of the motorcade and thought his master was returning. His legs straightened out and his ears pricked up, Eleanor noted. He was hoping to see his master coming down the drive.

———

A visit to Marian Anderson's studio in Danbury, Connecticut, for this book led Annie to the steps of the Lincoln Memorial, where Anderson performed before 75,000 people in 1939. The haunting statue of Lincoln overlooking the steps drew Annie to the summer home and studio of the sculptor who created it, Daniel Chester French. She then set forth on a journey to find Lincoln himself, traveling first to Sinking Spring Farm in Kentucky, where Lincoln was born, then to Knob Creek Farm, where he lived from the age of two until he was seven, then on to the cabin in Indiana where his mother died, and finally to Springfield, Illinois, Lincoln's home for nearly a quarter of a century before he became president.

I embarked on a similar journey when I began research on Lincoln for my book *Team of Rivals*. Knob Creek Farm, a guide explained, stood on the Cumberland Trail, which stretches from Louisville to Nashville. Caravans of pioneers passed by each day heading toward the Northwest—farmers, peddlers, preachers, each with a story to tell. Night after night, Lincoln's father, Thomas, would swap tales with visitors and neighbors while his young son sat transfixed in the corner. Young Abe listened so intently to these stories, crafted

from the experiences of everyday life, that the words became embedded in his memory. The following day, having translated the stories into words and ideas his young friends could grasp, he would climb onto the tree stump or log that served as an impromptu stage and mesmerize his own circle of young listeners. He had discovered the pride and pleasure an attentive audience could bestow.

Lincoln's storytelling ability played a critical role in his political rise. As a young lawyer, Lincoln traveled with his fellow lawyers on the judicial circuit every spring and fall. They shared rooms in boardinghouses and taverns. In these convivial settings, Lincoln was invariably the center of attention. When patrons settled down to eat and drink, the call would come for him to assume center stage. Standing with his back to the fire, he would entertain the crowd for hours, juggling one winding tale after another. As word of his storytelling ability spread, he won a circle of followers that later buoyed his quest for office.

Nowhere is Lincoln's storytelling prowess more evident than in the Gettysburg Address. The photograph of the earliest existing handwritten copy allows us to look over Lincoln's shoulder as he wrote the words that made the story of his country and the meaning of the war accessible to every American. The child who reworked his father's yarns into tales comprehensible to any boy had forged for his country an ideal of its past, present, and future that would be recited and memorized by students forever.

Just as houses tell stories, so do artifacts. I had seen the hat that Lincoln wore at Ford's Theatre the night he was assassinated, but Annie's focus on the black silk mourning band evokes a different memory. The mourning band commemorated the death of Lincoln's eleven-year-old son, Willie, from typhoid fever in the middle of the war. It was said that Willie, an avid reader, a budding writer, and a sweet-tempered boy, resembled Lincoln more than any other child in the family. Diary entries, letters, and newspaper accounts reveal how devastating Willie's loss was to Lincoln. Mary Lincoln's dressmaker, Elizabeth Keckley, observed that Lincoln "buried his head in his hands, and his tall frame was convulsed with emotion." To a White House visitor, Lincoln acknowledged: "That blow overwhelmed me; it showed me my weakness as I had never felt it before." Somehow the picture of the mourning band still on Lincoln's hat three years later brings home the continuing impact of Willie's death more powerfully than anything that was said at the time.

Annie notes that Lincoln often carried several pairs of gloves because he had to shake so many hands. This reminds me of the story Lincoln told of the day he signed the Emancipation Proclamation. Earlier that morning, at an overcrowded public reception celebrating the first day of 1863, he had shaken thousands of hands over the course of three hours. In mid-afternoon, when he went to sign the Proclamation, his own hand was numb and shaking. "If my name ever goes into history it will be for this act, and my whole soul is in it," he said. Yet, "if my

hand trembles when I sign the Proclamation, all who examine the document hereafter will say, 'He hesitated.'" So he stopped, put the pen down, and waited patiently until he could take it up again and sign with a bold and firm hand.

———

One of my favorite sections of this book is centered on the homes of the Concord writers—Ralph Waldo Emerson, Henry David Thoreau, and Louisa May Alcott. Concord has been my home for thirty-five years. My three children grew up and went to school in Concord. My sons attended Alcott Elementary School; they spent many a summer day swimming in Walden Pond. My husband had an office for a time in the Emerson Umbrella Center for the Arts. The Concord Museum was home to the rehearsal dinner for my son Michael and his wife, Lindsay, the night before their wedding. How wonderful it has been for my husband and me, loving history as we do, to live in this town where the past has been so zealously preserved. When our boys were young, I dragged them through all the houses and places photographed here. Michael, who teaches history at Concord Carlisle High School, is now at work creating a model interdisciplinary experiential curriculum called Rivers and Revolutions that makes full use of the rich variety of field sites in Concord.

Every April 19, Concord's past comes to life with the reenactment of the famous battle at the Old North Bridge, marking the first American victory in the Revolutionary War. I remember the excited reaction of a child in the crowd as he saw the minutemen come over the hill to meet the advancing redcoats. "Here come the good guys!" he shouted, to the shared amusement of everyone present. (I must confess that when I take visitors to the bridge to see where the famous "shot heard 'round the world" took place, my mind sometimes wanders back to a different shot heard 'round the world—the home run hit by the New York Giants' Bobby Thomson to beat the Brooklyn Dodgers in the 1951 playoffs—one of the worst moments of my childhood.) On the opposite side of the bridge, in yet another link between the sites Annie has chosen, stands the *Minute Man* statue—a farmer with a plow in one hand and a musket in the other—carved by Daniel Chester French. As a boy, French lived not far from Ralph Waldo Emerson.

I have walked through Emerson's home numerous times, stood in his library, observed his dining room, and strolled through his gardens. The chair nearest the door was generally reserved for the unsociable Nathaniel Hawthorne so he could escape with little notice if the after-dinner conversation went on too long. The writer George William Curtis recalled one such occasion when a large gathering of men and women were assembled around the table, engaged in "brilliant discourse." At the edge of the circle, Hawthorne sat, "silent as a shadow," but, Curtis recalled, "there was a light in his eye which assured me that nothing was lost. . . . Fine things were

said by the philosophers, but much finer things were implied by the dumbness of this gentleman with heavy brows and black hair. When he presently rose and went, Emerson, with the 'slow, wise smile' that breaks over his face like day over the sky, said: 'Hawthorne rides well his horse of the night.'" Just as the photograph of the dining room brings to life the stream of people who gathered there, so the image of the library calls to mind Emerson's daily routine. It is said that he rolled out of bed every morning and headed straight to the library to begin writing. On cold days, a fire blazed as he sat in his favorite chair at the round table that stood in the middle of the room, facing the bookshelves.

I share Annie's fascination with the daily routines of her subjects. The young Louisa May Alcott sat at her writing desk at Orchard House sometimes for eighteen hours at a stretch as she completed the first half of *Little Women* in six and a half weeks' time. In a journal entry in late May 1868, Alcott noted that she was beginning her "girls' story," though she "never liked girls or knew many, except my sisters; but our queer plays and experiences may prove interesting, though I doubt it." By June, she had sent off twelve chapters, and by July 15 had completed the manuscript. When the proofs came, she was pleased to find that "it reads better than I expected." So successful was the book that her publishers convinced her to write a second part, continuing the story. She began this in early November, working "like a steam engine." By November 17, she had completed thirteen chapters. "I am so full of my work," she confided to her journal, "I can't stop to eat or sleep, or for anything but a daily run."

———

What strikes me most about this collection is that even when Annie and I spend time at the same place, we see different things. She has captured the spirit of the people and the places in this book as surely as thousands of words could ever do.

—DORIS KEARNS GOODWIN

Emily Dickinson began pressing plant specimens into an herbarium when she was a schoolgirl in Amherst, Massachusetts. "I was raised in the garden," she told her cousin. She stopped adding to the herbarium when she was about fourteen, but she remained an avid gardener all her life. Her herbarium is now in a vault in the Houghton Library at Harvard. Dickinson identified the specimens on this page as species of cactus and dogwood.

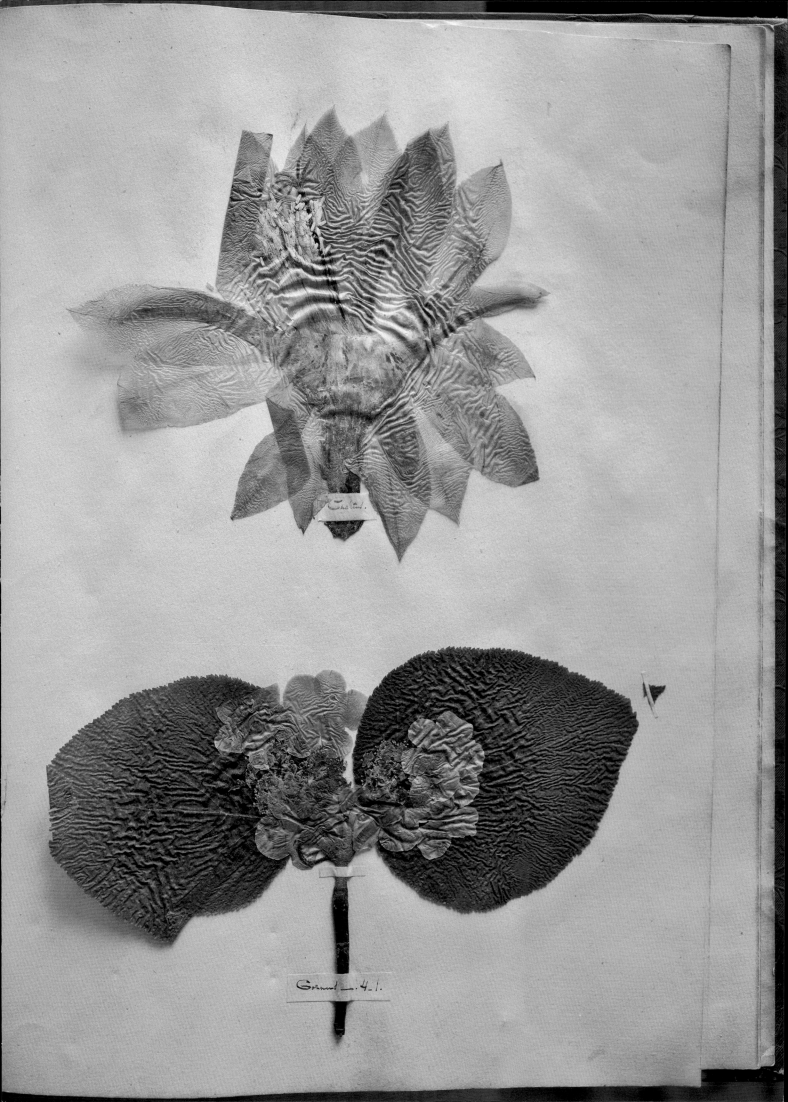

Emily Dickinson's brother, Austin, lived next door to her in a house called the Evergreens. The Dickinsons were a distinguished Amherst family. Emily and Austin's father built the Evergreens in 1856, when Austin married Susan Gilbert, who was then Emily's best friend.

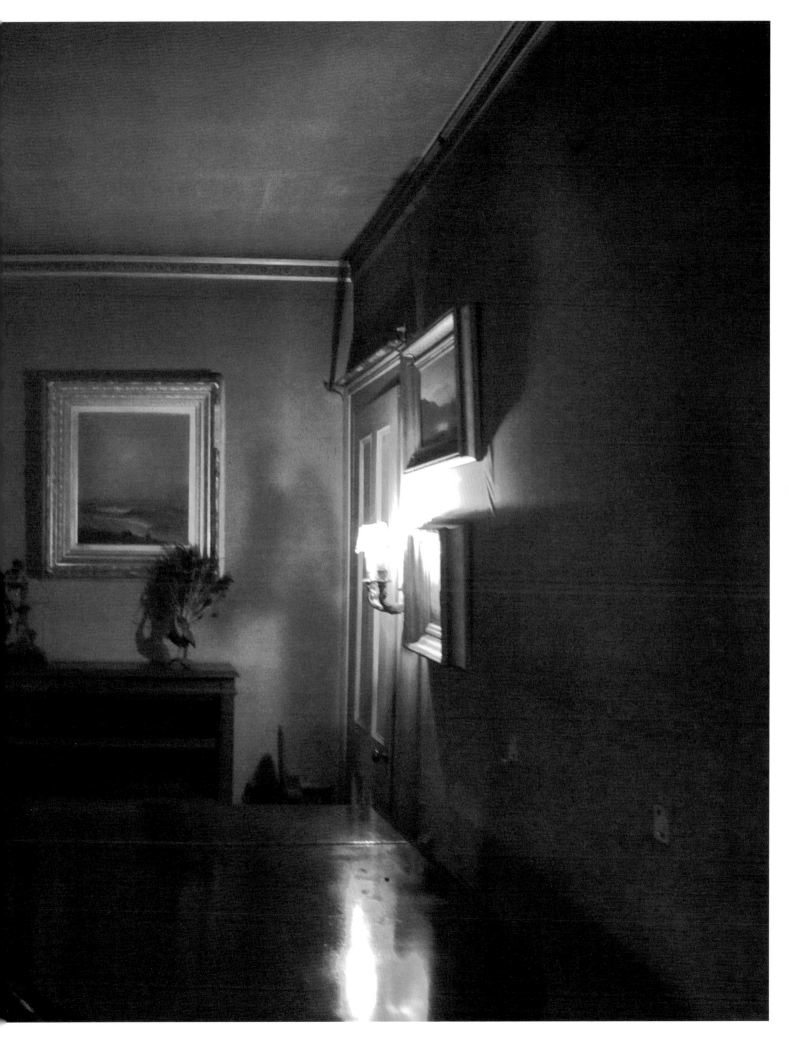

The Evergreens was the center of social and literary life in Amherst during the first years of Austin Dickinson's marriage. Ralph Waldo Emerson stayed there when he came to Amherst to lecture. Austin's daughter and her heirs preserved the house much as it was in the 1880s.

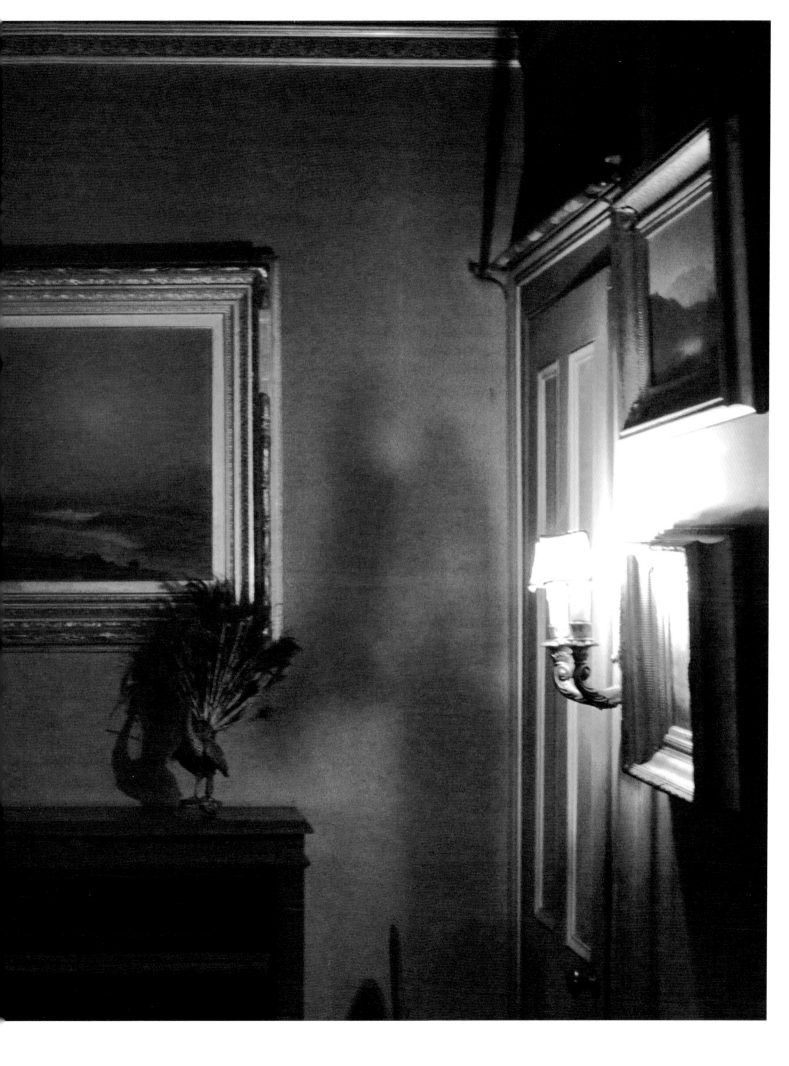

There was almost no light by the time I arrived at Emily Dickinson's house. I had brought a small digital camera, and I started taking pictures in an abandoned way. I wasn't thinking about it. One of Dickinson's white dresses was displayed in a Plexiglas case, and I found myself drawn to the detail in the dress, the alabaster buttons and the trim. If you took a picture of the whole dress, from far away, it was just a simple white dress. But if you came closer, there was a beautiful ornateness to it. For someone who

spent most of her time quietly by herself, the details would have been wonderful to contemplate. And to feel. They weren't meant for anyone else.

Emily and her sister lived alone in the house during the last years of their lives. After they died, it was sold. It's a museum now, but for decades other people lived in it. There was a second house on the museum compound, and the people who were showing us around asked us if we wanted to walk over to it. The light was nearly gone by then, and we started to say no, but we ended up taking a little path to the house next door. The houses are very close to each other, only about three hundred feet apart. The second house belonged to Emily's brother, Austin.

Austin's house was a revelation. I was stopped dead in my tracks. It was dark, mysterious. The wallpaper was falling off the walls. There were heavy curtains. Every bit of wall space had some kind of picture on it, oddly placed. The house had been left the way it was when Emily and Austin were alive. You could feel the people who had lived there. Austin's young son had died in one of the small bedrooms, and I found that I couldn't walk into it.

I discovered that with the digital camera I didn't need much light. It seemed like I could see into corners. There was none of the color and contrast distortion that you get with film when you push it. The camera was rendering things almost the way I was seeing them.

Emily Dickinson worked in her bedroom. She wrote thousands of letters and poems there, most of which were not published in her lifetime. She could see the path that led to her brother Austin's house from her bedroom window.

22

I didn't pay much attention to the pictures I took then. I left them in contact sheets in my studio, mixed up with pictures from the bar mitzvah of my cousin's son. The bar mitzvah was the reason I was in Amherst that spring day. Much of my family had come up for the occasion, and my younger sister Paula, who is a history buff, had suggested that we visit the Dickinson house while we were there.

Several years ago, Susan Sontag and I were planning something that we called the Beauty Book. The Beauty Book was going to provide an excuse for us to travel around to places we cared about and wanted to see. For me, it meant going back to taking pictures when I was moved to take a picture. When there wasn't an agenda. If you are on assignment for a magazine, there are always agendas. Things that have to get done. I care about my assignment work, but I wanted to try working without that pressure. To be in a situation where I took a picture just because I saw it.

After Susan died, I knew that I couldn't do the Beauty Book, although as time passed, I realized that I might do a different book, with a different list of places. The list

would, inevitably, be colored by my memory of Susan and what she was interested in, but it would be my list. This wasn't an idea that seemed obvious at first. It came gradually. Emily Dickinson was Susan's favorite poet.

————

The summer after the visit to Amherst, I was trying to spend a few weeks with my children at our place on the Hudson, in upstate New York, but I was preoccupied by financial difficulties that were distracting in the extreme. I kept having to go back to the city for meetings about business, and I would spend days sitting in rooms with lawyers. This was not something that young children could understand. They were mad at me.

We had planned a number of day trips that summer. We were going to visit Val-

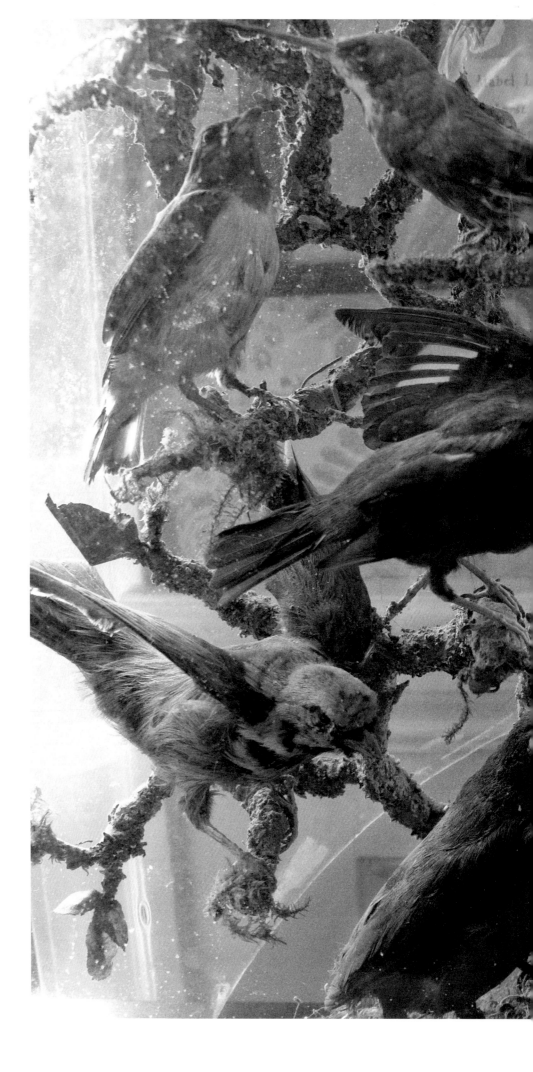

Life in the Dickinson family was complicated by the fact that Austin Dickinson had a lover, Mabel Loomis Todd. After Emily died, Todd edited her poems and oversaw their publication. She also founded the Amherst Historical Society and arranged for a friend of hers to leave her eighteenth-century house to the Amherst History Museum. A vitrine with stuffed birds from the former owner is in the museum's Todd Room.

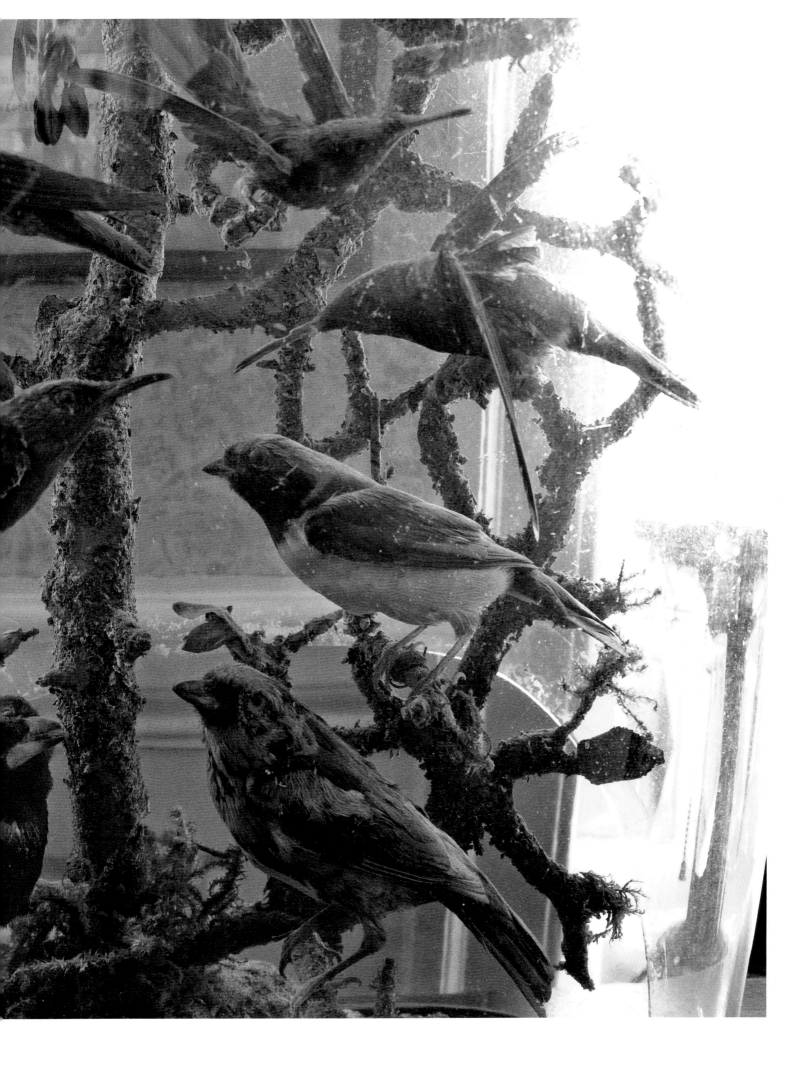

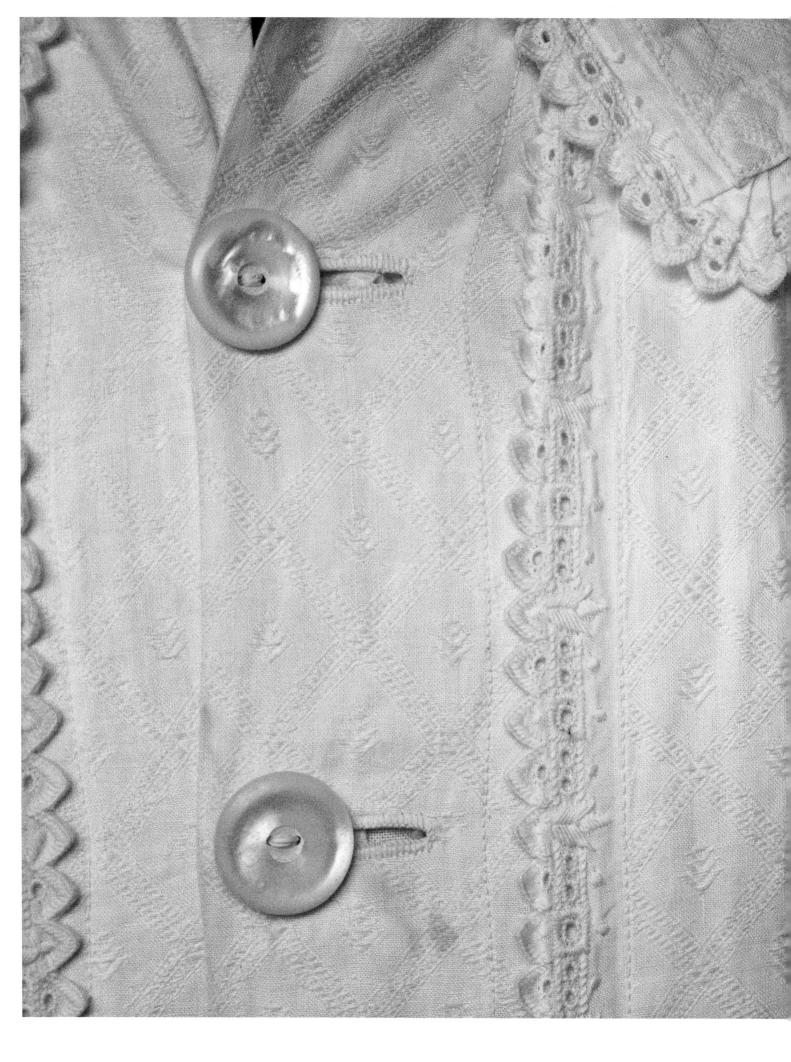

Emily Dickinson's only surviving dress

Kill, Eleanor Roosevelt's house in Hyde Park, and Olana, Frederic Church's house, and Walden Pond. The first trip I wanted to make, and the longest one, was to Niagara Falls. I thought that the kids would love Niagara Falls. Originally, we were going to take a train, and then I started to think about how my parents would have done something like this when I was growing up. I decided that the best thing to do was to go there by car. It was a six-hour drive. The children would eat dinner at home and put on their pajamas. We'd get there about midnight. I would put them to bed in the hotel and they could wake up whenever they felt like it. We would open the curtains of the hotel room and they would see the falls. The view would be a surprise. I bought books about Niagara Falls and we discussed the trip for weeks, going over details and talking about what it would be like.

Everything went pretty well at first. Our friends Nick and Alex and their daughter, Lui, came along, and we pulled into the town on the Canadian side on schedule. But when I went up to the desk at the hotel, the clerk said, "I'm sorry. At eleven o'clock we ran your credit card and it was rejected and we gave your rooms away."

I said, "You did what?" The credit card was to reserve the rooms. I had brought cash to pay for them. Just then Sarah, my oldest daughter, who was not quite eight, got out of the car with her Winnie-the-Pooh bear and began crying, "Mommy, Mommy." The four-year-old twins woke up and started crying. Everyone was crying.

The clerk said that they had a motel on the other side of town where there were rooms. I got back into the car and headed in that direction, but I stopped at every place we passed, trying to find a room that overlooked the falls. There was nothing. It was an August weekend and everything was totally booked up. I had to resign myself to going to the motel suggested by the man who had given away our rooms. We took the last two rooms they had and the kids fell asleep right away. I was unbelievably depressed.

When it became light the next morning, I got up and went over to the window and pulled open the curtains.

We were looking at a cement-block wall.

I felt like such a failure.

The view didn't seem to matter much to the kids. After they woke up, we just got dressed and went down to the breakfast room, where I had a long phone call with some lawyers. Then we went out on the boat and everybody got wet. While the kids had lunch, I had a conference call with more lawyers. I was upset and wanted to go home, but Sarah asked if they could go to a place that Alex and Lui had been looking at. I said sure and watched them as they skipped to a spot that overlooks the falls. After a while, I saw that they were mesmerized. I didn't quite get it, so I went to see what they were watching.

It was extraordinary. You really felt like you were floating over the falls. I stood behind the children and took a picture.

———

When I went back to work that fall, I looked more closely at the pictures I had taken at Austin Dickinson's house and I started thinking of other places I could explore. That's when I started to make lists. Crazy lists.

There were a few places in England that I was drawn to. I'd used Sigmund Freud's house once for a location. The curators there had been very accommodating, and they'd invited me back to take pictures for myself. I'd used Vanessa Bell's house at Charleston as a background for a Vanessa Redgrave picture, and for a Nicole Kidman sitting. But I'd never gone to Monks House, Virginia Woolf's country house, which is only a few miles from Charleston.

Coincidentally, around the time that I was making my lists of places, I went to London. I was being given the Centenary Medal of the Royal Photographic Society, the oldest photographic society in the world. They were also making me an honorary Fellow. Roger Fenton was one of the originators of the society. Julia Margaret Cameron—Virginia Woolf's great-aunt—had been a member. The award was important to me, and the trip provided an opportunity to test out my theories about the digital camera.

The day of the award ceremony, I drove with Karen Mulligan, who has worked with me for almost fifteen years, to Monks House. It's in the little village of Rodmell, about sixty miles south of London. A National Trust caretaker, Caroline Zoob, was going to show us around, but we got there earlier than we were supposed to and she had to leave for an appointment in the village. She said she would return in a few minutes. I walked to the garden in back, where Virginia Woolf's writing studio was, and peered through the window. It was windy that morning and the branches of the trees outside the house were moving. Light was filtering through the leaves and then through the window. The room was filled with light and the shadows of leaves were dancing

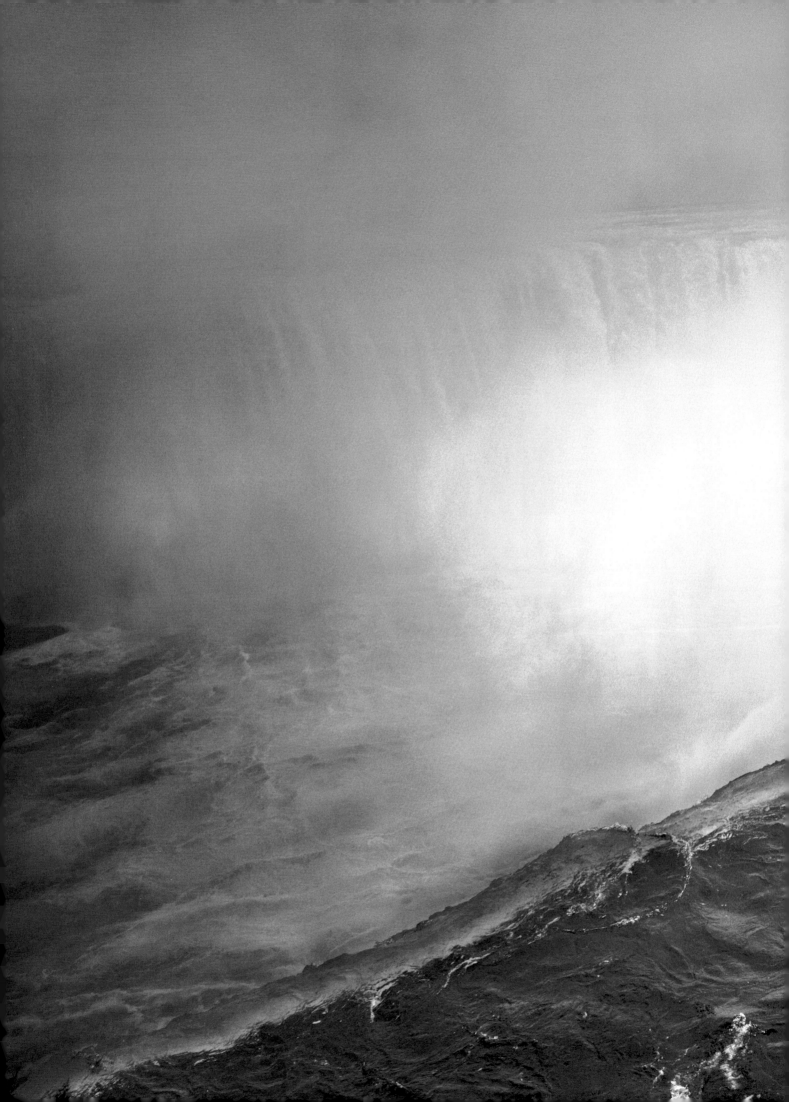

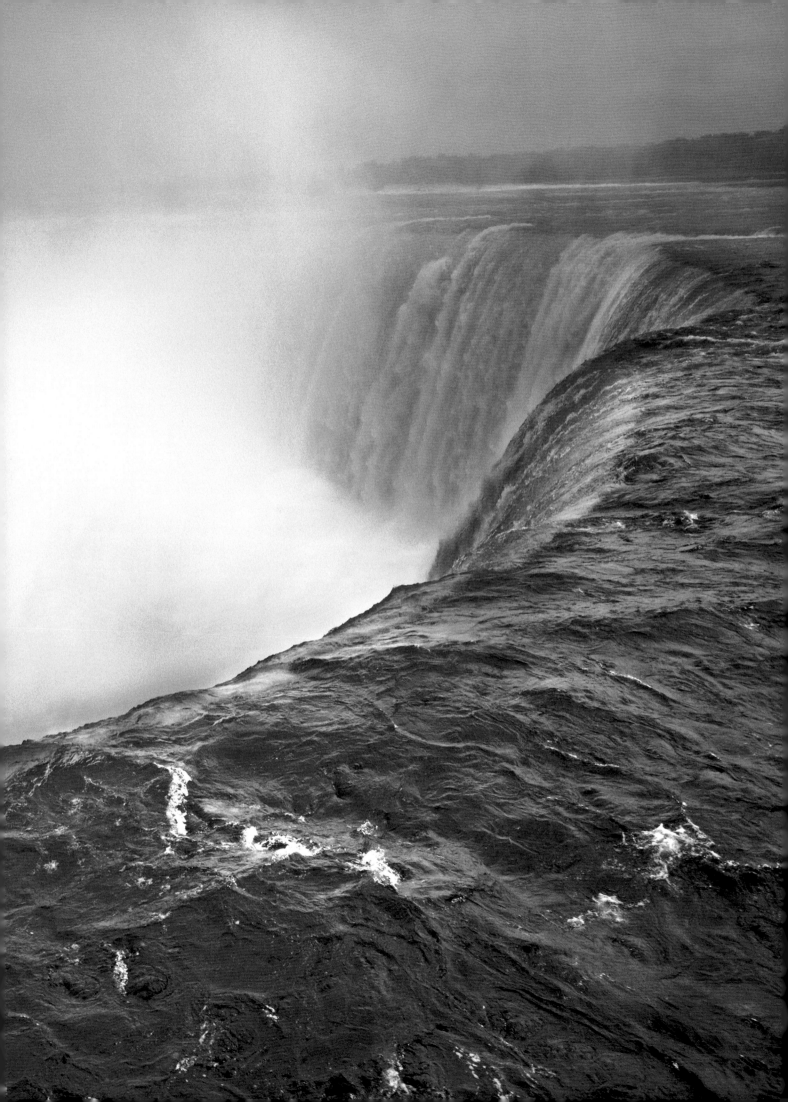

on Woolf's desk. It was the first time in my life that I wished I were making a moving picture. I think I did turn on the video of my digital camera, but I don't know if anything came out. The light blasting through the back window was very bright, not my kind of light, and the pictures are hard to read, but I got a reflection of the view on a piece of the window. You can just barely make out the desk. There were a couple of objects there, including Virginia Woolf's glasses.

When Caroline came back from town, she had the key to the writing studio and she opened it up and then went away. She left us a basket of jam and bread and a couple of cups of coffee. I thought, Don't leave me alone here. Please. It made me nervous. On the other hand, I felt so privileged.

I'd seen pictures of the room taken when Virginia Woolf was still alive, and it seemed that the desk had a hutch on it. You can't help but become a little bit of a detective in these situations. You want to verify everything. Caroline said that they thought it was the original desk but weren't a hundred percent sure. She confirmed later that it was, and that's when I began thinking about what curating a house entails. The core of Monks House was built in the early eighteenth century. Many people had lived in it before Virginia and her husband, Leonard, bought it, in 1919. They renovated it extensively over the years, as money came in from Virginia's writing and from the Hogarth Press, their publishing company. There was a beautiful green room, and Caroline said something like, "Yes, we took it back to the twenties." They picked a period. I remember being thrown by that. You think you are looking at it the way it was when Virginia Woolf lived there, but of course after she died Leonard lived in it for thirty years.

There is a fish tank with some fish in it in one room. Caroline said that sometimes people come through and ask if those are Virginia Woolf's fish. Or if the cat is Virginia Woolf's cat. A line of trees was at the edge of the property, blocking the view of adjoining pastures, which is what Virginia Woolf would have seen from her writing room. That's what happens. Views change. Different people move in. Or nobody at all lives there and the evidence of daily life disappears. According to Leonard Woolf, Virginia was messy, not only when she was working but in general. This is not something you would know from visiting Monks House now.

In his memoirs, Leonard describes Virginia's room as "not merely untidy but squalid." He remembers her table being littered with used matches, paper clips, broken cigarette holders, manuscripts, and bottles of ink. Virginia wrote first drafts in the mornings on a large plywood board with an inkstand glued to it. She sat in a sagging armchair with the writing board on her knees. Later, she typed out what she had written, and she did revisions on the typewriter. She wrote every day.

Monks House wasn't just a weekend place. The Woolfs had a house in London, but they spent the whole summer at Monks House and weeks at a stretch other times. Leonard cultivated an elaborate garden and Virginia took daily walks with their dog along the River Ouse or on the downs. They filled the house with pottery and furniture and carpets designed by Virginia's sister, Vanessa, and Duncan Grant.

PRECEDING PAGES:
Niagara Falls

Monks House became the Woolfs' only residence in the fall of 1940, when the London house was badly damaged by an air-raid bomb. They moved what was left of their possessions to the village. Some of it went into storage, but most of the books and papers were piled up in the rooms downstairs at Monks House. Virginia finished writing *Between the Acts* in February 1941. A few weeks later, she drowned in the River Ouse. She took a walk before lunch and didn't return.

———

The Hogarth Press, which Leonard and Virginia Woolf ran pretty much by themselves for years, had been publishing Freud's work in English since the 1920s. The Woolfs visited Freud at his new house at 20 Maresfield Gardens in 1939, not long after he emigrated to London. Leonard wrote that Freud's study was so full of antiquities that it looked like a museum. It *is* a museum now, with everything in the place it was when the Woolfs had tea there. Freud had a few patients in London, and he saw them until two months before he died, in the fall of 1939. He had lived in the house for only a year, but his study was set up exactly as it had been for decades in his apartment in Vienna.

Freud had stayed in Vienna long after it was safe for Jews. When he was finally persuaded to leave, after his daughter Anna was detained by the Gestapo, he was helped by influential friends, in particular Princess Marie Bonaparte, a rich patient and disciple. She provided the ransom money for Freud, most of his family, his collections, library, and furniture. Freud's son Ernst found the house in Maresfield Gardens. He supervised a renovation, which included making two ground-floor rooms into one area for his father's study, library, and consulting room. The walls are hung with portraits of Freud's mentors and prints of classical scenes. Shelves and tables are crowded with terra-cotta Chinese figures, marble Egyptian pieces, bronze Greek and Roman warriors and gods, painted mummy portraits, Etruscan mirrors, pieces of ancient glass and jade, pots, vases, and amulets. There are more than two thousand books.

Freud's daughter Anna inherited the mantle of psychoanalysis and became the keeper of the flame. Her father's study became a sort of shrine. The rest of the house was turned into a therapy clinic for children. Anna lived in the house until she died, in 1982, and it opened as a museum four years later.

When I was walking through the house, looking at all the rooms, I opened a closet door upstairs and saw a couch with very ornate, flowered upholstery. It was standing on its end. I was told that it had been in Freud's study and was his deathbed. He had been moved into the study after one of the first air-raid alarms sounded in the neighborhood. It was thought that he would be safer there than upstairs. Freud spent his last days looking out at the garden, surrounded by his collections and books.

———

When I took that first trip to England, I knew that not every place was going to be like Emily Dickinson's brother's house, but it took me a while to come to terms with the

Virginia Woolf worked in a greenhouse-shed behind Monks House, her country home in East Sussex.

*degree* to which the places weren't going to be like they were originally. Down House, Charles Darwin's house in Kent, is beautifully restored, but the gift shop is where his study had been.

Darwin bought Down House in 1842, when he was thirty-three and already famous. His journal of his experiences as a naturalist on the voyage of the *Beagle* had captured the popular imagination. Darwin had started out with no official role in the voyage, but the captain needed company and Darwin's wealthy father was willing to

pay his son's expenses. He was away for five years, during which he accumulated thousands of specimens and the intellectual basis of his life's work.

Down House became the center of Darwin's world. He rarely left it. He doubled the size of the original house, built a greenhouse, and cultivated extensive gardens. His daily routine included two or three walks on a looping path, the Sandwalk, that he had planted with trees and bushes. It was where he spent time thinking before going back to his study.

Darwin bred pigeons at Down House, and when I got back to New York I contacted Joanne Cooper, the curator of anatomical collections in the Bird Group at the Natural History Museum at Tring in Hertfordshire. The museum has one of the largest ornithological collections in the world. Joanne is a specialist in Darwin's domestic-bird skeletons. Several months later, when I went to Tring, she told me that she was delighted that I hadn't asked to see the finch collection. Most people do, since Darwin's finches are so famous. But the story about Darwin grasping the truth of evolution while he was studying the shapes of the bills of various finches in the Galápagos Islands is just a legend. Darwin wasn't very interested in the finches when he was in the Galápagos. He didn't know that much about birds, although he was learning. He thought of himself as a geologist first and an entomologist second. When he returned

Woolf wrote *Jacob's Room, Mrs. Dalloway, To the Lighthouse, Orlando, The Waves, Between the Acts,* and hundreds of stories, essays, and reviews at Monks House.

to London from the trip on the *Beagle,* he gave his bird specimens to an expert and was as surprised as everyone else to discover that almost all the birds he had brought back, when properly identified, were previously unknown species.

The first chapter of the *Origin of Species* has a long passage about pigeon breeding. "Believing that it is always best to study some special group, I have, after deliberation, taken up domestic pigeons," Darwin wrote. "I have kept every breed which I could purchase or obtain. . . . The diversity of the breeds is something astonishing. In the skeletons of the several breeds, the development of the bones of the face, in length and breadth and curvature, differs enormously." He joined pigeon clubs and documented things like how much mud his pigeons accumulated on their feet in wet weather. To compare the skeletons of the various breeds, he collected bodies and boiled them, although the smell and mess in the kitchen became too much for his wife and it was decided that the bodies could be sent out for more professional preparation.

Darwin was a skilled taxidermist, but his labeling system left something to be desired. He hadn't, for instance, labeled the specimens he collected in the Galápagos according to the island they came from. He realized this was important later. The problem was made worse because he had labeled things like a geologist, and the labeling method for rocks is not suitable for birds. Rocks have numbers painted on

them. Darwin would put a number on a piece of paper and attach it to a bird and then cross-reference the number with the specimen details in a notebook. Unfortunately, the notebooks and the specimens became separated over time.

———

One of the hardest parts of my work as a photographer is explaining what I'm doing while I'm doing it. Or before I do it. This has always been true. Talking demystifies the

Virginia Woolf's writing desk

process. My brain doesn't work like that. On the first trips for this project, I didn't even tell people exactly what the pictures were for. This was partly because I wasn't sure myself, but partly because I was reluctant to make the project official.

I knew that I was going to have to start explaining when I realized that I had to go back to Amherst for more material. The new phase would involve collaborating closely with curators, and the first curator I talked to at any length was Jane Wald at the Emily Dickinson Museum. (This was before I met Joanne Cooper at Tring.) I called

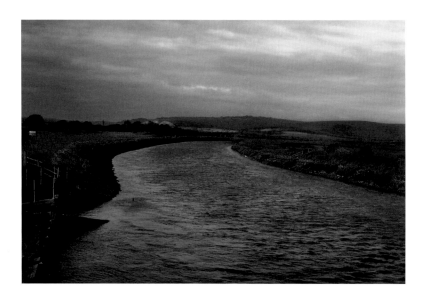

Jane and told her that I'd been there before and had made some pictures that I wanted to use for a book. There was a pause, and then she said, "How wonderful." She was so supportive. I was taken aback. I had thought it would be difficult, but it wasn't. The white dress that I had photographed through the Plexiglas on my first visit was a copy, and I asked Jane where the real one was. She said, "Oh, it's just down the street, in the Amherst History Museum. The woman who runs it, Pat Lutz, is on my board. I'll give her a call." I talked to Pat Lutz the next day and she couldn't have been nicer.

In 1813, Emily Dickinson's grandfather built the family's large brick house, which was known as the Homestead, on Main Street. It was set on fourteen acres. Emily was born there. During the last twenty years of her life she was more or less a recluse in it, a mysterious woman in white whom the neighbors referred to as the Myth.

The legend of the isolated, retiring poetess is misleading, although it is true that Dickinson never considered leaving Amherst. "I never thought of conceiving that I could ever have the slightest approach to such a want in all future time," she said to a friend who asked if she thought she might be missing something. "I feel that I have not expressed myself strongly enough," she added.

Emily was intellectually confident. She had been recognized as a brilliant student at the progressive Amherst Academy, which was affiliated with Amherst College and

PRECEDING PAGES AND THIS PAGE: The River Ouse, near Monks House, where Virginia Woolf walked every day. She drowned there in 1941.

was where she studied botany, geology, Latin, history, and philosophy. She went to the Mount Holyoke Female Seminary—one of the first women's colleges in the United States—for a year. Until some time in her late twenties or early thirties, she had a reasonably active social life. She attended lectures, concerts, college functions. Her sister-in-law, Sue, entertained frequently at the house next door, the Evergreens, and Emily took part in dinners, teas, and lawn parties there. She improvised on the piano for guests—"weird and beautiful melodies," one visitor recalled.

Even after Dickinson withdrew from normal life—following some kind of crisis, perhaps emotional or perhaps physical or perhaps both—she kept up a passionate, witty, and deeply engaged correspondence with many people. Much recent scholarship is devoted to inconclusive speculation about with whom Emily was in love and what exactly went on. Her family life was not simple. The most disruptive element was the extramarital affair conducted by her brother, Austin, with Mabel Loomis Todd, a young faculty wife. Many of the lovers' assignations took place behind closed doors on the sofa in front of the fireplace in the Homestead dining room. By that time, Emily's father and mother had died and Emily was living at the Homestead with her sister, Lavinia. The sisters' apparent complicity in Austin's relationship with Todd widened a deep rift with Sue, next door. Emily hadn't taken the path to the Evergreens in years except to pay a visit when her eight-year-old nephew died of typhoid fever.

The Amherst History Museum, where I went to photograph the real white dress, is in an eighteenth-century house. The museum is part of the Amherst Historical Society, which was founded by Mabel Loomis Todd in 1899, four years after the death of her lover, Austin. Mabel Loomis Todd played an important role in Emily Dickinson's legacy, even though the two women never met. (Sometimes Mabel would sit at the piano and sing in the downstairs parlor at the Homestead, knowing that Emily was upstairs or in another room and would be, unavoidably, listening.) After Emily died, in 1886, her sister had discovered hundreds of poems in a bureau in her bedroom, many of them carefully stitched together in little packets. There were also drafts, alternate versions, fragments on scraps of paper. Poems were not dated or titled. Todd, through sheer force of will mostly, managed to have selections of the poems published. She became Dickinson's principal editor. Her texts—with the punctuation changed to conform to convention, rhymes altered, and titles added—were accepted as authoritative until the 1950s.

Although much of Emily's correspondence was destroyed or lost, both Mabel Loomis Todd and Sue Dickinson had significant caches of manuscripts and letters, and they and their heirs were warring camps for years. It was a war with high stakes, since Dickinson's poems immediately became popular and she became famous. There were issues of copyright, royalties, interpretation, and physical ownership of what was belatedly seen as a national treasure. Sue Dickinson lived in the Evergreens until her death in 1913. The house and its trove of papers were passed on to her daughter.

The Jones Library, a public library that has a substantial collection of material

FOLLOWING PAGES: The painters Vanessa Bell—Virginia Woolf's sister—and Duncan Grant lived at Charleston Farmhouse for many years in a complicated, busy household a few miles from Monks House. Charleston is the most important remaining example of Bloomsbury decorative style.

Portraits by Duncan Grant of Vanessa's sons, Julian and Quentin, hang on the wall of her bedroom. The cupboard on the right was decorated by Vanessa.

Vanessa designed the paisley pattern stenciled on the walls of the Garden Room, which is next to her bedroom.

The Studio was one of the warmest rooms in the house. Duncan Grant painted the panels around the fireplace. Vanessa inherited the glass-fronted cabinet from her father.

The unfinished plaster bust of Virginia Woolf on the Italian chest of drawers was made in 1931. It is next to a portrait of Vanessa and Virginia's brother, Adrian Stephen, painted by Duncan Grant in 1910.

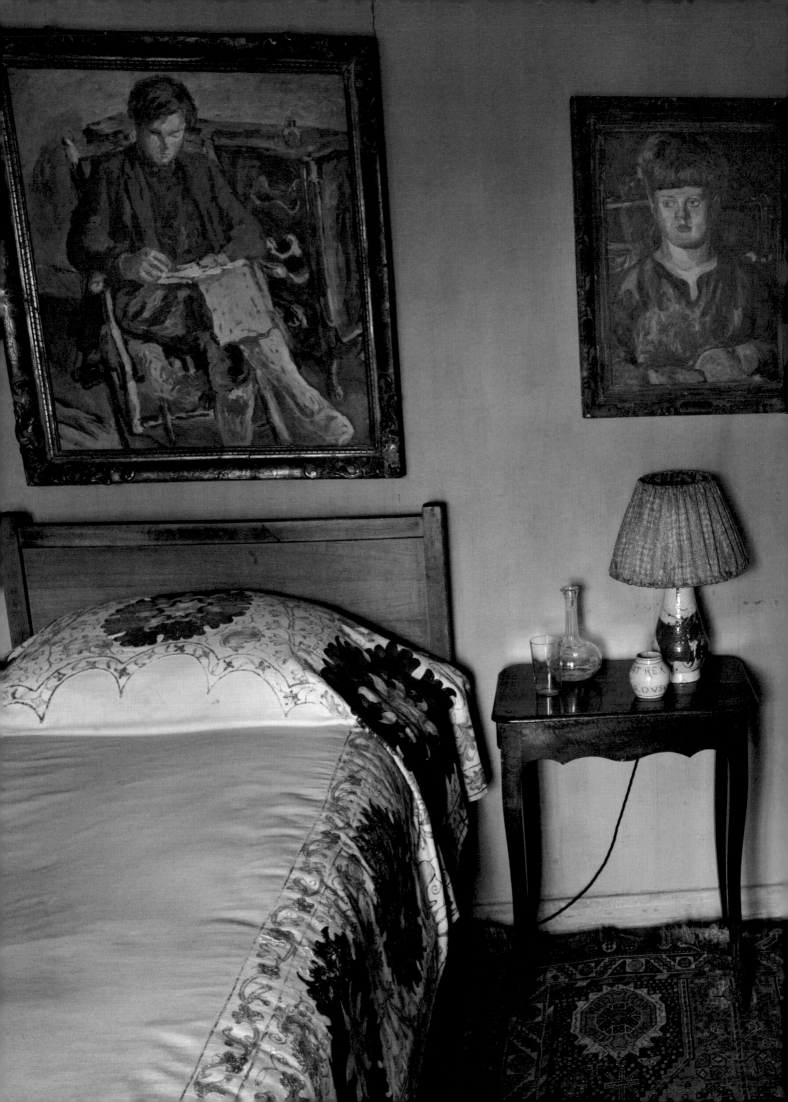

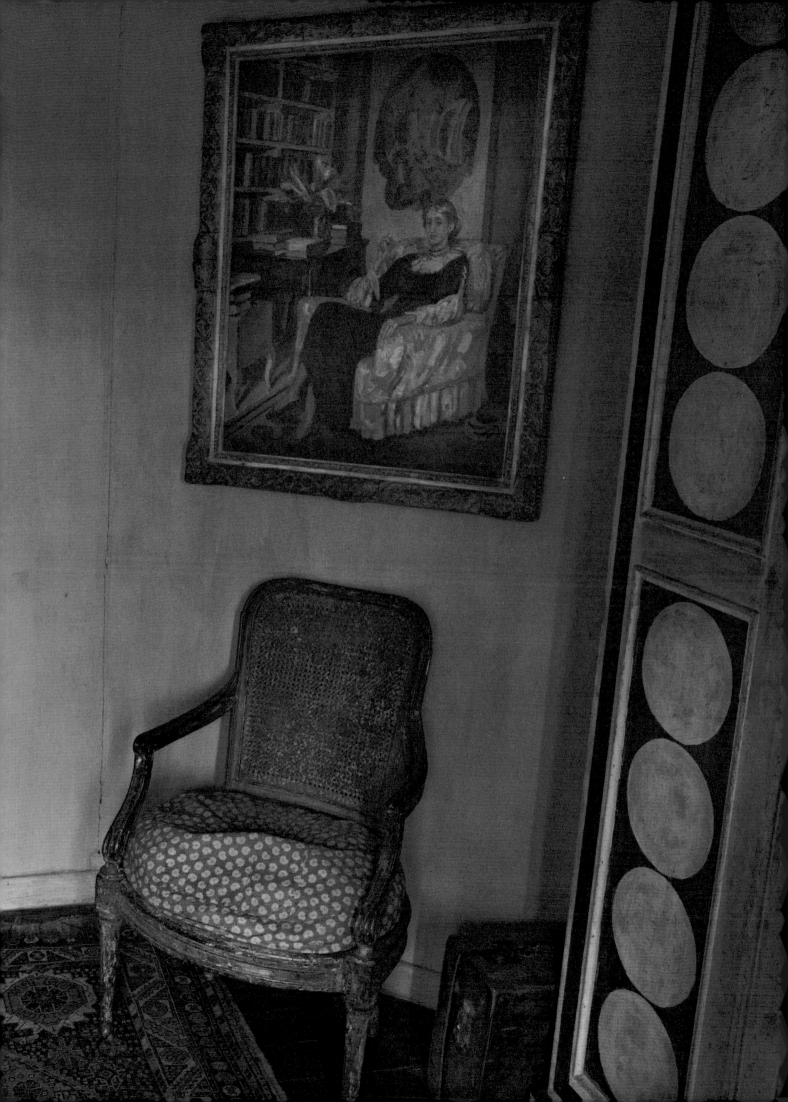

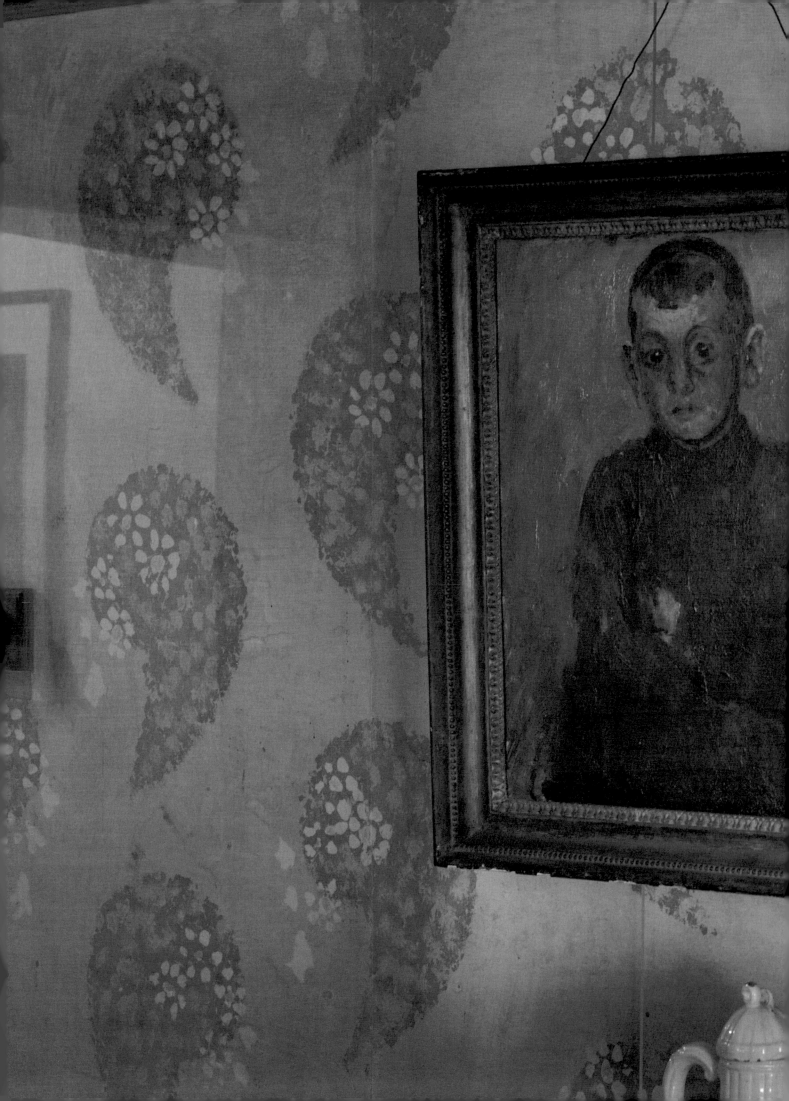

on Emily Dickinson, is next door to the Amherst History Museum. They also have a collection that documents the life of Robert Frost, who lived in Amherst and taught at Amherst College. The curator of special collections, Tevis Kimball, brought out a textbook from Emily's years at the Amherst Academy. It was an atlas, designed to

illustrate the geography of the heavens. You could imagine how that would have fed into her brain. Kimball also showed me a letter from Dickinson. Pressed bluebells were attached to it. Emily was an avid gardener and she often included pressed flowers with letters and with the many copies of poems that she sent to family and friends. She must have spent as much time gardening as writing.

When the dispute over Emily Dickinson's estate was finally settled, most of the Dickinson material, I kept being told, went to Harvard. Where is the bureau that the packets of poems were found in? Harvard. Where is the table she wrote on? Harvard. Where are her books? Harvard. At that point I was still convinced that my subject was people's houses. I hadn't even come to terms with photographing objects. Nevertheless, a few weeks after we visited Amherst, my assistants, Nick Rogers and Matthias Gaggl, and I were in the pristine, climate-controlled Emily Dickinson Room of Harvard's Houghton Library. Leslie Morris, the curator of modern manuscripts and rare books, was letting me photograph Emily's herbarium, the book of pressed flowers she made when she was a girl. The specimens are mounted in an album bought in a stationery store. They are brittle and prone to crumbling, and the book usually resides in a vault. I photographed a few pages, very gingerly, as it sat on a specially built stand.

The writing room and library of Vita Sackville-West, Virginia Woolf's great friend and the model for the time-traveling aristocrat in *Orlando*, is in the tower of Sissinghurst Castle, in Kent. Sackville-West and her husband, Harold Nicolson, bought the ruined castle in 1930 and restored it. Her writing room looks out over their vast garden.

By this time, I understood the importance of establishing relationships with curators. I had even made an appointment with the park supervisor at Walden Pond in Concord to talk to him about photographing the site of Henry David Thoreau's cabin. Actually, I made several appointments and then had to change them. This seemed ludicrous when I got to the pond. It's in a public park a few minutes outside of town. You don't need an appointment. We had driven over from Boston, and we left the car in the parking lot across the street from the pond and walked to the ranger station, where they have a great bookstore. The man who was waiting for us gave me a map.

It was already noon on an early summer day and very bright and I knew there was no hope of a good photograph, but I thought I would try to get the lay of the land. It's about a half-mile hike from Red Cross Beach, a sandy stretch on the north shore of the pond, to the place where Thoreau's cabin had been. There were a lot of swimmers in the water, which was very blue. I'm not sure what I expected to find, but I didn't realize that the distinguishing feature of the site is a pile of rocks. This was explained in a catalog of the Thoreau Collection in the Concord Museum, which I had picked up at the store at the entrance to the pond. In 1872, ten years after Thoreau died, Bronson Alcott, Thoreau's neighbor and friend and Louisa May Alcott's father, took a visitor to the site. They left some stones in tribute, and Alcott encouraged what became a tradition. People started signing and dating the stones. There is a colored postcard of the site from 1908 in the museum catalog. The pile of rocks is smaller than the one that was there the first day I visited the pond. David Wood, the curator of the museum, explained to me later that the size of the pile has fluctuated. In the 1970s it was said to have disappeared altogether. It has since grown.

The picture on the postcard is interesting. For one thing, the view of the pond from the cabin site is much clearer than it is now. There weren't as many trees in 1908 and they weren't as big. There were probably even fewer trees when Thoreau was there. Walden Pond had woods, but in general the land around Concord was open then. Homes were still heated with wood, and much of New England was deforested. Thoreau writes about hearing the sound of axes when he goes for walks. The bean field he cultivated was in an eleven-acre pasture that was full of stumps. His friend Ralph Waldo Emerson had bought the pasture and the adjoining smaller woodlot of pines. Emerson speculated about building a cabin there for himself, but it was Thoreau who had the time and skills to do it. He moved into the cabin on July 4, 1845, and he lived alone there for two years. The cabin had one room and was relatively small, only ten by fifteen feet. It faced the water, and Thoreau wore a path to the pond's edge. He swam there early every morning and fished at night or just sat in his boat playing his flute by moonlight. He also walked to town nearly every day.

A new railroad was being built through Concord, and the tracks ran about five hundred yards behind Thoreau's cabin. Twenty years later, the railroad company built

Sigmund Freud's couch in his study at 20 Maresfield Gardens in London

CHOLOGY
OF SEX
—
AVELOCK
ELLIS

The Art
of Life
Gleanings
from the
Works of
Havelock
Ellis

STUDIES
IN THE
PSYCHOLOGY
OF
SEX

HAVELOCK ELLIS

SEX IN
RELATION
TO SOCIETY

STUDIES
IN THE
PSYCHOLOGY
OF
SEX

HAVELOCK ELLIS

SEXUAL
INVERSION

STUDIES
IN THE
PSYCHOLOGY
OF
SEX

HAVELOCK ELLIS

ANALYSIS OF THE
SEXUAL IMPULSE
LOVE AND PAIN

STUDIES
IN THE
PSYCHOLOGY
OF
SEX

HAVELOCK ELLIS

MODESTY
SEXUAL PERIODICITY
AUTO-EROTISM

INEMANN

F. A. DAVIS Co.

F. A. DAVIS Co.

F. A. DAVIS Co.

F. A. DAVIS Co.

a holiday pavilion between the tracks and the pond. There was a railroad stop there. The pavilion burned down at the turn of the century, but the railroad was soon irrelevant anyway. There were new roads and automobiles to bring visitors to the pond. Thoreau's writings are founding documents of the modern conservation movement, but the place that inspired them was not isolated when Thoreau was alive and certainly not after his death.

Thoreau's cabin was moved to a farm north of Concord two years after he left it. The Concord Museum collection includes many of his things, including his walking stick, which is notched out in inches, and a three-tiered mahogany-and-pine box that

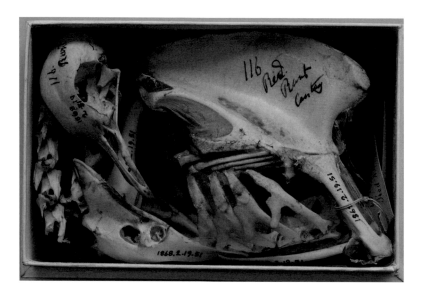

A pigeon skeleton from Charles Darwin's collection at the Natural History Museum in Tring, England. When Darwin returned from his trip on the *Beagle*, where he had collected specimens that led to his theories about natural selection, he began breeding and studying pigeons at Down House, his estate in Kent.

he made for geological specimens. The most important thing they have is Thoreau's desk, a simple pine writing desk, painted green, with a slanted top. Thoreau wrote the first draft of *Walden* and the essay "Civil Disobedience" on it. He didn't lock the door of the cabin at Walden Pond, but he locked the desk with his papers in it. You can tell by the way the paint is worn off around the keyhole.

The bed that was at Walden Pond is in the museum too. On my second trip to Concord, David Wood very kindly took the bed out of the display area in the museum so that I could photograph it. While we were working and talking, someone mentioned that Thoreau had died on the bed. I was taken aback. After Thoreau left Walden Pond, he moved into his parents' house on Main Street and he took the bed with him. It was brought downstairs to the front parlor during his final illness.

My interest in Thoreau and Walden Pond had brought me to Concord. Once there, I couldn't help but be pulled into other people's lives. The contents of Ralph Waldo Emerson's study are in the Concord Museum, in a replica of the real study. This seemed a little strange, since Emerson's house, where the real study is, is literally across the street from the museum. When I was at the Houghton Library for the first

time, Leslie Morris said that she had heard I was going to Concord to see David Wood, and she insisted that I go to the Emerson house too.

I was being led into a big subject.

Because of Emerson, Concord was the capital of American Transcendentalism. Most of the Transcendentalists were from New England. Thoreau was born in Concord. Emerson was born in Boston, but he had deep family roots in Concord. The encounter between the minutemen and the British at the North Bridge took place next to his grandparents' farm. Emerson moved to Concord in 1834. He and his wife and children and his mother, plus numerous rotating houseguests, lived in a big white house with a barn and a garden near the center of town. Thoreau became his protégé soon after he left Harvard. They took long walks together, often out to Walden Pond. Thoreau moved in with the Emersons and helped run the house. He went to live at Walden Pond as a sort of experiment in the theories that they shared about self-reliance and the importance of a simple life in tune with nature. Thoreau left the cabin when Emerson's wife asked him to move back in with them while Emerson was on one of his popular lecture tours, preaching self-improvement and radical individualism.

The big white house still belongs to the Emerson family. Emerson's great-great-great-granddaughter, Eliza Casteñeda, met me there on my second trip to Concord. Eliza served us tea and snacks on the table in the dining room. Emerson's house is large and rambling, but it's hard to imagine it as full of people as it almost always was. Emerson liked having a community of friends around him. At one point, for a year and a half, he even turned his home into a boardinghouse, run by someone else, with him and his family as boarders. This was during the period that Thoreau was living at Walden Pond. Thoreau's mother had turned their home into a boardinghouse also, which may have provided an additional motive for Thoreau's gravitation to the peace and quiet of the pond.

The house is pretty much as it was in the later years of Emerson's life. It's a private museum now, kept up by Emerson's descendants, who open it to visitors part of the year. It's not easy to keep these old houses going. The day after we were there, we visited Orchard House, where one of Emerson's oldest and dearest friends, Bronson Alcott, lived with his family for twenty years. It too is maintained by enthusiasts. Orchard House is about a half mile from the Emerson house, on the Lexington Road. I hadn't planned on going there either, but on my first trip to Concord we kept driving by it and I finally said, "Okay, let's go in." I bought a ticket and asked the guide to do a quick walk-through. The house hasn't been overly restored, and you can get close to things in it. I noticed some original wallpaper.

On the next trip, I made an appointment with Jan Turnquist, the executive director of Orchard House. Jan worked as a part-time guide at the house for many years. Her specialty was, and still is, portraying historical figures. She does Louisa May Alcott, of course, but also Harriet Beecher Stowe and Phebe Emerson, Ralph Waldo Emerson's grandmother, among others. Students who work as guides on tours dress up as the

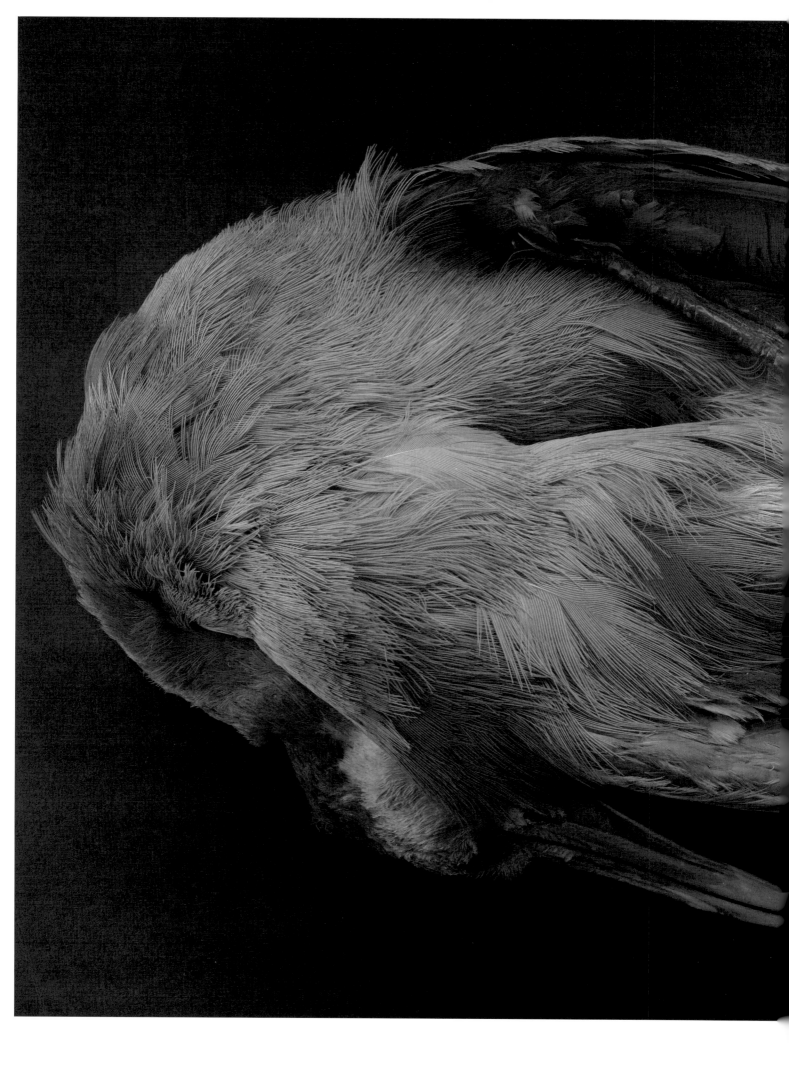

The Sandwalk, the looping path at Down House where Darwin walked every day.

Alcott sisters and tell their stories to visitors. This is all in the spirit of the historical Alcotts, who staged theatricals of their own. They put up a curtain between the parlor and the dining room.

Jan said that the preservation of Orchard House started in 1911. The Louisa May Alcott Memorial Association bought it and fixed it up. Orchard House was one of the first house museums. The association is still the owner. In 2000 they received a grant

from the Save America's Treasures program and were able to build a foundation under the part of the house that had been sitting on the ground. One of their main problems is working around the structural weaknesses that Bronson Alcott introduced. He took out weight-bearing beams. Bronson was a very impractical man who was always tinkering. "He was good-hearted," Jan said. "He didn't mean to make a mess of it."

That could serve as a succinct description of Bronson's whole life. He moved to Concord from Boston in 1840, in part to escape from disastrous forays into running progressive schools. He was said to be a brilliant speaker in private, a genius of some kind, but he didn't do well in public, nor as a writer, which meant that he was always broke. He had views on pretty much everything, especially food. He preferred "aspiring" vegetables, like beans—not beets and carrots, whose edible parts grow underground. Following his strictures wasn't always so easy, especially during the year spent trying to make a success of a utopian community called Fruitlands. Louisa May titled a satire of the Fruitlands experiment "Transcendental Wild Oats." Her mother appears as the character Sister Hope. "Unconverted but faithful to the end," Louisa May wrote, she "hoped, after many wanderings over the face of the earth, to find rest for herself and a home for her children." Their efforts ended badly, and they all nearly starved.

The Alcotts' poverty and erratic life—they moved something like thirty times—was offset by the generosity of Bronson's friends. Louisa May was tutored by Thoreau

and had the run of Emerson's library. In 1857, when Bronson had a little money and was able to buy Orchard House, she was twenty-four and had already had some stories published. Her younger sister Lizzie died after a lingering illness shortly before they moved into the house, and a year later her older sister, Anna, was married. In 1862, Louisa May volunteered as a nurse in a hospital for Union soldiers in Washington, D.C. She almost died of typhoid fever there. Her first literary success, *Hospital Sketches,* was based on her experiences in the war. The life-altering work, *Little Women,* came a few years later. It was an immediate bestseller, and Louisa May became wealthy and famous. Curiously, that same year Bronson finally had a publishing success himself and was financially solvent.

I thought I would be at Orchard House for an hour or two, but Jan took me to a back room to look at things that weren't on display. There were all kinds of treasures wrapped in tissue paper in archive boxes—locks of Louisa May's and her parents' hair, costumes from amateur theatricals. It was in the back room at Orchard House that I came to terms with photographing objects. I resigned myself to using a tripod, looking for better lenses, better cameras.

What I was accumulating was a notebook. I had realized that at Walden Pond. Concord is a deep well of stories about people and places. You could spend your life studying them. I was incredibly lucky to be able to walk into the rooms there and get a sense of what it was like to live in them.

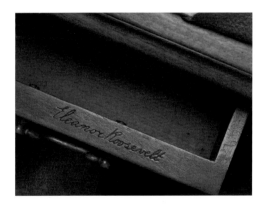 

I kept going back to Concord, and especially to Walden Pond, where I never could seem to get just the right view. I returned there a few weeks after the first trip and was at the cabin site at sunrise. Then I went in the fall, when the trees were losing their leaves. I tried again in winter. Each of the trips gave me something.

———

Val-Kill, Eleanor Roosevelt's home in the Hudson River Valley, isn't far from our place in the country. I had gone there when I first started spending time in the area. The idea of the president's wife living in a factory building made out of cinder blocks fascinated

Eleanor Roosevelt's desk was made at the Val-Kill furniture factory. Her name is branded into the lip of the desk drawer. The objects on the desk include a string holder decorated with printed paper.

The unheated sleeping porch in the Val-Kill cottage was next to Eleanor's bedroom. It overlooks a pond and is surrounded by trees. Eleanor often slept there, even in cold weather.

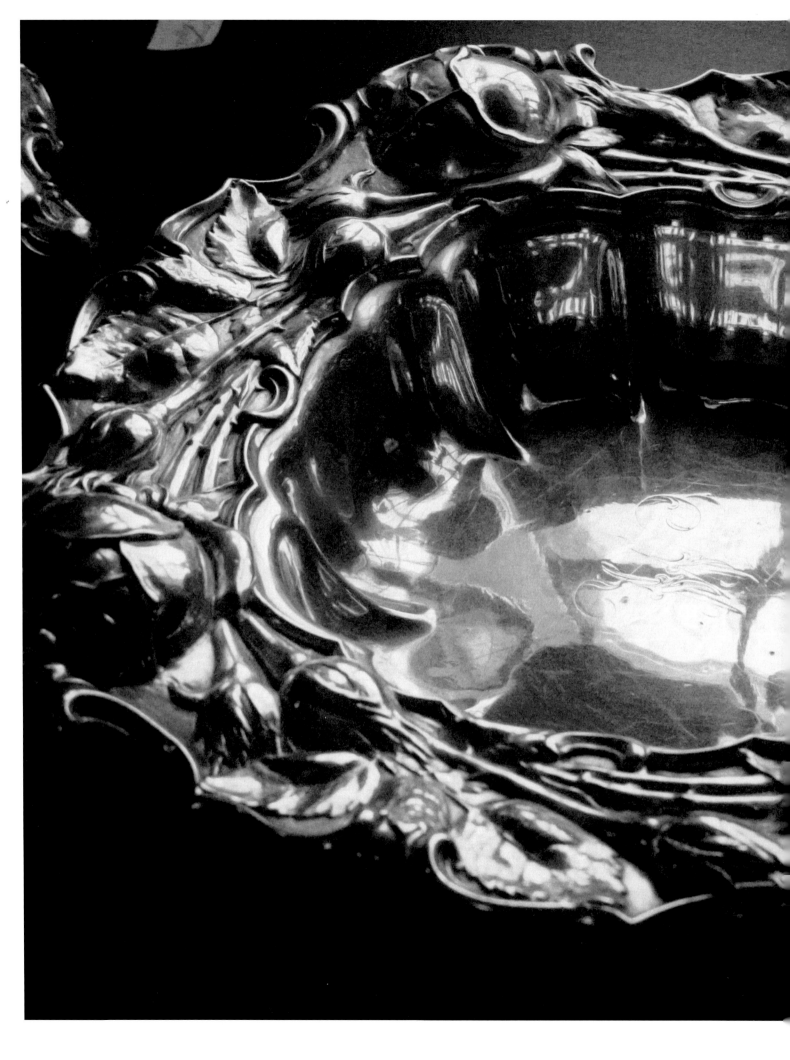

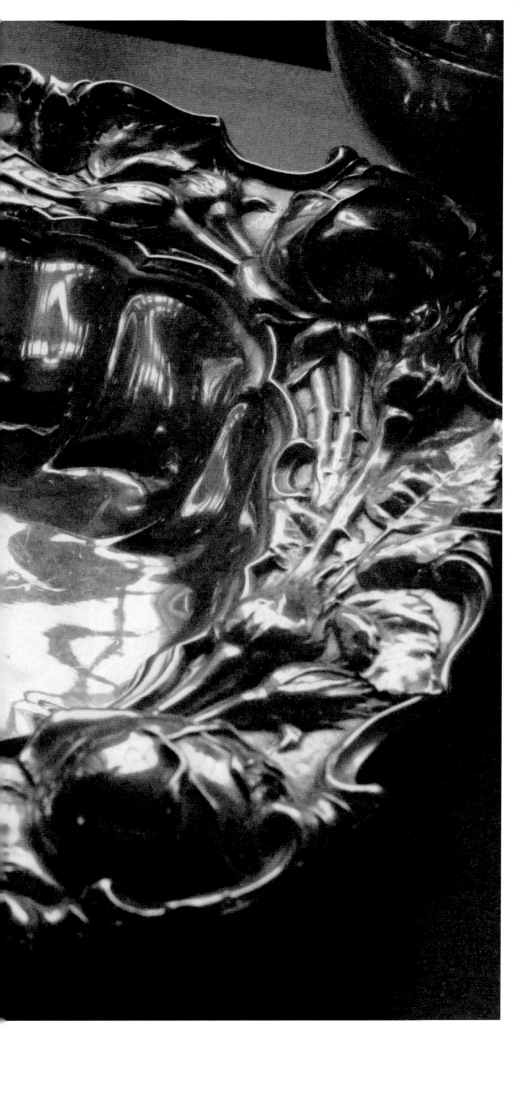

A silver serving dish on
a table near the dining
room at Val-Kill is part
of a collection of silver
pieces from Eleanor's
family. FOLLOWING PAGES:
The living room at Val-Kill,
which was also the office
of Eleanor's secretary.

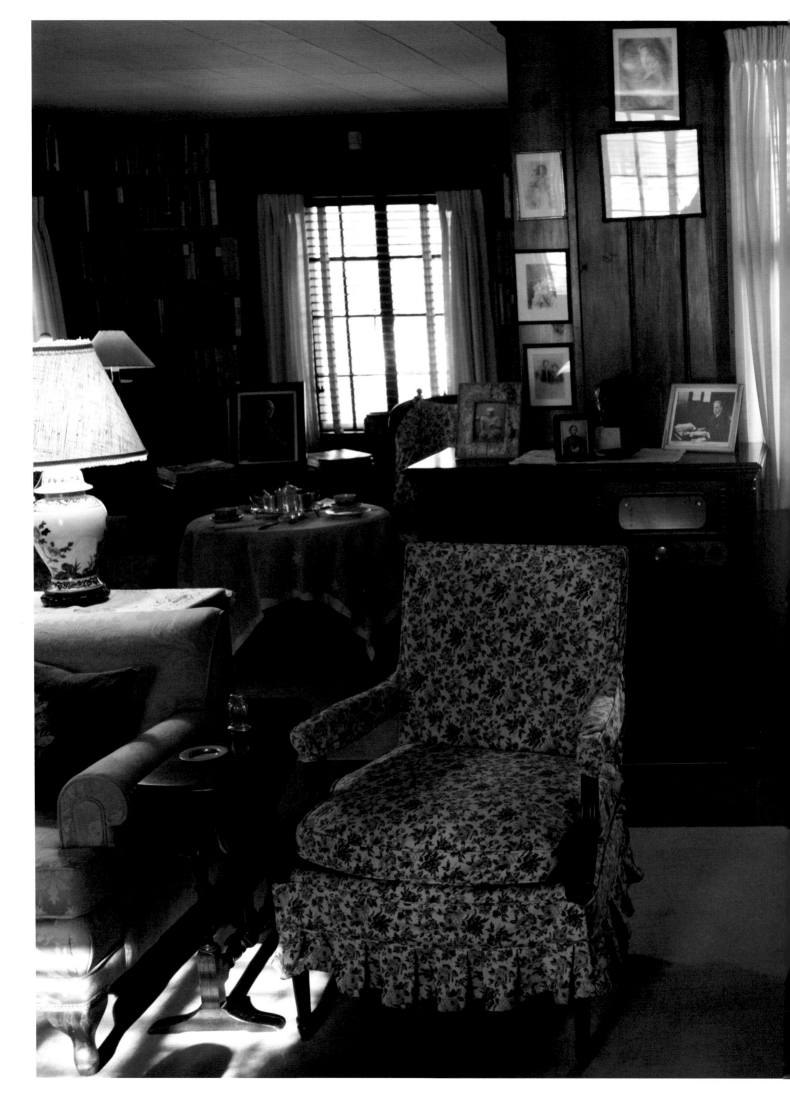

me. For a while, I thought about building a house out of cinder blocks myself. I was also intrigued by the Roosevelts' living arrangements. The first lady and the president lived in separate houses.

Eleanor Roosevelt's mother died when she was eight. She was raised by her maternal grandmother in a townhouse in New York and on the family estate on the Hudson, about thirty miles north of Val-Kill. When Eleanor was fifteen, she was sent to a girls' school in England. After she married Franklin Delano Roosevelt, in 1905, her

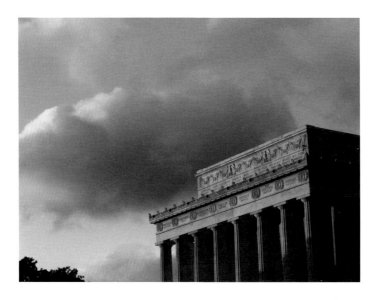

domestic life was dominated by her formidable mother-in-law, Sara Delano Roosevelt, who was extremely close to her only child and who controlled his inheritance. Eleanor and Franklin lived with Sara at the Roosevelt home in Hyde Park and in a double town-house that Sara built for them on Sixty-fifth Street in New York. Sara was also a pres-ence in the various official residences that later came with Franklin's political life—the governor's mansion in Albany, the White House.

Eleanor Roosevelt found her place in the world in the early 1920s. Her life had changed in 1918, when she discovered that her husband had been having a long affair with Lucy Mercer, her social secretary. Eleanor was then a docile wife and the mother of five children between the ages of two and twelve. Three years later, Franklin was crippled by polio. Eleanor supported him during his recovery and encouraged him to continue his political life. She became his political partner, although she carved out an independent life of her own. She was deeply involved in the League of Women Voters and other progressive organizations. Her closest friends were feminist activists.

Franklin built Val-Kill for Eleanor. It served many purposes, not the least of which was to keep her friends away from his mother, who disapproved of them. The prop-erty adjoined the Hyde Park estate but was about two miles from what would come to be known as the Big House. The idea for the new compound came during a picnic

After Abraham Lincoln was assassinated, in 1865, Congress approved plans to erect a monument to him. The Lincoln Memorial was dedicated in 1922. The figure of Lincoln gazes out over the reflecting pool in the National Mall in Washington, D.C.

next to the Val-Kill stream in the late summer of 1924. Franklin, Eleanor, and several of their friends, including Marion Dickerman and Nancy Cook, whom Eleanor had met through the New York State Democratic Committee, were there. Someone remarked that it would probably be the last picnic of the year, since Sara was closing the Hyde Park house. Franklin said not to worry, that Eleanor and her friends should have a place of their own to stay in. He made a lifetime donation of the property and asked a contractor to dig out the stream and make a pond. At first, the main residence at

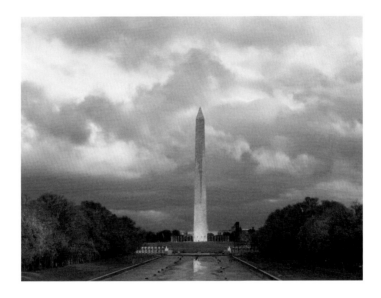

Val-Kill was a gray fieldstone house that was referred to as the Cottage by everyone except Sara, who called it "that hovel." In 1926, they opened Val-Kill Industries in a second building, the one made out of cinder blocks. Nancy Cook ran the factory there, which produced reproduction colonial furniture.

In the 1930s, after Franklin became president and they moved to Washington, Eleanor rented an apartment on East Eleventh Street in New York City as a refuge when she was in town for meetings, which she often was. Her relationship with Cook and Dickerman had frayed, and in 1937 Val-Kill Industries was closed. Eleanor moved into the factory building, renovating it as her residence at Val-Kill, with an apartment for her secretary. She closely supervised the furnishings, pictures, and books that went into it, and what was planted around it. She stayed in the big Hyde Park house when Franklin visited, but even then she worked at the Cottage. (The original cottage became known as the Stone Cottage, to distinguish it from the cottage made from the old factory building.) There were twenty rooms of various sizes and shapes, and many guests could be accommodated. On Labor Day, the White House staff came over for a picnic. When Franklin died, in 1945, the Big House was turned over to the government. Eleanor bought Val-Kill and several hundred acres of land from his estate. After she died, in 1962, the property was sold and the Cottage was divided into rental

Marian Anderson appeared on the steps of the Lincoln Memorial on Easter Sunday 1939, after she had been denied permission to sing at Constitution Hall, which had a "white artists only" policy. She sang "My Country, 'Tis of Thee" to an audience of 75,000 people. The crowd on the mall stretched all the way to the Washington Monument. "I had a feeling that a great wave of goodwill poured out from these people, almost engulfing me," she recalled in her memoir, *My Lord, What a Morning.*

One of Marian Anderson's concert gowns from the mid-1940s, when she was at the height of her fame as a singer. She had begun singing in the choir of the Union Baptist Church in South Philadelphia when she was six. By the time she was thirteen, her income from appearances supported her mother and her two younger sisters.

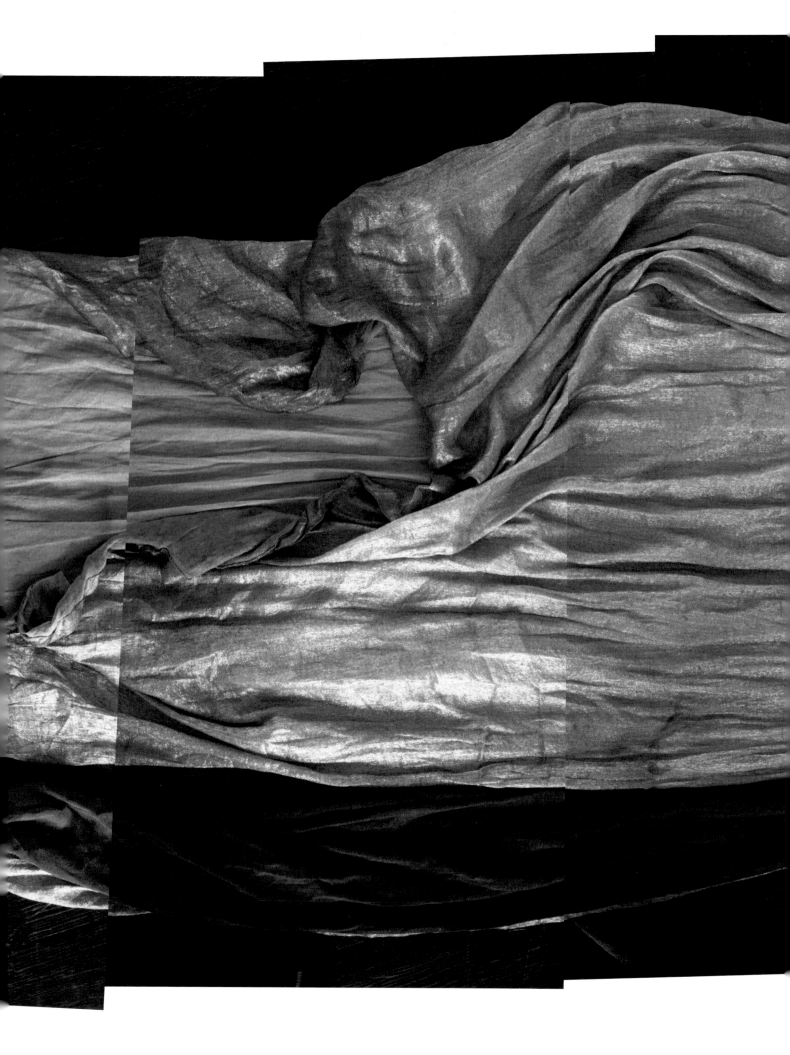

FOLLOWING PAGES: The bloodiest battle of the Civil War was fought on farms near the little town of Gettysburg, Pennsylvania, on July 1–3, 1863. One of the most famous photographs of the war, *Home of a Rebel Sharpshooter*, was made by Alexander Gardner at a spot called Devil's Den. Two or three days after the battle, Gardner moved the body of a dead soldier from a nearby field and staged the photograph.

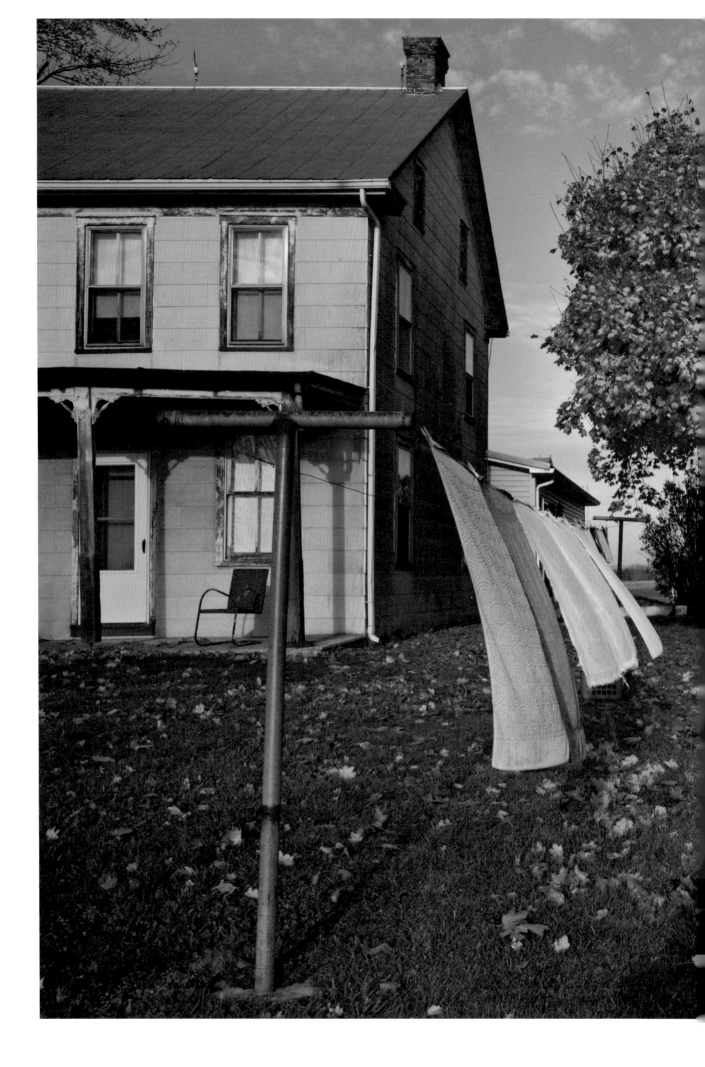

Four score and seven years ago our fathers brought
forth, upon this continent, a new nation, conceived
in liberty, and dedicated to the proposition that
"all men are created equal"

Now we are engaged in a great civil war, testing
whether that nation, or any nation so conceived,
and so dedicated, can long endure. We are met
on a great battle field of that war. We have
come to dedicate a portion of it, as a final rest-
ing place for those who died here, that the nation
might live. This we may, in all propriety do. But, in a
larger sense, we can not dedicate— we can not
consecrate— we can not hallow, this ground—
The brave men, living and dead, who struggled
here, have hallowed it, far above our poor power
to add or detract. The world will little note, nor long
remember what we say here; while it can never
forget what they did here.

It is rather for us, the living, to stand here,

ted to the great task remaining before us—
that, from these honored dead we take in-
creased devotion to that cause for which
they here, gave the last full measure of de-
votion—that we here highly resolve these
dead shall not have died in vain; that
the nation, shall have a new birth of free-
dom, and that government of the people by
the people for, the people, shall not per-
ish from the earth.

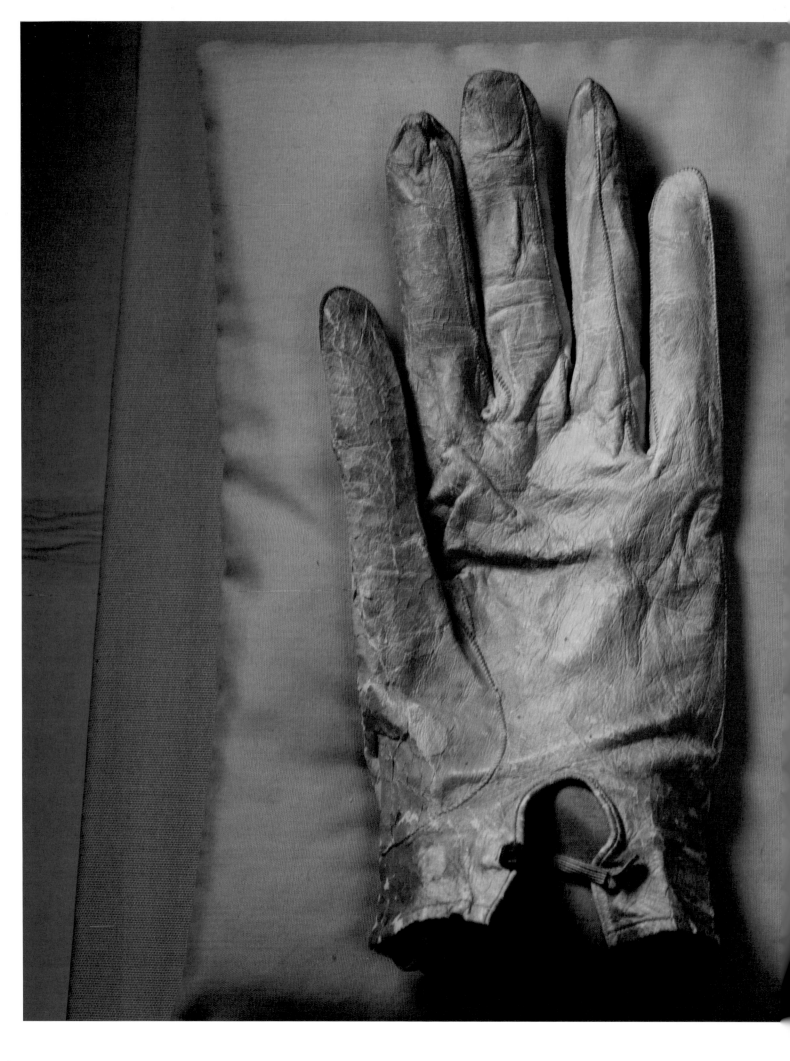

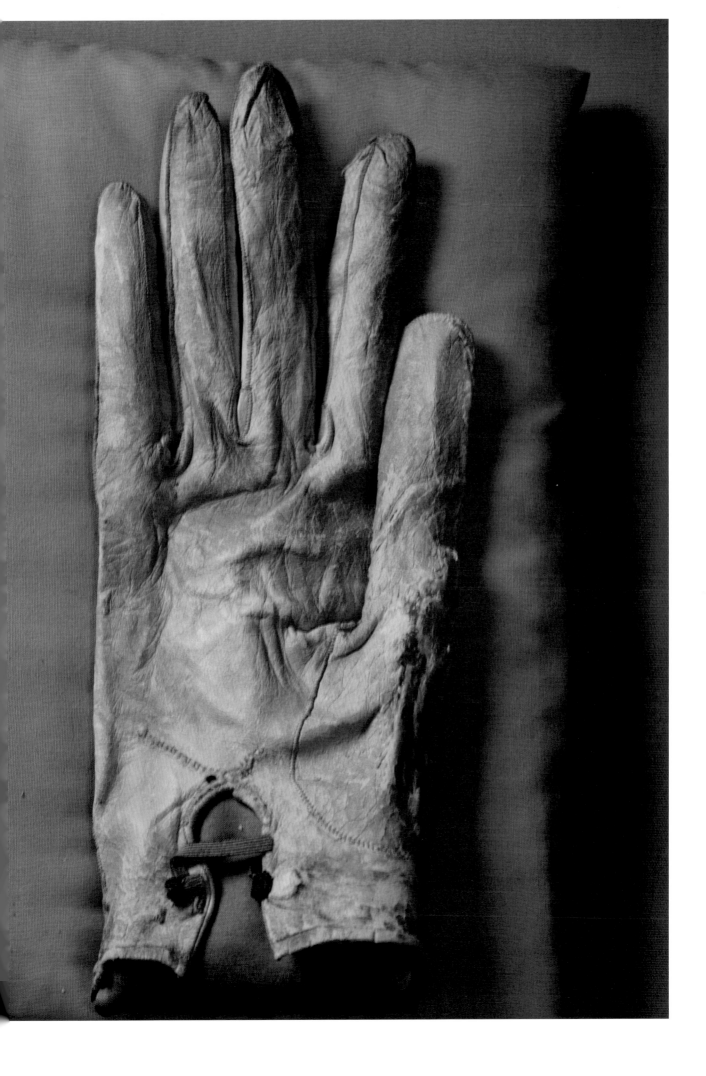

PRECEDING PAGES: The house of the farmer Jacob Lott was at the center of a line drawn by Union artillery and cavalry on the last day of the battle at Gettysburg. Four months after the battle, Lincoln gave a short speech at the dedication of the cemetery for Union soldiers. The first draft of what became known as the Gettysburg Address is in the Library of Congress. Lincoln was shot at Ford's Theatre in Washington on April 14, 1865. The gloves he had in his pocket are now in the Abraham Lincoln Presidential Library and Museum in Springfield, Illinois. THIS PAGE: The hat Lincoln wore to the theater on the night he was killed is part of the collection of the Smithsonian National Museum of American History.

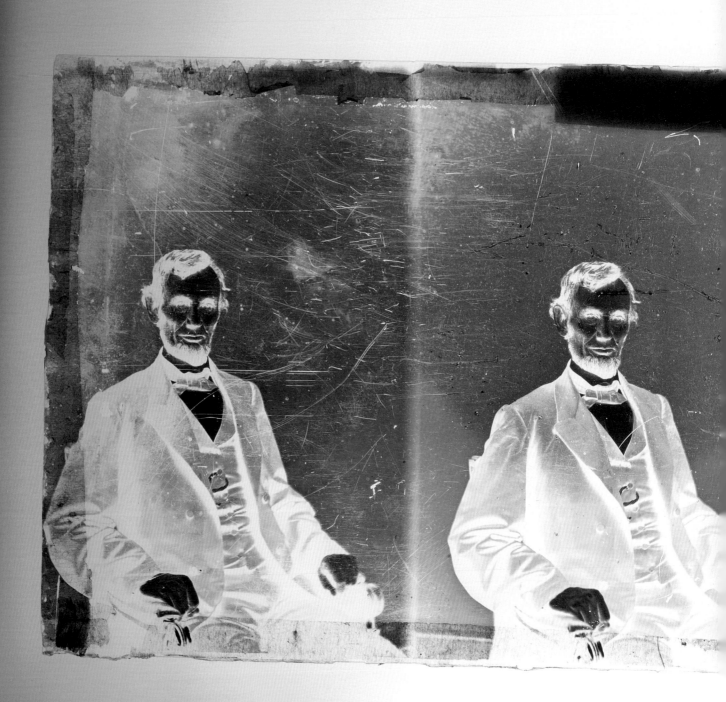

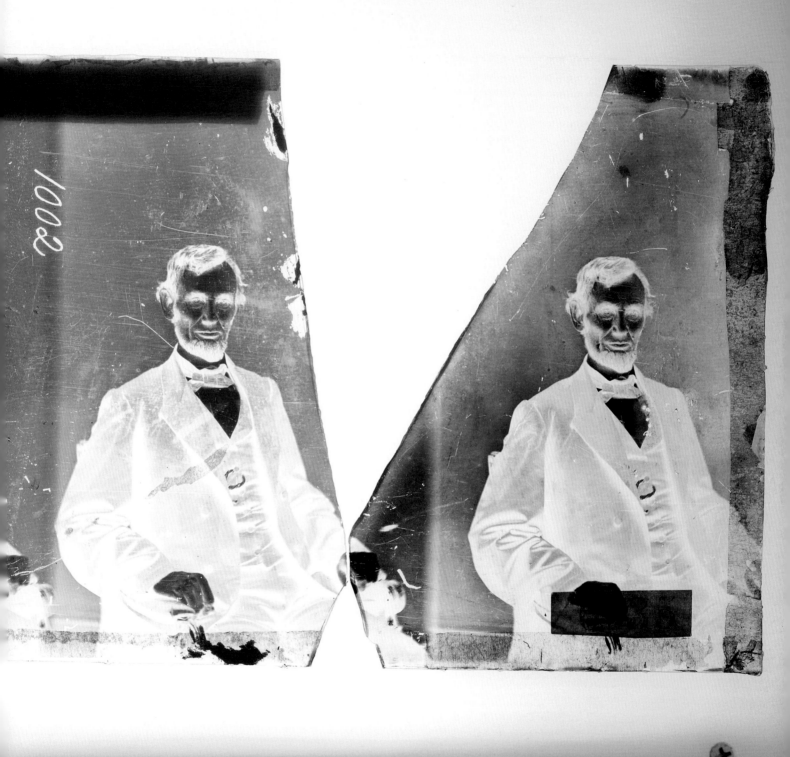

units. Val-Kill was saved from developers in the mid-seventies. In 1977, President Jimmy Carter designated it the Eleanor Roosevelt National Historic Site.

Val-Kill is cared for by the National Park Service, and when I went there I was shown around by the curator, Frank Furtal, who is a friend of mine. The houses were empty when the Park Service took them over, and their contents had to be reassembled. Frank said that about half the things now in the Cottage belonged to Eleanor and about half are replacement pieces. The Park Service has a fund that can be used to buy things back. There are various sources. Ebay is one. Frank was particularly proud of a recent purchase, a Ludwig Bemelmans painting of the Roosevelt summer retreat on the island of Campobello, in New Brunswick. It was hanging over the fireplace in the living room. There are photographs of it hanging somewhere else, but Eleanor moved things around all the time, so there is not necessarily one spot that is right.

Eleanor's bedroom was upstairs. It had a sleeping porch that was unheated, and Frank said that Eleanor slept there well after the weather turned cold. She came in only when her family insisted. I wanted to photograph Eleanor's view of the pond from the sleeping porch, but the first time I went to Val-Kill there was snow on the ground. The next time I went, in the spring, there were too many leaves. I couldn't see through the windows the way I wanted to. When I went back again, in November, you could see the pond clearly. One of the rangers explained that it had filled in and they didn't have enough money to dredge it. The pond was much smaller than it had been when Eleanor was alive.

———

There's a house museum in Danbury, Connecticut, in the middle of town, where Marian Anderson's studio has been preserved. We drove there in the afternoon that first day I went to Val-Kill. Anderson lived on a farm outside of Danbury for more than fifty years. She and her husband, Orpheus Fisher, bought the property in 1940. They had been looking for a house not far from New York for some time, but it was difficult to find anyone who would sell to a black couple. It didn't matter that Anderson was by then a famous and widely revered singer. Racial prejudice was a fact of life even in otherwise liberal northern states like Connecticut. Anderson and Fisher were able to buy the farm because he was so light-skinned that he could easily pass for white. He negotiated the deal before the sellers were aware of who he and his wife were. When they found out, they tried to stop the sale, but it was too late.

The farm was a refuge from Anderson's grueling performing schedule. She traveled from city to city all over the world in what were essentially one-night stands. Fisher usually stayed at home. He renovated buildings, designed and built furniture, raised sheep and cows and chickens, and took care of their numerous pets. At first they had a hundred acres and a rambling Victorian house and a barn, but after a few years they sold half of the original property and Fisher designed a three-bedroom ranch-style house on the plot of land that included Anderson's practice studio and

PRECEDING PAGES: A glass negative of a multiple-lens portrait of Lincoln made on February 9, 1864, by Anthony Berger at the Brady Gallery in Washington, D.C. The negative is now in the collection of the National Archives. The portrait session that day also produced the images used on the penny and the five-dollar bill.

the swimming pool. Fisher died in 1986. Anderson died seven years later, at the age of ninety-six, and the farm was turned over to a developer who had bought it some years earlier but had let them live out their lives there. Her studio was moved to Danbury, where it now sits on a parking lot in back of the museum. I'm glad that the building was saved, but it is kind of sad to look out the window and remember what Anderson could see. "My studio is removed from the house. A brook runs by it," she told a newspaper reporter. "It is very quiet. An occasional wind in the trees is the only sound."

The director of the museum, Brigid Guertin, brought out a box of clothes that had been given to them by a woman who had been close to Anderson. Most of Anderson's things were auctioned off, but this box had been in the woman's attic for years. We

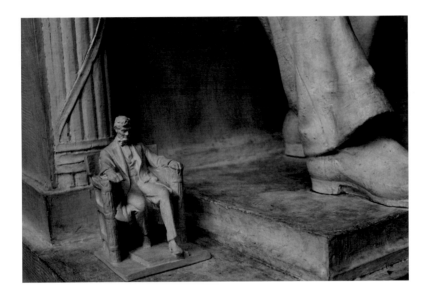

looked through it and I pulled out a gold dress with a red-velour panel that cut through the long, swirling skirt like a scar. There were sweat marks where the sleeves met the bodice. This was one of the dresses that Anderson performed in, and you could tell that it was well used. I photographed it spread out on the studio floor.

There were several kimonos in the box of clothes in Danbury, and later, when I was going through photographs in the University of Pennsylvania's Marian Anderson Collection, I saw that Anderson collected kimonos. There were also photographs of her in the gold dress. It must have been one of Anderson's principal concert dresses in 1945 and 1946. Philippe Halsman made a portrait of her in the dress around that time. She is standing in front of a piano. Anderson was at the height of her fame then. She was on the cover of *Time* magazine on December 30, 1946.

Anderson spent a great deal of time alone in her hotel room when she was on the road in the United States. When she toured in the South, which she did often, particularly early in her career, she couldn't eat in hotel dining rooms unless special arrangements were made. In the beginning, she couldn't even stay in hotels in the

The sculptor Daniel Chester French, who made the seated statue in the Lincoln Memorial, worked in his studio at Chesterwood, in Glendale, Massachusetts. French used plaster models of the statue, which was eventually cut from twenty-eight separate stone blocks.

The plaster working models in Daniel Chester French's studio include *Genius of Creation* and *Victory*.

Daniel Chester French made casts of his own hands as models for the monument to Lincoln in Washington.

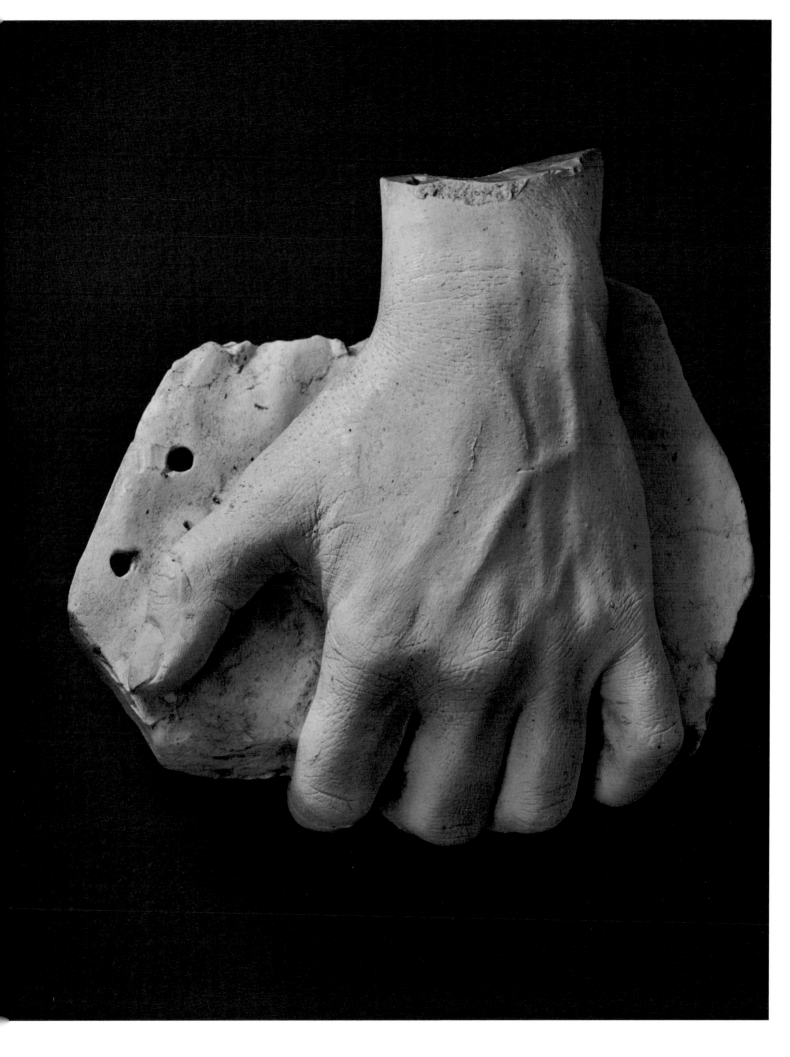

South. It was not easy to work around segregation laws and customs. Anderson was never an activist, but by the late thirties, when she had become a popular and critically acclaimed singer, she was in a position to be very useful to the civil rights movement. Her performance on the steps of the Lincoln Memorial on Easter Sunday, 1939, was of enormous political significance.

The Lincoln Memorial appearance was the result of an attempt by Howard University to rent Constitution Hall in Washington, D.C., for a recital by Anderson. The Daughters of the American Revolution own Constitution Hall, which in 1939 was

the best theater for large concerts in the city. The hall's rental contracts had a "white artists only" clause. Blacks were allowed into concerts by white performers, but they had to sit in special sections at the rear of the balcony. The DAR refused to waive the race ban for Marian Anderson.

Franklin Delano Roosevelt was in his second term as president in 1939. His New Deal policies were in effect, and black Americans were feeling cautiously hopeful about social progress. Eleanor Roosevelt in particular had been encouraging. Three years earlier, she had invited Marian Anderson to sing at the White House. Eleanor's response to the Constitution Hall debate was decisive. She announced in her syndicated column that she was resigning her membership in the DAR because she disapproved of its policies and saw no point in trying to work with it. A national poll indicated that two-thirds of the country agreed with her.

On Easter Sunday, the day that Anderson would have sung at Constitution Hall, she appeared on the steps of the Lincoln Memorial before a crowd that stretched out over the mall. It was a cold day, and she stood in front of a microphone in a full-length fur coat. Her performance was broadcast on the radio and recorded on newsreels. It included "My Country, 'Tis of Thee" and opera arias and Schubert songs. The encore was "Nobody Knows the Trouble I've Seen." The event lasted less than half an hour, but it was a transformative national experience. Marian Anderson would forever afterward be a beloved symbol of African American dignity. Lincoln was transformed too. The Lincoln Memorial had been created to honor him as the man who had preserved the Union. Now he was inextricably associated with the idea of emancipation.

Georgia O'Keeffe's great subject was the desert landscape of New Mexico. She lived there for the last thirty-seven years of her life. She had two houses— one in the badlands at a place called Ghost Ranch and another in the small town of Abiquiu. The Georgia O'Keeffe Museum and Research Center in Santa Fe houses a large O'Keeffe archive that includes rocks and bones she collected on walks and camping trips.

Daniel Chester French, the sculptor who created the seated statue in the Lincoln Memorial, was from Concord. When he was a young man, he studied art with May Alcott at Orchard House. She gave him modeling clay and sculpting tools and encouraged him to be an artist. French and his family had moved to Concord when he was seventeen. His father, a lawyer and judge with a practice in Boston, bought a farm about a mile from the center of town. In 1873, when French was twenty-three, a committee led by Ralph Waldo Emerson awarded him the commission for a statue commemorating the minutemen who fought the British. President Grant and most of his cabinet came for the unveiling of the statue, and Emerson read his poem about the battle, but by then French was in Italy, studying art. By the time he returned to the United States, his father had been appointed assistant secretary of the Treasury, and the family moved to Washington, where French received his first government commissions.

Daniel Chester French became one of the most well-known and successful Beaux Arts sculptors in America. He and his wife and daughter lived in New York in an elegant townhouse in Greenwich Village. They spent a few summers in Concord, where French had a small studio, but he needed a bigger place to work. He had many commissions, and he worked on a large scale. In 1897, he bought a farm near Stock-

bridge, Massachusetts. The architect Henry Bacon, a friend who had collaborated with French on several projects and who would design the Lincoln Memorial, drew up plans for a studio. French called his farm Chesterwood, after his grandparents' home in New Hampshire. A few years after the studio was built, Bacon designed a three-story stucco residence for him in a style that was a sort of hybrid of a colonial mansion and an Italian country villa. Edith Wharton, who built a house nearby around the same time,

FOLLOWING PAGES:
In the 1940s, Georgia O'Keeffe made some of her greatest paintings at what she called the Black Place, a group of barren hills in a remote spot 150 miles west of Ghost Ranch. She camped out there often. It was a fertile source for her rock collection.

A rattlesnake skeleton is set into a glass-topped panel along an adobe wall in O'Keeffe's living room in her house in Abiquiu.

O'Keeffe made a series of paintings of pelvic bones. In the paintings, blue sky often fills the empty sockets of the bones.

A collection of handmade pastels are in the O'Keeffe Research Center in Santa Fe.

The small red hill is in back of O'Keeffe's house at Ghost Ranch.

The door in the adobe patio wall is what first attracted O'Keeffe to the house in Abiquiu. She painted it many times.

The bed in her studio at Abiquiu faced a large glass window.

O'Keeffe could see the Cerro Pedernal from the patio at Ghost Ranch.

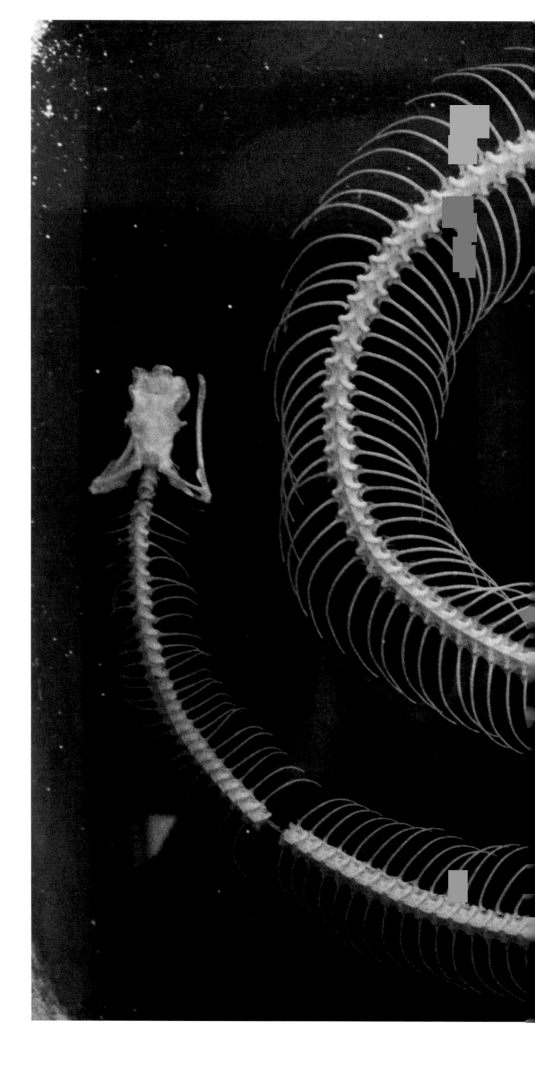

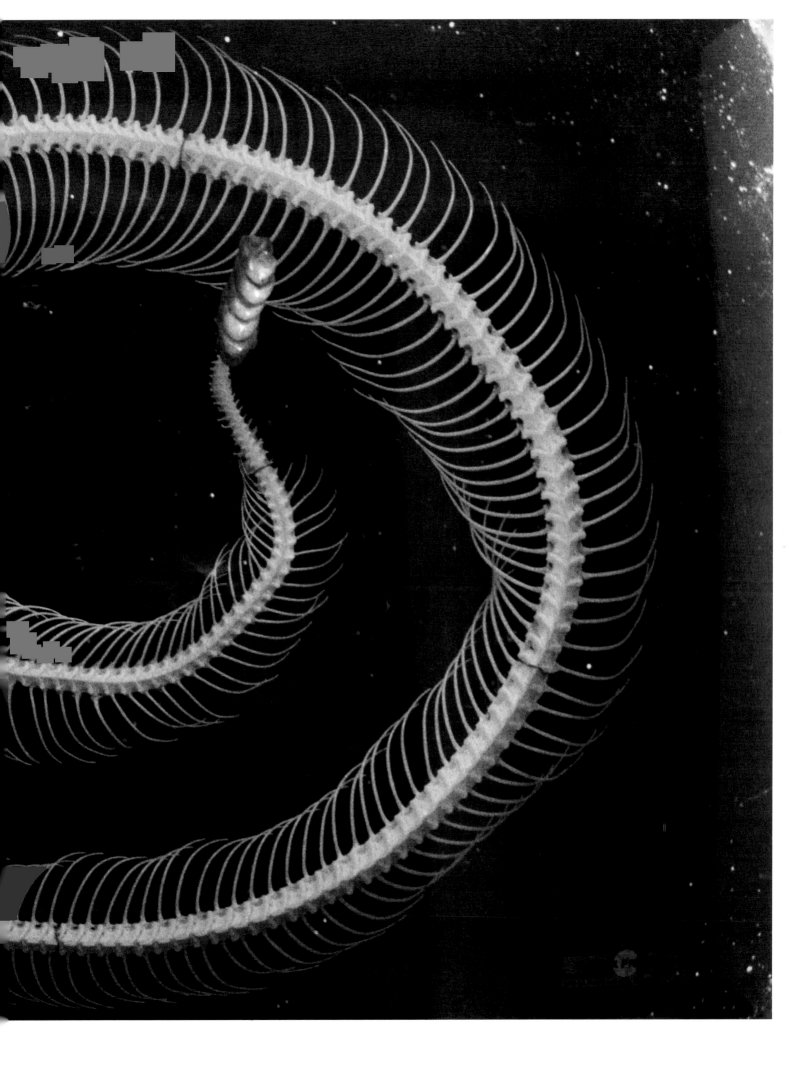

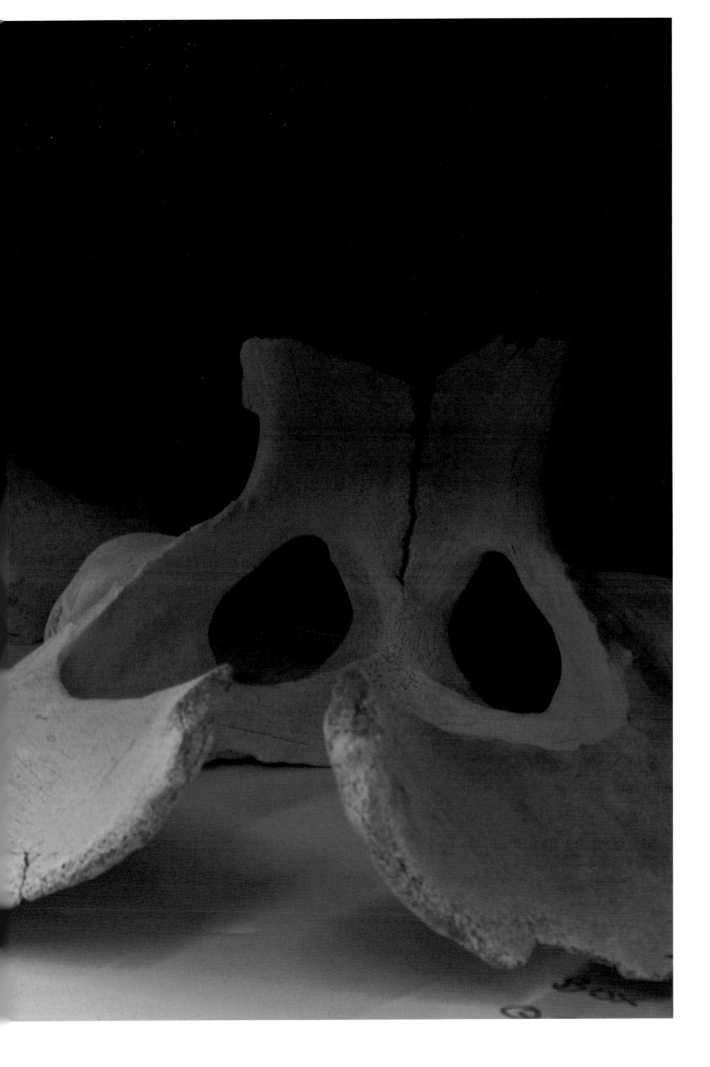

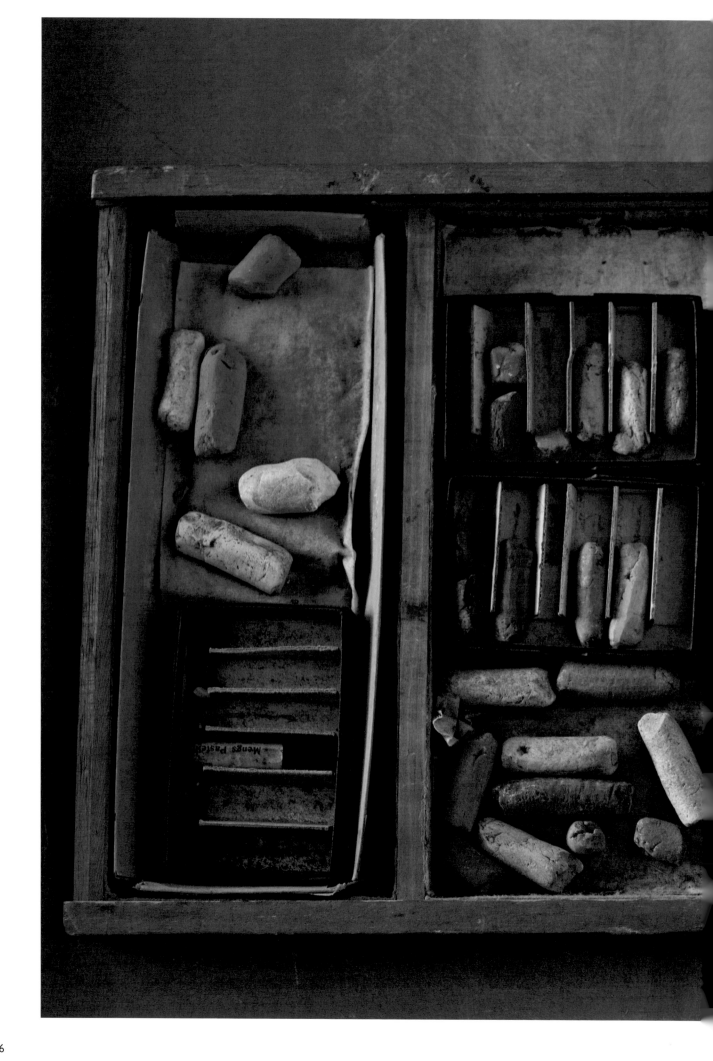

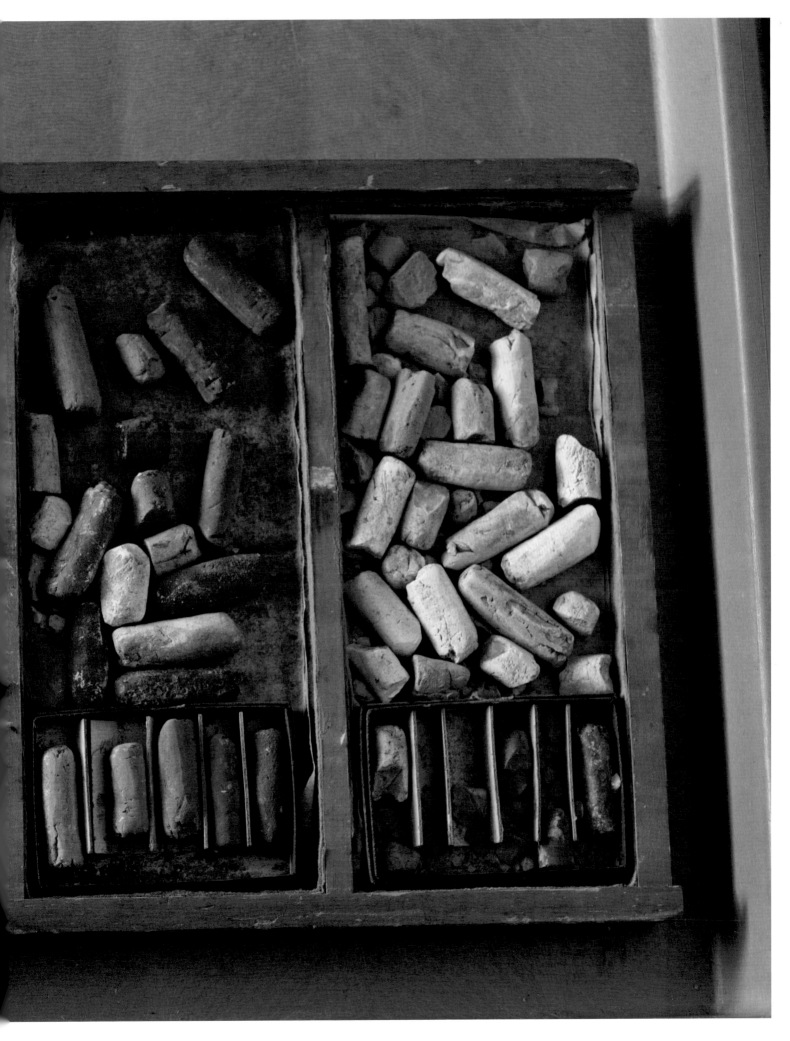

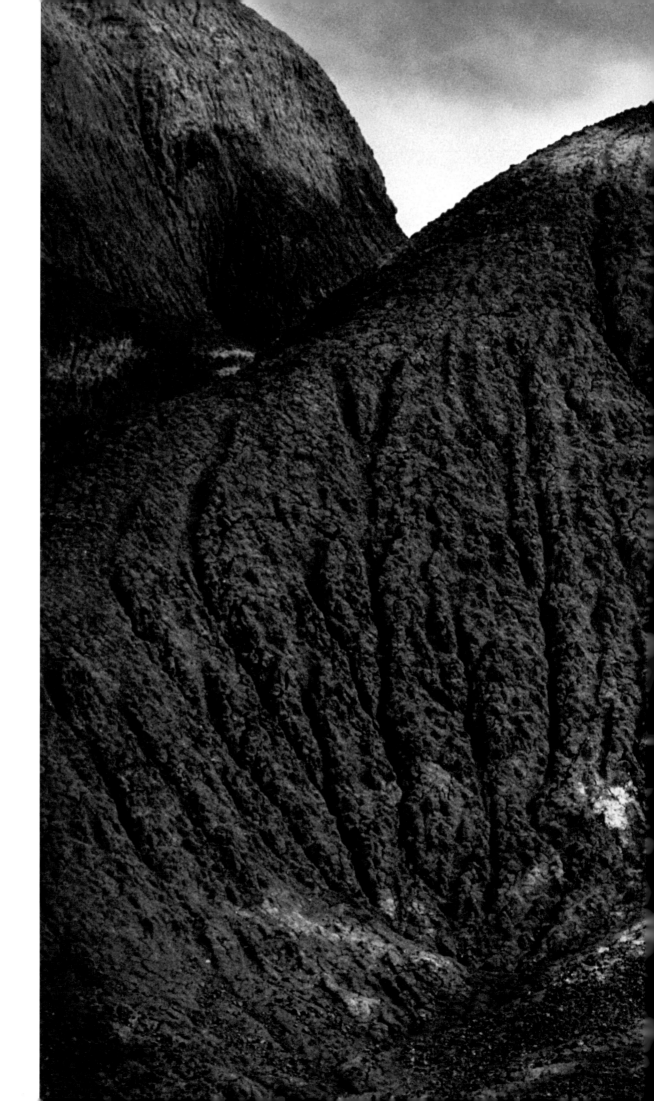

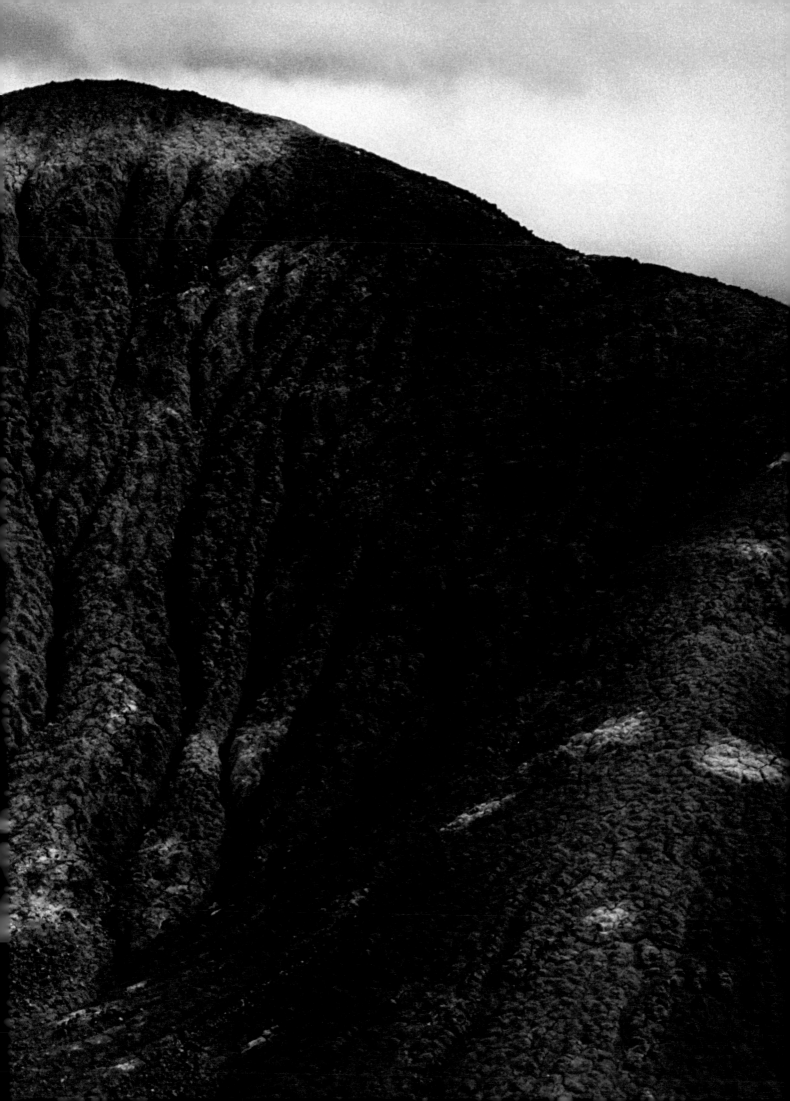

the Mount in Lenox, would visit Chesterwood to follow the progress of the buildings and the gardens. Isadora Duncan danced on the terrace.

French spent six months a year at Chesterwood, from May to October, for the rest of his life. I went there for the first time one afternoon after I had been working in Concord. Chesterwood is owned by the National Trust for Historic Preservation, which runs it as a study center as well as a museum. The director, Donna Hassler, showed me around the house and the studio and the grounds. French's studio is large, with a peaked ceiling and skylights. The most unusual feature is a set of train tracks that extend from the modeling table out to the side garden through thirty-foot-high doors. The modeling table rests on a flatcar that can be pushed outside. French designed the system because he wanted to be able to look at his work in natural light and from a distance before it was cast in bronze or carved into marble. He would adjust the details for the effect of sunlight and shadows. The Lincoln Memorial statue is French's most famous work by far. He was offered the commission in 1914. Two years later, he was working on a seven-foot model. For reference material, he used a plaster cast of a life mask of Lincoln and photographs that a collector had sent him. He also referred to castings of his own hands.

My aunt Sally Jane has a place in Great Barrington, not far from Stockbridge. A few weeks after my first visit to Chesterwood, the family converged at Sally Jane's for a reunion. My sister Susan was in from California with her two daughters. Susan, like most of the rest of my family, is drawn to historical sites. She's also an artist, and she said that she was going to visit Chesterwood. This came as a surprise to me, since Susan didn't know what I was working on. We drove over to Chesterwood, and they wandered off while I looked around in the bookstore. I bought a first edition of the memoirs of French's wife and a copy of *Looking for Lincoln,* a big book about Lincoln's legacy that accompanied a PBS series. Then I went to find my sister. When I rounded a corner, I saw Susan and my nieces in front of an interactive display. Five or six important events that occurred at the Lincoln Memorial are available. You can push a button and hear the "I have a dream" speech. My sister had pushed the button for Marian Anderson singing "My Country, 'Tis of Thee." She and her daughters were crying.

———

In 1860, when Lincoln was running for president, someone asked him for information about his early life for a campaign biography. Lincoln replied that it could be summed up in a phrase from Gray's Elegy: "the short and simple annals of the poor." He wasn't sentimental about his family's poverty. Life was hard and there were few opportunities, even for a smart boy who was able to educate himself. The arc of Lincoln's life, and what came afterward, is an outsized and tragic version of the American dream—from a log cabin in the wilderness to a magnificent shrine.

The log cabin fascinated me. It is emblematic. It made me think of Thoreau and Walden Pond. But what was "the" cabin? There was the birthplace cabin in Kentucky

and more than one boyhood cabin and maybe a cabin that went on the road with P. T. Barnum after Lincoln died.

The morning that we flew to Kentucky for the cabin search, a winter storm watch was in effect. Heavy snow was expected across most of the central and eastern parts of the country by nightfall. We rented an SUV at the Louisville airport and drove toward Hodgenville, a little town about fifty miles away. The Lincoln Heritage Trail begins in Hodgenville, which is near two historic sites: Sinking Spring Farm, where Lincoln was born, and Knob Creek Farm, where he lived until he was nearly eight. There are log cabins on both sites.

In 1894, nearly thirty years after Lincoln was assassinated, an entrepreneur, Alfred Dennett, acquired Sinking Spring Farm with the idea that he would develop a tourist site. That part of Kentucky was still too remote for much tourism, and Dennett soon gave up, but he had constructed a cabin made from logs purportedly from the Lincolns' original one-room cabin, and he took it on a tour. After Dennett went into bankruptcy, the Lincoln Farm Association, which included prominent Americans such as Mark Twain, bought the logs and brought them back to Kentucky. The logs were used to assemble the current birthplace cabin, which sits inside a neoclassical marble-and-granite temple on top of a small hill. Fifty-six wide stone steps, representing the fifty-six years of Lincoln's life, lead up to the temple.

Money for the memorial was raised through a subscription system. Hundreds of thousands of people from all over the country contributed small amounts, usually less than a dollar. Everyone who participated received an engraved membership certificate. The architect, John Russell Pope, later designed Constitution Hall, the National Archives building, the National Gallery of Art, and the Jefferson Memorial. The birthplace cabin turned out to be a little too big for the space and it was cut down by about four feet. The logs also turned out not to be the original logs. That was not proved until 2004, when scientists specializing in tree-ring dating calculated that they originated about forty years after Lincoln was born.

Lincoln didn't talk much about his childhood, but he did describe the family farm at Knob Creek, which is about ten miles from the birthplace. He said that it was "composed of three fields, which lay in a valley surrounded by high hills and deep gorges." As we were driving through the hills on the way there, I thought about how it didn't really matter that the cabins are theoretical. The landscape is still there. Knob Creek is still there. It's the creek that Lincoln fell into when he was playing on a log. A friend, Austin Gollaher, rescued him. The cabin the Lincolns lived in was torn down in the nineteenth century, but in 1932, a new cabin was constructed on Knob Creek Farm. Logs thought to be from the neighboring Gollaher family cabin were used.

Lincoln's father had bad luck with real estate. There were drawn-out legal disputes about the land they lived on in Kentucky, and in 1816 the family moved to the new state of Indiana, where pioneers had clearer title to the land they settled. We took back roads to the Indiana boyhood site, where there is a memorial that includes the grave

FOLLOWING PAGES: Martha Graham's studio on Sixty-third Street in New York City was demolished in 1999, eight years after her death. Her company works in a new studio in the same location. Old props, including pieces from sets designed by Isamu Noguchi, are stored in a warehouse in Yonkers. The iron gates to the old studio lean against the back wall.

of Lincoln's mother. The land along the way is all farms now, but it was hard to imagine how people were making a living there. That part of the country has been hard hit by the economy.

The Lincolns moved again in 1830, when Abraham was twenty-one. His father and stepmother lived briefly on a farm near Decatur, Illinois, which was then a tiny village. Abraham helped build their cabin and split rails for a fence, but he soon left home for good. The log cabin near Decatur was, I learned, the one that went on tour after the assassination. It was dismantled by John Hanks, Lincoln's second cousin, and taken to Chicago and then to Boston. The last sighting of it, at least as far as we can ascertain, was at P. T. Barnum's museum in New York. It was apparently lost at sea while being shipped to England.

In his early years in Illinois, Lincoln had many jobs. He worked as a carpenter, a riverboat man, and a surveyor. Eventually he became a lawyer and settled in Springfield. Most of his life as a politician was spent in Springfield, where he was married and bought the only house he ever owned. He and his wife and three of their four sons are buried there. The Abraham Lincoln Presidential Library and Museum is in Springfield. It's a new museum, with high-tech displays and state-of-the-art dioramas in a complex that covers three blocks.

Nick and Matthias and I drove to a hotel in Springfield in the evening. The next morning at dawn we met James Cornelius, the curator of the Lincoln collection at the museum. I had talked to him on the phone about photographing one of Lincoln's stovepipe hats. James showed me the hat, which was in a display case. Lincoln had tipped it so often that his fingers had left two marks on the brim. He had touched it in the same place again and again. James said that was probably because he was so used to swinging an ax in repetitive motions. The museum also has a piece of the bloody dress worn by the actress who was performing at Ford's Theatre the night of the assassination. She went into the box and held Lincoln's head on her lap while doctors tried to resuscitate him. The pair of gloves Lincoln had in the left-hand pocket of his jacket at the theater were also stained with blood. Lincoln had to shake hands so often that he carried two pairs of gloves. Looking at the gloves was like looking at Lincoln's hands.

The museum has thousands of documents and artifacts. James said that the economic downturn had led to an increase in the number of things people tried to sell them—copies of the Gettysburg Address that looked old, family Bibles, pieces of fabric that someone remembered being told came from one of Mary Lincoln's dresses. He said that family Bibles are always thought to be valuable, but they are usually not worth much except to members of the family.

The copy of the Gettysburg Address in Springfield is one of five copies written out in Lincoln's hand. He gave it to Edward Everett, a famous orator who was the principal speaker at the dedication of the Union cemetery at Gettysburg. Everett spoke for two hours to wide acclaim. A musical interlude followed, and then Lincoln spoke for three minutes. Although what Lincoln said would become widely regarded as one of

the greatest speeches ever made, it was Everett who got all the attention at the time. A manuscript of Everett's speech was to be bound in a special volume and sold to raise money for veterans of the war. Everett asked Lincoln to contribute a copy of his remarks. It was in the vault when I was in Springfield. It goes back and forth between the vault and the display area. This is because, as James explained, it is in a literal sense

a living document. The old paper dries out and shrinks when it is on display. Then when it goes back into the vault, it adjusts to the temperature and humidity controls there.

The vault is like a rather large closet, with shelves full of all kinds of things. They have a Tiffany diamond necklace in the shape of a heart that Lincoln gave to his wife. James brought out a book containing photographs that Mathew Brady made of the people who were at Lincoln's deathbed. Lincoln died in a small room across the street from Ford's Theatre. He lay there unconscious for about nine hours. Only a few people could fit into the room at one time, but over the course of the night, many people came and went. Within a day or so, a publisher was organizing a commemorative painting of the event. Brady's photographs were to be used by the painter to create a room in which over forty people could be seen grieving. The idea was that the painting would then be made into an engraving, which would be sold by subscription. Although it seems peculiar now, pretty much everyone who was asked, including Lincoln's son Robert, agreed to come to Brady's studio to pose. Robert stood with a white hand-kerchief clutched to his chest. He appears exactly that way in the painting. The book in

Graceland, Elvis Presley's home in Memphis, has been kept more or less the way it was when he lived there. The rooms on the ground floor attract thousands of tourists, but the second floor, where he died, remains private. The turntable Elvis used in his bedroom was brought downstairs and put in a storeroom.

Elvis was born in a two-room house that his father had built in Tupelo, Mississippi. His birthplace is now a small museum.

Springfield is one of two copies of a promotional brochure for the engraving project, which never actually happened.

By the time we had finished our work in the vault and packed up our equipment and loaded it into the car, it was obvious that we weren't going to get back home that night. The blizzard had hit and airports were closed. I was supposed to have chaperoned a field trip for my daughters' school the next morning, but that was canceled too,

so we decided to drive to Ohio, to the Garst Museum, in Greenville, which has a large collection of Annie Oakley material that I wanted to see. During the trip, I read a book that reproduced manuscripts of some of Lincoln's writings. The texts were accompanied by comments from various American literary and political figures. The editors used the so-called second draft of the Gettysburg Address, the one that Lincoln gave to his secretary John Hay. There was the farewell to Springfield, and a draft of the Emancipation Proclamation, and letters to his wife and to friends.

You can get lost in the subject of Lincoln. The scholarship and commentary about his portraits is one of many well-developed areas. I discovered later that it wasn't strange at all that Mathew Brady, who was at the time the most successful portrait photographer in the country, would make pictures for the artist who painted the deathbed scene, or that the people who posed would have thought their participation appropriate. It was customary for photographers to collaborate with painters and printmakers. Almost as soon as photography was invented, it was used as the basis for group portraits of historically significant events. A substantial segment of the Brady studio business was supplying pictures of prominent people to magazines, newspapers, and book publishers to appear in the form of woodcuts and engravings and lithographs. It wasn't until the late 1850s, a few years before Lincoln's assassination, that Brady tried to market his portraits as being equal to paintings.

The case for photographs being fine art was undercut by the popularity of cartes de visite. These small pictures, the size of a visiting card, were sold by the millions starting around 1860. One of the earliest cartes de visite sold by the Brady studio was a portrait of Lincoln taken a few hours before he gave his famous speech at the Cooper Union in New York. This was the speech where he used the line "Let us have faith that right makes might" as part of an eloquent argument that the Constitution allowed for the curtailment of slavery. It was the speech that made him a leading candidate for president. Lincoln said later that it was Brady's photograph that got him elected.

Much of Brady's huge archive languished in various states of neglect until thousands of his glass-plate negatives were acquired by the National Archives and the Library of Congress in the 1940s. I went to Washington several times to photograph some of the material there. The Library of Congress has the earliest existing draft of the Gettysburg Address. It's on two sheets of paper. The first sheet is Executive Mansion stationery and the second one is a longer piece of paper written on in pencil. The draft is suspended in a stainless-steel case filled with inert argon gas kept at low humidity. There is Plexiglas on both sides. The woven fabric that supports the two pieces of paper in the case made it a little hard to photograph, especially since I wanted

the emotional aspect of the writing, but they certainly weren't going to take the document out for me. They did remove it a couple of years ago, to check for leaks and install new gaskets on the case. Someone with a digital camera that did what is called hyperspectral imaging photographed it then. The image was so sharp that it revealed fingerprints no one had noticed before.

There are 130 known portraits of Lincoln. Mathew Brady is now credited with eleven of them, although "operatives" in his employ took many more. Brady hardly ever actually took a picture in the sense that we think of today. He created the

The stairs to the private quarters are reflected in the mirrors in the Graceland dining room.

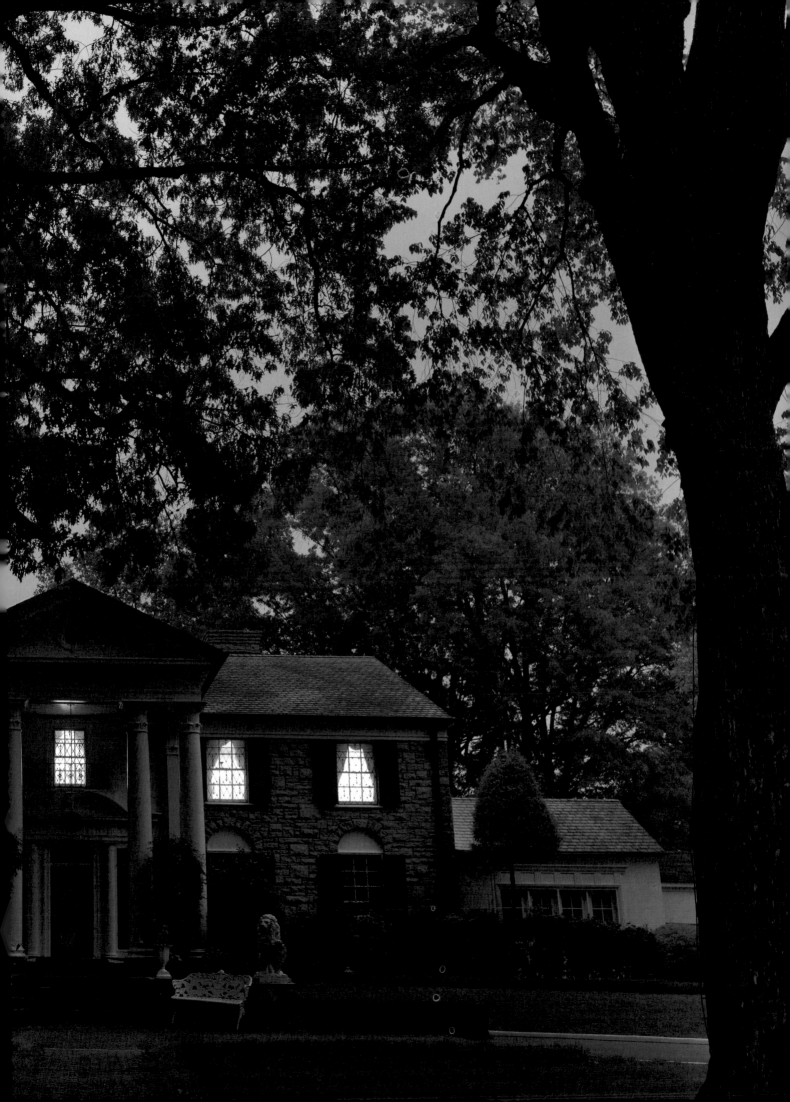

Elvis kept guns and he used them. The television set from his house in Palm Springs was a casualty sometime in the 1970s.

PRECEDING PAGES: Graceland, with the lights on in Elvis's bedroom.

FOLLOWING PAGES: Elvis's 1957 Harley-Davidson Hydra Glide motorcycle and the Meditation Garden at Graceland. Elvis, his mother, his father, and his grandmother Minnie Mae are buried in the Meditation Garden, on the far side of the swimming pool.

4b

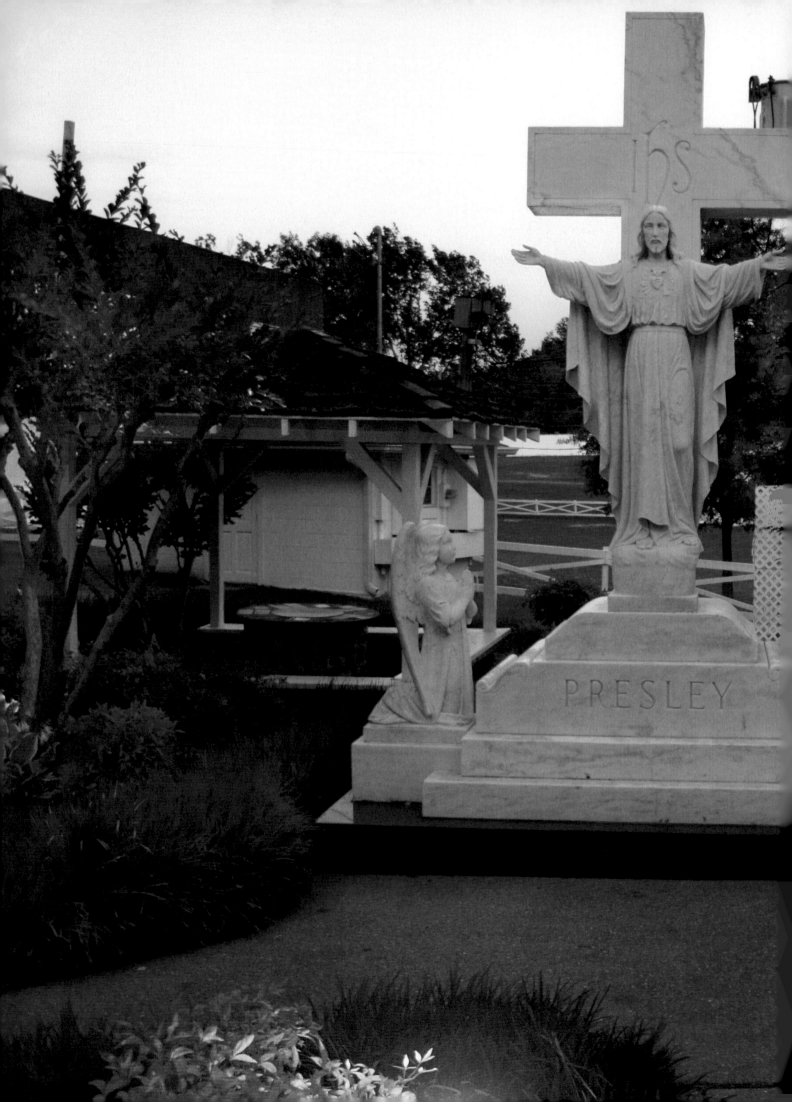

concepts for pictures, attracted clients, posed celebrities, presided over technicians, and marketed the work. Among the Library of Congress's holdings is the glass plate of a portrait that became a very popular carte de visite. It was also used for the engraving of Lincoln's head on the five-dollar bill. While I was photographing it, I thought of

something that Daniel Weinberg, the owner of the Abraham Lincoln Book Shop in Chicago, had written to me about a glass plate we were discussing. He reminded me that the photons that bounced off Lincoln had once passed through it.

The National Archives has a negative from the Brady studio in which four images appear on a horizontal glass plate. This is unusual. Brady used a camera with four lenses to make portraits for cartes de visite, but it produced a negative with two images on top and two on the bottom. It is possible that a two-lens camera was used and that the glass plate was moved over after one pose was fixed on half of it. Or perhaps it is a copy negative. This is a mystery for scholars to sort out. I had to photograph the plate twice, since it had broken into two pieces. The curators didn't want to take more than one piece out at a time. Many of these negatives have gotten a lot of wear. They weren't always treated with the care they get now.

The portraits of Lincoln tell the story of a man's life through his face. It was the first time that photography had been used this way. Before, people were photographed once or twice in their lives. Lincoln was photographed from every possible angle. I don't know if you can ever get a true likeness of a person. That was especially true with early photography, when the sitter had to be still for so long. Lincoln's secretary John Nicolay wrote that "Lincoln's features were the despair of every artist who undertook his portrait." They never got the mobility of his features, the animation of someone who smiled and laughed. "The picture was to the man as the grain of sand to the mountain," Nicolay said. "There are many pictures of Lincoln; there is no portrait of him."

PRECEDING PAGES: Thomas Jefferson's vegetable garden at Monticello, his home in the foothills of the Blue Ridge Mountains in Virginia. Jefferson inherited several thousand acres of land. In 1768, when he was twenty-five, he decided to build a house for himself. The house and the surrounding gardens became a lifetime project. The house grew to twenty-one rooms. The gardens were a laboratory for Jefferson's ideas about a national economy based on agriculture.

The sweet potato on the preceding pages is from the garden, as are the Carolina lima beans and scarlet runner beans on these pages. Jefferson cultivated over fifty varieties of bean.

Photographs were my way into the landscape of Gettysburg. On the drive down to Pennsylvania, I looked at William Frassanito's books about Alexander Gardner and Mathew Brady and the other photographers who worked on the battlefield. Their pictures are some of the earliest photographs of war. Gardner made it possible for the general public to see the actual carnage of battle.

I didn't remember Gettysburg very well from my visits as a child. I imagined that it would be rolling hills, and I had the idea that I could photograph nothingness—an empty field where something terrible had taken place. I was thinking of Roger Fenton's photographs of the Crimean War, which were taken in 1855, eight years before the battle of Gettysburg. Fenton's battlefields are desolate landscapes. In reality, of course, the battlefield at Gettysburg is filled with monuments. There are more than thirteen hundred statues and commemorative markers and plaques.

Alexander Gardner was the first photographer to get to the battlefield. He arrived sometime on July 5, 1863. The fighting had been over for more than a day by then. Gardner and his assistants, Timothy O'Sullivan and James Gibson, were traveling north, from Washington, where Gardner had recently established his own business after having managed Mathew Brady's studio there. They were held briefly by retreating Confederate soldiers a few miles south of town. Most of the Union dead had been buried by the time they reached the battlefield, but there were still Confederate bodies lying in the open. Gardner and his men parked their wagons near a farm where fierce fighting had taken place three days earlier.

William Frassanito was my guide to all of this. Frassanito has studied Gettysburg since he was a boy. He is a detective and a scholar, not to mention an obsessive. The

FOLLOWING PAGES: Jefferson was an avid collector. The entrance hall at Monticello, where he greeted visitors, was a kind of museum. There were engraved wall maps and two Native American maps on leather, a clock designed by Jefferson, moose and elk antlers, fossils and stuffed specimens of North American animal species, Old Master paintings, and numerous artifacts brought back by Lewis and Clark from their exploratory expedition to the Pacific coast.

details of Gardner's work had been obscured by faulty captions and spotty history until he sorted it out. Frassanito spent five years looking for a particular rock that was visible in some of the pictures. I carried Frassanito's books around, studying his diagrams of the placement of bodies and the juxtaposition of original photographs with modern views. I tried to understand Gettysburg by following in Alexander Gardner's footsteps. It was muddy, and we had to crawl over fences and avoid cow droppings.

The battle of Gettysburg took place in an area that encompassed more than ten square miles of farms. One hundred and sixty-five thousand soldiers fought there during the course of three days. More than fifty thousand of them were casualties—

eleven thousand killed, twenty-nine thousand wounded, ten thousand missing. The Confederate soldiers were forced to retreat before they were able to bury all of their comrades, and the Union soldiers buried their own dead first. When Mathew Brady and other photographers arrived, a few days after Gardner had completed his work, the fields were cleared of human bodies, at least where they were visible.

Gardner used two cameras: one that held an eight-by-ten-inch glass negative and another one with two lenses that made smaller, stereo glass negatives. One of his wagons was used for preparing the plates. A solution known as collodion was poured over a plate, which was coated so that a perfectly even surface was light-sensitive. The plate was put in a light-proof holder and taken out of the wagon and inserted into one of the cameras. The picture had to be already set up, since the solution on the plate couldn't be allowed to dry. After it was exposed, the plate was taken to a darkroom, which was probably in Gardner's second wagon, where it was developed.

Frassanito says that Gardner produced sixty negatives at Gettysburg and that about 75 percent of them include corpses. Captions identified some of them as Union soldiers for many years, and there were various other inaccuracies, including the locations where they were said to have been found. Frassanito's most startling revelation

Jefferson's study is part of a suite of four interconnected spaces that provided a refuge from the rest of Monticello, which was filled with family and friends. Jefferson's bed is in an alcove that is open to the study on one side and his bedroom on the other side. He kept a collection of scientific instruments in the study. His private greenhouse and his library were only steps away. During the last seventeen years of his life, Jefferson rarely left Monticello.

was that some of the photographs were set up. The same rifle appears with different bodies. It was a prop. More damning, at least from the point of view of modern journalists, was the moving of bodies from one place to another to get a dramatic effect. One of the most famous photographs of the Civil War is a picture of what Gardner identified as a "rebel sharpshooter" lying against the rocks of Devil's Den, where Confederate soldiers were said to have constructed a sniper position. Frassanito proved pretty conclusively that Gardner and his men carried the body—of an ordinary infantryman, not a sniper—from where it had fallen, seventy-two yards away, and placed it in the rocks, next to the rifle they had propped up there. It's one of the most discussed examples of a staged war photograph. Roger Fenton seems to have set up some of his photographs too. A great deal has been written about whether he moved the cannonballs in "The Valley of the Shadow of Death." Apparently, he did.

I photographed the fields in the direction of the High Watermark of the Confederacy, where Pickett's Charge failed and ended the battle. I had heard the theory that Pickett would have succeeded if Jeb Stuart's Confederate cavalry had gotten to him in time to help, so we drove over to East Cavalry Field, where Stuart's troops were stopped. At one point in the afternoon on that last day, General George Armstrong Custer led a regiment of four hundred men and horses in a crazy charge toward several thousand of Stuart's horsemen. The fighting there drew to a close around the same time that Pickett's Charge, three miles away, was over.

As we drove down the road past East Cavalry Field, I saw a farm with wash hanging out. The farmhouse had been at the center of the final battle. It was almost too beautiful to photograph. I went up and knocked on the door, and a woman wearing a long dress and an apron answered. I asked her if she would mind if I took some pictures. She said to go ahead.

It was a farm in 1863 and it's still a farm.

———

I came to Georgia O'Keeffe through Alfred Stieglitz and the role she played in his work. His portraits of her are some of the greatest portraits ever made. He started photographing her in 1917, shortly after they met. She was twenty-nine and he was fifty-three. She had been teaching art in a remote town in Texas. He was at the center of the modernist movement in America and ran one of the most influential galleries in New York. He began showing her drawings and paintings and moved in with her almost immediately. Between 1917 and 1937, Stieglitz made more than three hundred portraits of O'Keeffe. In 1921, when he showed several of the photographs in a retrospective of his work, they caused a sensation. She would become the most well-known woman artist of the twentieth century, but she was recognized as Stieglitz's nude model and muse first.

The landscape that O'Keeffe staked out as the subject of her life's work is in northern New Mexico, near Santa Fe. She went there regularly starting in 1929 and

FOLLOWING PAGES: The compass used by Meriwether Lewis and William Clark on their journey to the Pacific in 1804–1806. Jefferson had sent them in search of a river or a series of connected rivers that would provide a passage from one coast of the continent to the other. They made maps, collected plant and animal specimens, and established relationships with Native Americans.

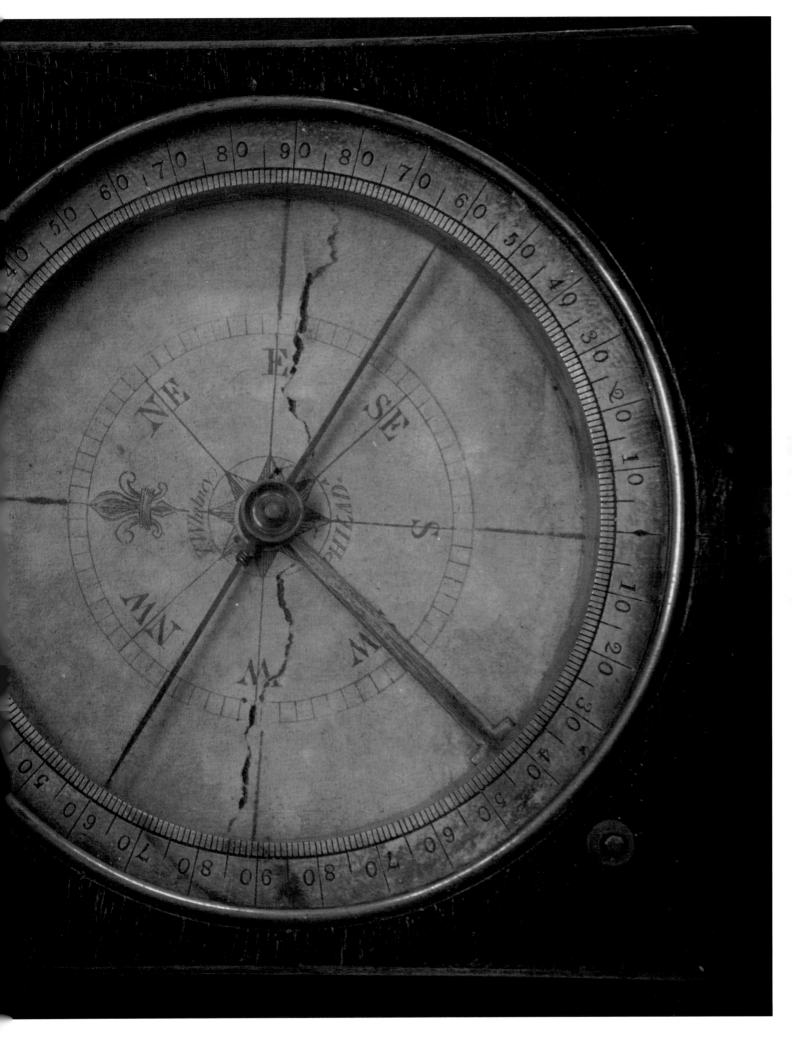

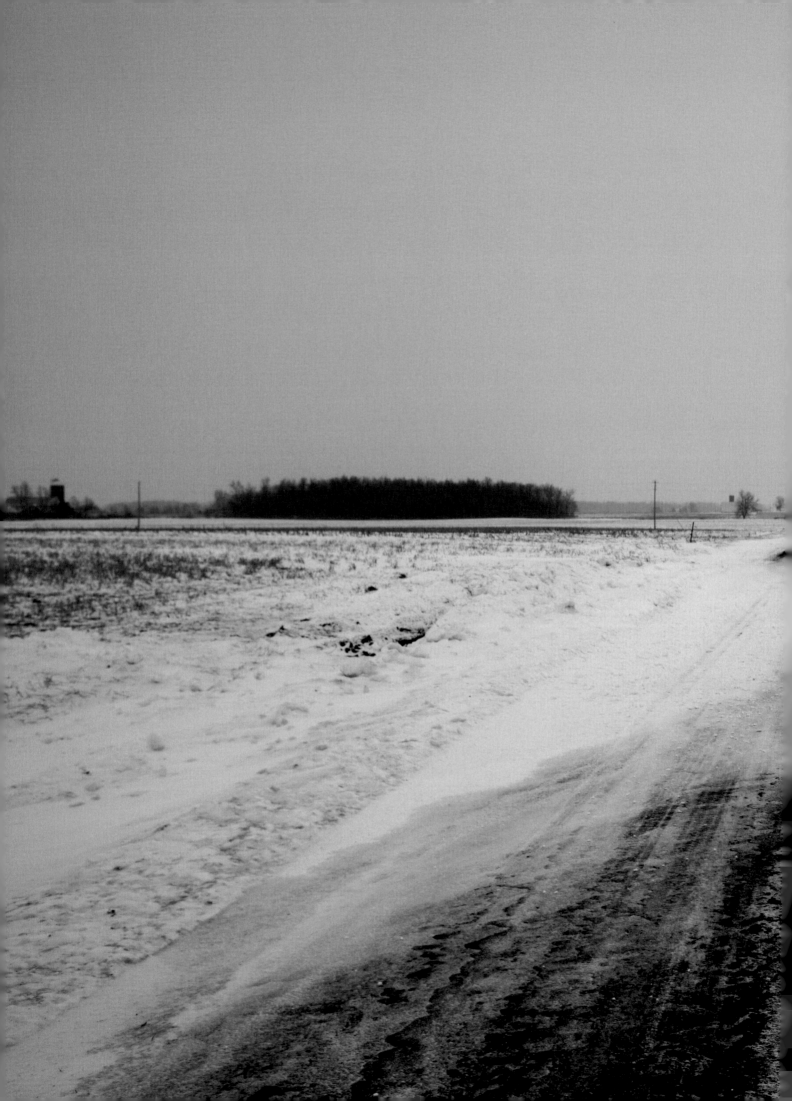

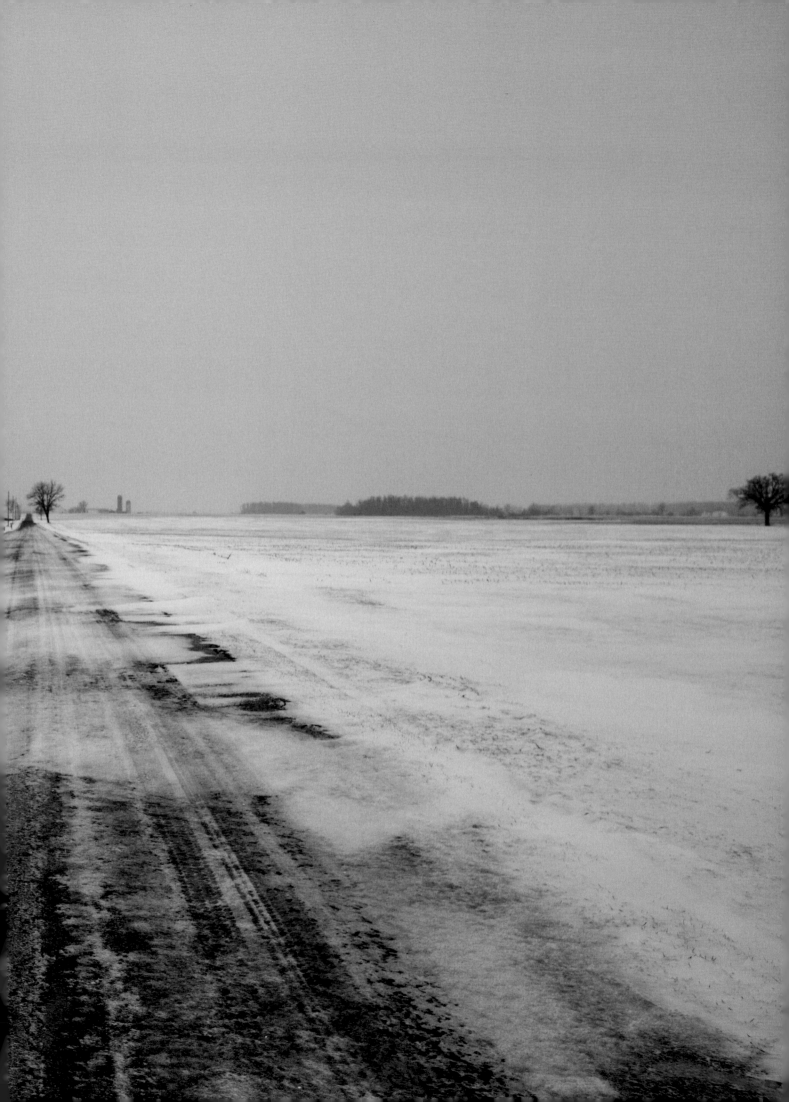

moved there permanently twenty years later. She had a house in the town of Abiquiu and another one, a few miles further into the badlands, at Ghost Ranch. I'd been to Santa Fe, and to Taos, which is also nearby, many times, but I'd never been to either of O'Keeffe's houses until I accepted an award from the Georgia O'Keeffe Museum.

Georgia O'Keeffe saw the country around Santa Fe for the first time in 1917, when she was on a vacation in the West with her sister. "From then on, I was always trying to get back there," she said. In 1929, five years after she and Stieglitz were married, she visited on a trip with Rebecca Strand, the wife of the photographer Paul Strand. They stayed with Mabel Dodge Luhan at her villa in Taos. Mabel Dodge Luhan was an eccentric heiress who had married a Pueblo Indian and had a sort of artist's salon in the desert. D. H. Lawrence and his wife, Frieda, stayed there. O'Keeffe painted every day. "In the evening, with the sun at your back, that high, sage-covered plain looks like an ocean," she told Calvin Tomkins years later, when he was writing a profile of her for *The New Yorker*. "The color up there—the blue-green of the sage, and the mountains, and the wild flowers—is a different kind of color from anything I'd ever seen."

In the mid-thirties, O'Keeffe began staying at Ghost Ranch, a remote dude ranch in a spectacular landscape. There were no telephones, and it was hard to get to by car, but it had an airstrip for private planes. For several years, she rented a house three miles from the main compound. It had a large room with a plank floor, a stone fireplace, and plenty of room for guests if she chose to have them. She spent the fall and winter with Stieglitz in New York and the spring and summer at Ghost Ranch. She bought the house in the fall of 1940. There was another house she had been interested in, a ruined adobe hacienda in Abiquiu with a view of the Chama River Valley, but she hadn't been able to reach an agreement about price with the owners, who ended up giving it to the Catholic Church. O'Keeffe was able to acquire it from the Church in 1945. She now realized that its most valuable asset was its water rights and its enormous garden. The renovation of the Abiquiu house was completed in 1949, the year O'Keeffe moved to New Mexico for good. She was sixty-two. Alfred Stieglitz had died and she had spent three years in New York, settling his affairs. From then on, she would spend the winter and spring in Abiquiu and the summer and fall at Ghost Ranch.

My guide on the drive out to Abiquiu the first morning I was in New Mexico was Barbara Buhler Lynes, the curator of the O'Keeffe museum and the director of the museum's research center. I didn't expect to be moved when we walked into O'Keeffe's studio, but I found myself weeping. It's hard to describe the sense of solitude and peace in that room. There is a narrow bed with a woven linen covering. O'Keeffe's bedroom, which is around the corner, is about the size of a closet and has another twin bed in it and two windows that extend to the edge of the wall, so that they meet. She looked out over the desert. There was a pile of rocks on the window in the bedroom. O'Keeffe picked up rocks when she went on walks or camping trips. Barbara said that after a while people would bring a rock or two for her when they came to visit. She made a pile of the ones she didn't like, and she would recycle them. As guests were

When Annie Oakley traveled with Buffalo Bill's Wild West show, she stayed in a tent decorated with Indian blankets, cougar skins, and satin pillows. PRECEDING PAGES: Farmland in Darke County, Ohio, where Oakley was born. After she left Ohio and became a performer, Oakley was almost always on the road. She literally lived out of a trunk.

leaving, she would say, "Oh, take a rock with you." They would be thrilled that Georgia O'Keeffe had given them a rock. They didn't know that it was from the reject pile.

There was a very sophisticated—for the time—stereo system in the living room. People write about sitting with O'Keeffe for hours listening to Beethoven sonatas. She told Calvin Tomkins that she could always read music and had thought about being a musician. He noticed that her record collection was primarily instrumental music and that Monteverdi was a favorite. She also had recordings of John Cage and Philip Glass.

As we were driving down the road to Ghost Ranch, Barbara kept saying, "You see that rock over there? It is . . ." and she'd name one of O'Keeffe's paintings. Barbara has done an exhaustive study of the exact places that O'Keeffe painted. It's in the book *Georgia O'Keeffe and New Mexico: A Sense of Place*. There are photographs of the various sites alongside reproductions of the paintings. It reminded me of what William Frassanito did at Gettysburg. Finding the vantage point and comparing the real thing with the rendering of it. Barbara's point in the book is to show that the paintings are not literal. O'Keeffe started out as an abstract artist and then veered into quasi-figurative work for various reasons, but, as Barbara writes, "she never abandoned abstraction." She reduced and simplified forms, imposed colors to emphasize different shapes, manipulated perspective, synthesized hues from different times of day. I saw what Barbara meant when I looked at a reddish hill in back of the Ghost Ranch house. It was familiar from a painting made in the thirties. In the painting, it is huge. I assumed it was a mountain. The real hill is about twelve feet high. It looks like a big anthill.

A few months later, I was able to get back to New Mexico, and this time I did more work with Barbara in the research center, which is across the street from the museum. It's extremely well organized. There's a big room of flat files with drawers full of paintbrushes, charcoals, palettes, and clothing. Barbara would open a drawer and some nicely folded painting smocks would be lying there. I found O'Keeffe's pastels especially moving. She made them herself. They were the color of the landscape. Reds and browns and yellows and blues. And they were worn. She had used them.

In the book of photographs that John Loengard took of O'Keeffe in 1966, he writes about following her white Lincoln Continental to Ghost Ranch and having a nice lunch that was prepared by the cook there. O'Keeffe didn't really live alone out there in the desert. There were always people around to help her. But she retained a certain kind of isolation to the end. She was solitary the way Thoreau was solitary. And she was steadfast in her work.

The simplicity of her single bed with the threadbare linens and the horizon line says it for me. You can tell what was important to her. I've seen some ways I wish I could live, and on some level Georgia O'Keeffe sets the bar.

——

Serious collectors inhabit a world of their own. I ventured into it only once, when I was looking for an ace-of-hearts target that Annie Oakley had shot through. I'd seen

The Annie Oakley collection in the Garst Museum in Greenville, Ohio, includes a pair of riding boots made for Oakley. FOLLOWING PAGES: The heart target is from a private collection. One of Oakley's most popular stunts was shooting through the center of a small heart on a card (actual size of heart: 1 3/16" x 1").

Annie Oakley met Sitting Bull in 1884, shortly before both of them joined Buffalo Bill's Wild West show. He gave her a ceremonial hair ornament that is now in the Garst Museum. It is made of dyed horsehair and porcupine quills.

the target in a television documentary. My sister Barbara, who was helping me with research, tracked down Annie Oakley's grandniece, Bess Edwards, who put us in touch with William Self, a collector who lived in Los Angeles. He invited us to his house and let me photograph the version of the target that he owned. Self was eighty-nine and had been an Annie Oakley buff since he was a boy.

William Self grew up in Dayton, Ohio, not far from where Annie Oakley was born and died. He was fifteen when he saw Barbara Stanwyck in the movie loosely based on Annie Oakley's life. Oakley's brother, who lived in nearby Greenville, had lent some souvenirs for a display in the theater lobby where the movie was playing. Self visited the brother and decided to write Annie Oakley's biography. He persuaded his father to let him travel to Cody, Wyoming, to visit the Buffalo Bill Museum, where he studied Annie Oakley's scrapbooks, but when he turned eighteen he went off to the University of Chicago and majored in political science and the biography remained unwritten. He became an actor and then a film and television producer. He was a trustee of the

Buffalo Bill Historical Center in Cody. His collection of Annie Oakley memorabilia included several of her guns and a wig she wore during performances after her hair turned white.

William Self's ace-of-hearts target was probably used in a marksmanship exhibition toward the end of Oakley's life. According to Oakley's most reliable biographer, Shirl Kasper, there is no evidence that she used such a card in Buffalo Bill's show, although she seems to have developed the ace-of-hearts stunt in 1889, while she was performing with Buffalo Bill in Paris. At first, she used a pistol to shoot through the center of an ace-of-hearts playing card. Sometimes she turned the card sideways and shot it so that the edge split. Over the years, the card was modified. The one William Self had is 4 ⅝ inches wide and 1 ⅞ inches high. An image of Oakley on a horse is on the left side of the card. The heart image has a single hole in the center. Oakley would probably have been shooting from about forty feet away.

The historical Annie Oakley was—as well as can be ascertained—quiet, polite,

FOLLOWING PAGES: Pete Seeger bought an uncleared patch of woods on a hill above the Hudson River in 1949. He built a cabin there from trees he had cut down himself. He has a vegetable garden and a garage full of tools and supplies for fixing what needs to be fixed.

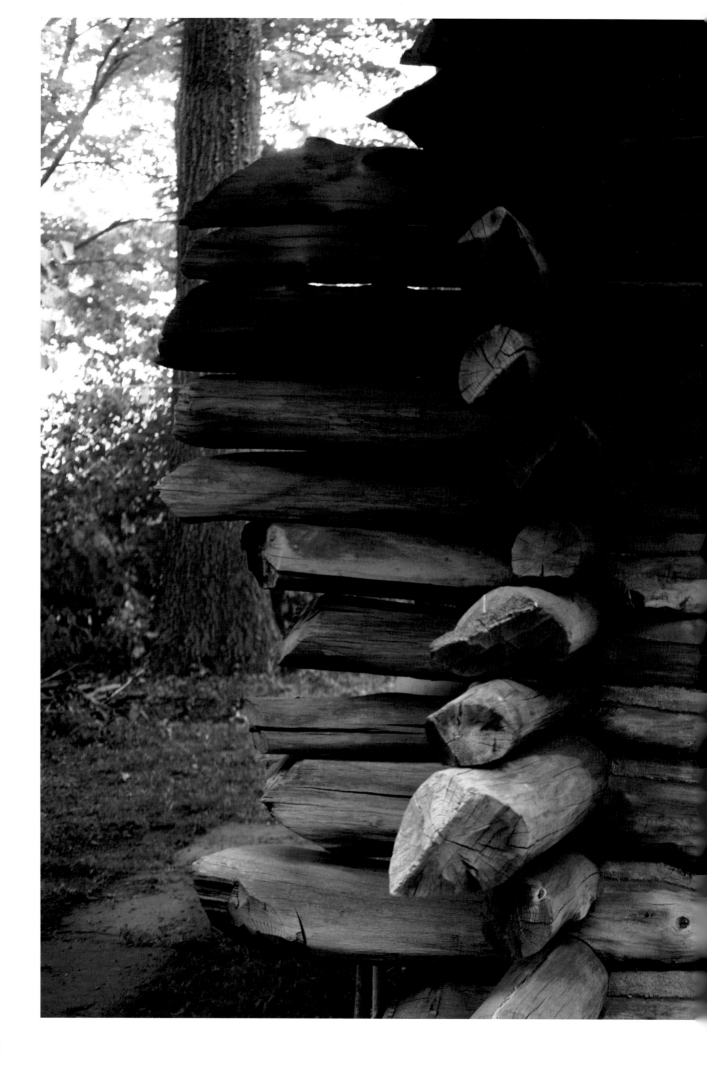

self-consciously ladylike, devoted to her husband and dog, hardworking, and frugal. She didn't drink, smoke, or swear. She was short, only about five feet tall, and seldom weighed more than 110 pounds. She had grown up in the Midwest, the daughter of Quakers. Her childhood was miserable. She was born in a log cabin built by her father, who died when she was five. He had taught her to hunt, and by the time she was eight she was shooting quail.

Annie Oakley's life story is a model of resilience: rags to riches and stardom, like Elvis, only Annie Oakley had inherited the Puritan side of the American character. Her talent was remarkable, almost magical, and she developed it diligently. Her husband, Frank Butler, was a handsome Irishman from New York who had a shooting act. Annie beat him in a shooting match in her hometown when he came through Ohio in 1881. She was twenty. They were married the following year and were rarely apart for most of the rest of their lives. They worked together in variety shows and for circuses until early in 1885, when Annie got her big break. She was hired by Buffalo Bill.

In 1887, when Buffalo Bill's Wild West show went to London for Queen Victoria's Jubilee, it had several hundred performers and crew, including 97 Indians, plus 160 horses, 16 buffalo, and numerous bears, elk, and deer. Annie Oakley had quickly become Buffalo Bill's principal draw. She would make her entrance in an arena on foot, wearing an embroidered skirt and leggings with pearl buttons. She waved and blew kisses and skipped to the center of the arena, to a table where her rifles and shotguns were laid out. Her act lasted only about ten minutes, but it was a nonstop virtuoso performance. She would shoot dozens of glass balls in succession; turn her back to a target and aim by looking in a hand-held mirror or a table knife; walk away and wait until a clay bird had been released from a trap and then run to the table, hurdle it, pick up a rifle she had left in the dirt, and shoot the clay bird before it hit the ground.

Louisa May Alcott and her family moved to Orchard House on the Lexington Road in Concord in 1858. Louisa May embroidered her initials on a silk-lined pouch. The pouch is now in her upstairs bedroom at Orchard House.

Frank managed the act, took care of the guns, and set up the targets. When they traveled with Buffalo Bill, which they did for seventeen years, they had their own stateroom in one of the troupe's railroad cars. After they retired from touring and gave only exhibitions, they preferred to stay at a resort in Pinehurst, North Carolina, where Annie could hunt every day. She also gave shooting lessons to women. She said that she had taught fifteen thousand women to shoot. In 1917, when the United States declared war on Germany, she offered to raise a women's regiment for "home protection." She wasn't a feminist, but she had strong views based on her own experience. "I have always maintained that outside of heavy, manual labor, anything a man can do a woman can do practically as well," she said. "Certainly, this is true in the use and manipulation of firearms."

———

I've been looking at Barbara Morgan's photographs of Martha Graham practically my whole life. I keep going back to them. They represent the very best kind of collaboration between a photographer and a subject. Morgan said that she got the idea of photographing Graham after she went to an exhibition of drawings and pictures of Isadora Duncan and realized that they recorded the woman but not the work. Morgan

felt that modern photography could do a better job of portraying "the dancer's fugitive art," and she worked with Graham for four years on a project that became a book. Graham chose sixteen dances that she thought were her most important ones. They created the photographs in empty theaters and studios and then laid out and sequenced the images to evoke whole dances.

The cover picture on Morgan's book, which was published in 1941, is a portrait of Graham in *Letter to the World,* her dance about Emily Dickinson. I thought that I might

In the early 1860s, Louisa May and her sister May filled a fan with the signatures of friends.

Beth Alcott made the rag
doll in the blue dress in
the 1850s. Her sister May
painted its face. Louisa
May gave the doll on the
right to May's daughter,
Lulu, whom she took care
of after May's death.

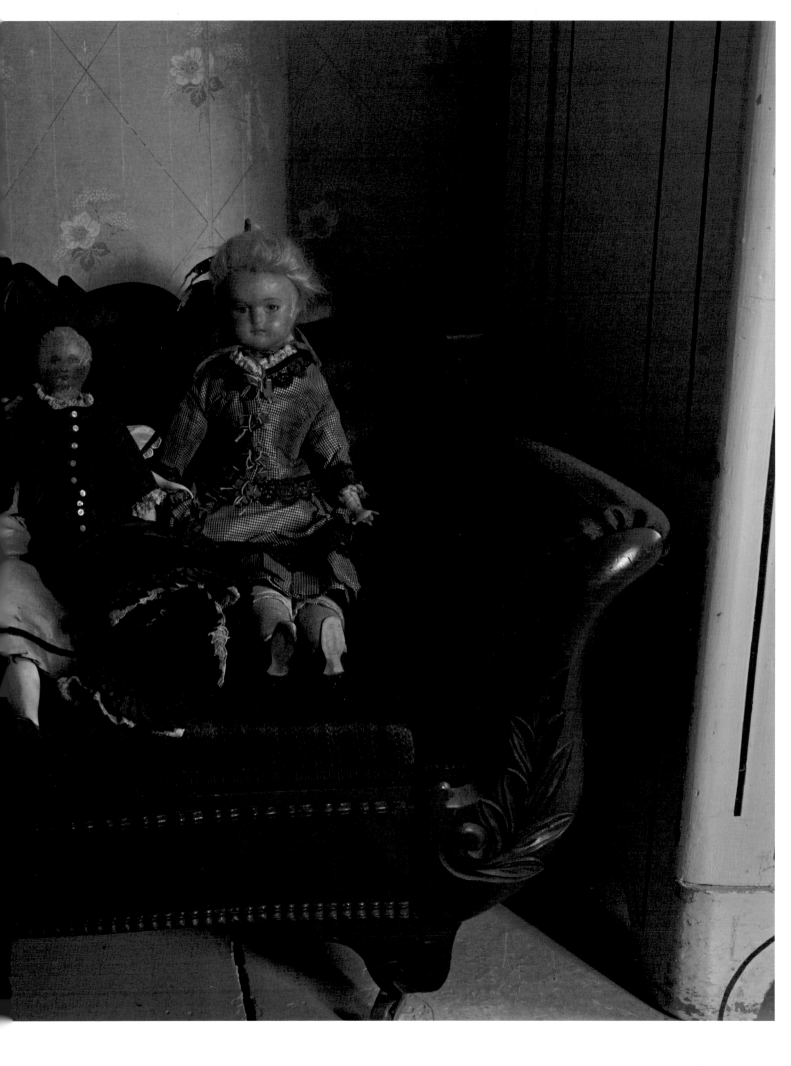

I observed an improvement of coun-
tenance in Anna: it is not so perceptible
in Louisa; the interiour life has not yet
typified, and mirrored itself forth, in the
fleshly visor of flesh: it is labouring to come
into sight, and shape itself in the out-seeing coun-
tenance — the spirit's terrestrial face.

And verily, in the wise — the pure — and
the good, it is no insignificant visor — it searcely
hideth the features of the divinity within — it seems,
indeed, but a self-covering veil, by which it shields
its celestial beauty from the gaze of the polluted,
and raiseth it, at fit season, to captivate the
virtuous onlookers. Virtue holds her court in the
heart, but she visiteth the countenance of man,
at fit times, and looketh out upon the external
world, from the orbs that she there illumines!
All ye who pass by her house, veil not to salute
her as she beckoneth to you, from her seat —
to the frailer in life, and the remembrance thereof
shall never depart —

Friday. November 7 —

—

Conduct and Discipline.

—

I have seen them less to-day than usual;
Anna being confined to her chair and Louisa
deeply interested in her amusements. I find
that their presence is essential to enfuse a
depth and fervour of interest: if I see them but
little; if I depend on the statements of their mother
for the facts of the day, my record loses much
of the freshness and force of delineation that
are given from a personal survey of them through
the day. It wants life, reality, naturalness: the
spirit of fact is wanting, though the fact itself
appears.

And thus it is with reference to all
speculations on humanity; they must be
bred and sustained by the events and per—

be able to photograph the costume Graham wore in the Morgan photograph, although I knew that her company had gone through rough times and that over the years they might not have been able to preserve things like old costumes. The saga of the perils of the Martha Graham company is well documented. I called them up and asked anyway, and they confirmed that the costume had most probably disappeared, but they said they would be happy to take me to their warehouse in Yonkers to look around.

PRECEDING PAGES:
All of the Alcotts kept journals. One of the pages of Bronson's journal has an outline of his and Louisa May's hands. The journal is in the Houghton Library at Harvard.

May Alcott, the model for Amy in *Little Women*, was an artist. Her drawings on the Orchard House walls include a copy of an etching that she borrowed from Ralph Waldo Emerson.

Martha Graham had a studio and a school in a three-story brick townhouse with a garden at 316 East Sixty-third Street, near the off-ramp of the Queensboro Bridge, for forty years. One of her wealthy benefactors had bought it for her in 1952. Before she moved in, it had been a school for small children, and it retained very low benches and other inconvenient details, but the Martha Graham company was always stretched for cash and only so many improvements could be made. Graham was said to find things like weeds growing through the floorboards charming.

When Graham died, in 1991, at the age of ninety-six, she left everything to her companion and caretaker of many years, Ron Protas. He became the artistic director of the company and the arbiter of how Graham's works should be presented. Protas was already a divisive figure in the company, and the hostility toward him grew. There was also the larger issue of how to sustain an organization after the death of the artist who was its raison d'être. By 1998, the financial strains had reached a crisis point, and the Sixty-third Street building was sold to a developer. The developer's daughter had studied with Graham and she had convinced her father that he should build a new

building on the site and let the company have space in it. In the meantime, the company and school had to move. *The New York Times*'s accounts of the move include photographs of dancers carting off pieces of the soon-to-be-demolished building and going through piles of soggy photographs rescued from a flooded basement.

The next few years were difficult. The company suspended operations in 2000, and Ron Protas was dismissed as artistic director and voted off the company's board.

In 2003, the Martha Graham Center of Contemporary Dance opened in the new six-story apartment building that replaced the old townhouse on Sixty-third Street.

Anne Posluszny, the company's stage manager, showed me around the Yonkers warehouse. There were two or three rooms piled high with boxes and trunks. Anne said that a few years ago, during the ongoing financial crisis, they had to consolidate the space and had thrown some things away. She said it was nothing important. We found a box of props from *Deaths and Entrances,* the dance/drama about three sisters who are probably the Brontës, or maybe Graham and her two sisters. Isamu Noguchi's big crossed wooden spears from *Clytemnestra,* Graham's only full-evening work, stood in a corner. During performances, they were turned on their sides and used to transport triumphal warriors and corpses. Anne said that they were probably the original spears from the 1958 production. The spears used in later productions were constructed to come apart for easier storage.

The iron gates from the entrance to the old Sixty-third Street studio leaned against the far wall of the storage room. Anne said that a few years ago, she had brought

Louisa May put together albums of cartes de visite, small (2½" x 4") albumen prints that were popular collector's items. The subjects include a photograph of Colonel Robert Gould Shaw, who commanded a regiment of black soldiers in the Civil War; Helena Modjeska, a Polish actress who was much acclaimed in the United States in the 1880s; and Adelaide Ristori, a famous Italian actress who debuted in New York as Medea in 1866.

Louisa May Alcott's father,
Bronson, built a desk
for her in her bedroom
at Orchard House. She
wrote *Little Women* there.

Virginie Mécène, a former Graham dancer who is now the director of the school, to the warehouse to look for props for a production that the student company was putting on. Mécène broke into tears when she saw the gates. She hadn't seen them since they were in front of the old building.

Dance is the most fragile of the arts. Writers have their texts. Composers have a score. But dance exists only in the moment. After a choreographer is gone, the most reliable preservationists are dancers who have performed the work under the

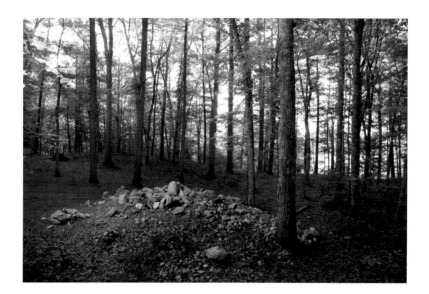

choreographer's guidance. It was said for years, even before Martha Graham died, that Ron Protas alienated the people who could have best helped preserve her dances. Even if that weren't so, her work, like all dance, is vulnerable to time. There are films of performances and coaching, but they can never be as effective as a choreographer shaping movement on an individual human body. Or, in Graham's case, dancing the roles herself. Which makes me treasure Barbara Morgan's photographs even more.

———

When you think of important women photographers and their subjects, Barbara Morgan and Martha Graham come immediately to mind, and, in the nineteenth century, Julia Margaret Cameron and her gallery of Victorian literary figures. Cameron's pictures are beautiful, maybe too beautiful. They are what came to be thought of as portrait photography. Her work didn't influence me, but I own some of her pictures and I admire her because she was so in love with what she was doing.

Cameron was born in Calcutta in 1815. Her father's family was involved in the British administration of India and her mother was French. In 1838 she married Charles Cameron, a prominent figure in the government in Calcutta who was twenty years older than she was. He had invested heavily in coffee plantations in Ceylon, and in 1848

they moved to England, apparently thinking that they could live well on the income from the plantations, although in fact they would always be short of money.

Julia Margaret Cameron was sociable, generous, and eccentric. Her large family included her six children, several adopted children, and the husbands and children of her sisters, who had also moved to England. Her friends were artists and writers and public intellectuals. In 1853, one of her greatest friends, Alfred, Lord Tennyson, the poet laureate, took a house near the remote village of Freshwater, at the western end of the Isle of Wight, on the English Channel. He was seeking privacy—a place to work that would protect him from his many admirers. The Camerons visited the Tennysons there often, and in 1859, while her husband was in Ceylon attending to his estates, Julia Margaret Cameron bought two cottages down the hill from the Tennyson house. She called one of them Dimbola, after one of their plantations in Ceylon. A few years later, when the two cottages were joined, the rather large complex became Dimbola Lodge.

Freshwater was soon neither private nor remote. There were many illustrious visitors, including Darwin, William Makepeace Thackeray, Lewis Carroll, Edward Lear, and other less well-known guests who came for the dinners and dances and impromptu plays that Cameron presided over. Queen Victoria and Prince Albert had a summer house further down the island.

Starting early in 1864, after Cameron was given a camera by her daughter and son-in-law, the guests and the neighbors were the subjects of lengthy portrait sessions that often involved costumes and props. Cameron was already forty-eight when she started taking pictures. She taught herself how to do it, with the advice of friends, and although she always gave away more pictures than she sold, she very quickly became "professional" in the modern sense. She was an unusual woman for her day in many ways, not least because she earned money to help support her family.

Julia Margaret Cameron's studio is gone now. The garden in back of Dimbola Lodge was developed in the 1960s, and houses were built there. I went through other people's yards to get to the long brick wall where Cameron had built a special gate for Tennyson to use when he visited her. Dimbola Lodge itself was saved from destruction in the early 1990s by a private trust of Cameron enthusiasts who keep it running by operating a teahouse and exhibition spaces.

There was a little balcony outside of Julia Margaret Cameron's bedroom window where she could watch people go by in the street. When she saw a likely candidate for a photograph, very often a child, she would go down and try to persuade them to sit for her. She had a forceful personality and was hard to resist, although people did try to resist. Sitting for a Cameron portrait has been described as both agonizing and boring. Exposures could take seven minutes. That's a long time to sit perfectly still, and she didn't use those head supports that other portrait photographers of the period supplied for their subjects. Then there was the setup time. Costumes to put on, poses to be struck, lighting to be arranged. Cameron didn't rush things, and she took care of pretty much everything herself, with the help of her maids. She used more or less

OPPOSITE AND FOLLOWING PAGES: The site of Henry David Thoreau's cabin on Walden Pond is marked by a pile of rocks left by visitors. Bronson Alcott started the tradition of leaving stones there.

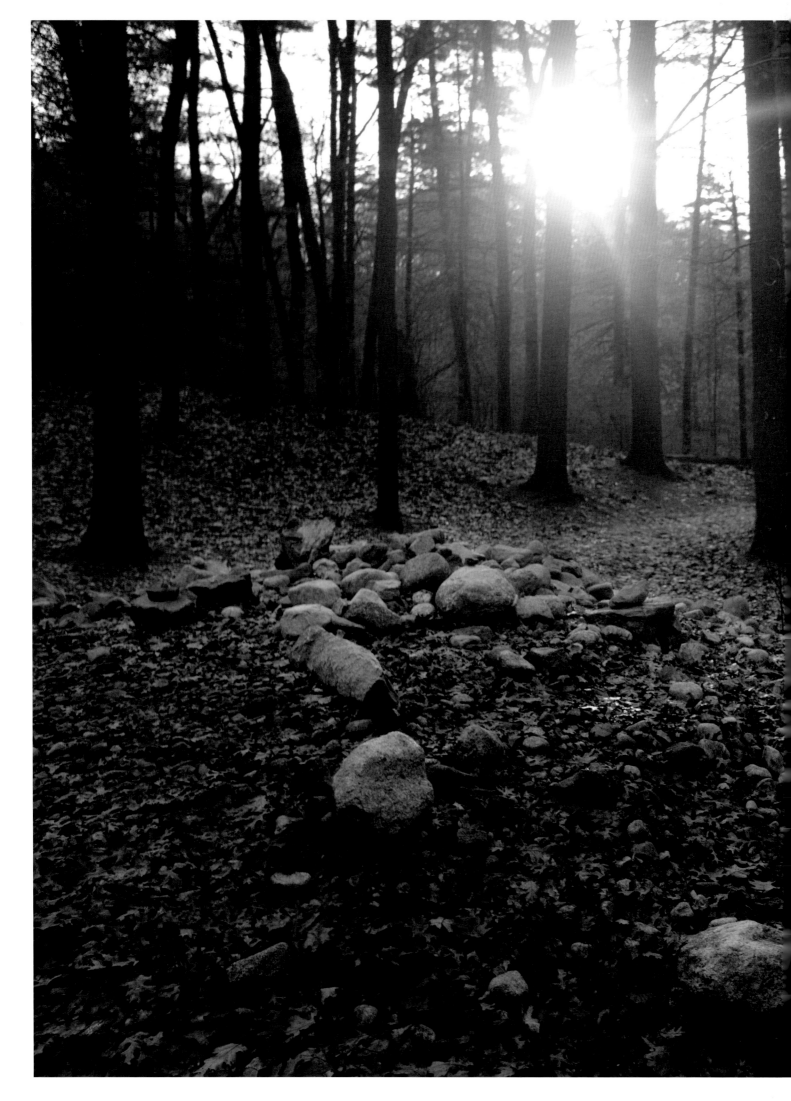

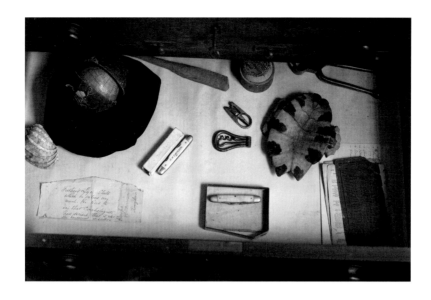

the same technique that the Civil War photographers used but she didn't have professional assistants or a staff to prepare and process glass plates. She might go through a hundred plates to get the image she wanted. People who were there described her as being disheveled, with chemical stains on her clothes.

Cameron's favorite model was one of her beautiful nieces, Julia Jackson. Some of her most haunting portraits were made of Julia shortly before she was married, in 1867. Julia's first husband died a few years later and she married Sir Leslie Stephen, with whom she had two daughters: Virginia Woolf and Vanessa Bell. In 1926, Woolf wrote an introduction to *Victorian Photographs of Famous Men and Fair Women,* a collection of Cameron's work that marked the belated critical acceptance of her importance. Around the same time, Woolf was working on a play, *Freshwater,* a spoof of the Tennyson/Cameron community on the Isle of Wight. It was performed at Vanessa

FOLDOUT: The frame and caning of the bed that Thoreau slept on in his cabin at Walden Pond were taken from a Chinese sofa bed. Thoreau attached legs to the frame and made a bedstead. The bed is now in the Concord Museum.

THIS PAGE: A drawer in a cabinet in Ralph Waldo Emerson's study is full of objects that would be interesting to a child. Emerson enjoyed carrying children around his house in Concord and telling them stories. There is a miniature globe, a turtle shell, pocket knives, folding scissors, and a folding bottle opener. The hat that Emerson wore on his daily walks hangs next to the door to the carriage house at Emerson's home.

FOLLOWING PAGES: Emerson's bedroom window overlooked a garden designed by his wife. A painting of Vesuvius erupting hangs in the hallway outside the parlor. The contents of Emerson's study are now in the Concord Museum, across the street from the Emerson house. Carleton Watkins's photographs of Yosemite and Mount Shasta are on the wall of the Emerson dining room.

4

Lieut Victoria Cross

Bell's studio in London in 1935, during a birthday party for her daughter. Vanessa played Julia Margaret Cameron and Leonard Woolf took the part of her husband.

I went back to the Isle of Wight a second time because I hadn't been able to get a picture I liked of the bay from Dimbola Lodge. I wanted to show the land and the water. This time I had spoken to Rebecca Fitzgerald, the woman who is restoring Tennyson's house, Farringford, which is higher up than Dimbola and has better views. We were

running pretty late, but Rebecca gave us a tour of the house. She was showing us a piece of woodwork that she thinks Tennyson might have carved himself when I looked out the window and saw that the light was going. We raced out the door and got to the top of the down, above the sheer chalk cliffs, as the sun was setting.

Cameron wrote an essay, "Annals of My Glass House," about her experiences as a photographer. She recalled starting out with no technique but knowing that she wanted to "arrest all beauty that came before me." She was an artist and she didn't care that her photographs didn't look like anyone else's. One of her sons, Henry, had become a photographer, and he had told her that her pictures were "flukes." Her lens didn't have much depth of field. Fine-tuning things can take the life out of them. I saw two or three of Henry Cameron's pictures in a drawer at Dimbola Lodge. They were properly exposed. The prints were skillfully made. And they were boring. Julia Margaret Cameron's printing was inconsistent and parts of the pictures were soft, but they were never boring. There was something beautiful about not being in control all the time. Not being totally proficient. It was magic.

———

There is no trace of the Isle of Wight in Julia Margaret Cameron's pictures. Everything in her work is directed in, not out. She created a world in a little studio made from

THIS PAGE AND PRECEDING PAGES: During the years John Muir lived alone in Yosemite (1868–1873), he became the foremost collector of botanical specimens from the valley. The *Teak Tictonia Grandus,* unlabeled grass, and *Amelina Licharotii* are part of the collection of the John Muir National Historic Site in Martinez, California, on the farm where Muir lived after he was married.

a chicken coop behind her house. Cameron was interested in personalities, stories, relationships. Ansel Adams's photographs are exactly the opposite. The story for him is about a pristine, uninhabited place.

I wanted to make an homage to Ansel Adams. To make a picture that showed that the places he photographed are still there. The view is protected, not least because of what Ansel did to make people aware of how extraordinary the landscape is and how

John Muir kept detailed journals in small bound notebooks that would fit in his pocket (this page and following pages). The notebooks provided the material for his articles and books. They are now part of the Holt-Atherton Special Collections at the University of the Pacific in Stockton, California.

The names on the folder (opposite), which is at the John Muir National Historic Site, are of Muir's principal correspondents. Muir had met Jeanne Carr when he was a student in Wisconsin. She and her husband, who was a professor of natural history, moved to California and were an important part of Muir's circle there. Jeanne Carr helped Muir identify botanical specimens. Asa Gray was a professor at Harvard. John Redfield founded the Herbarium at the Academy of Natural Sciences in Philadelphia.

precious. Ansel joined the Sierra Club in 1919, when he was seventeen, and he worked as a custodian at the Sierra Club headquarters in Yosemite during the summer for four years. Not too long afterward, he was elected to the board of directors. He was devoted to the cause of preservation.

One summer in the 1980s, when I was teaching at the annual Ansel Adams Yosemite Workshop, I walked out to Inspiration Point to take a picture. The clouds had rolled in and the valley looked magnificent. It seemed amazing to me that you could just walk up and take an Ansel Adams picture. Of course you couldn't really. Ansel himself said that people were disappointed when they went to these places and their pictures didn't look like his. His picture represented a moment he had worked on for a long time. He called his method "visualization," and in his autobiography he pinpointed exactly when he understood that was the way he wanted to work. It was a bright spring day in 1927, and he and some friends had climbed up to Half Dome. He was working with glass plates and he had only one plate left when he realized that he knew in his mind's eye how he wanted the finished print to appear. He changed the filter and opened the exposure wide and took what would become one of his most famous Yosemite landscapes. "I had been able to realize a desired image: not the way the subject appeared in reality but how it *felt* to me," he wrote.

That summer in the eighties when I was at the workshop, I met Jeanne Adams,

Botanical Notes.
Carr, Gray, Redfield &c
With named Specimens by
Gray      Yo. Book

of departure. Like [24] comets
the far points of their orbits, p
animals seem to be moving
of all specific limits, but, by
motions calculable or otherw
they return to whence they set out
4th

W, O, Clouds cum. 30
Warm balmy bright creat
is this day. The purple & ye
of the soil & of the old plant a
is rapidly fading in the deepe
green of young life
The little triangular rock fe
{Gymnograma triangularis} is unro
tiny fronds in sweetly arrange
Knots & mantlings along the rock
of Cascade Creek, I do not know
of any fern that has so wide a
vertical range as this hardy & com
gold powdered fellow, I have met i
on the Lower Joaquin & at all al
to the summit of the Sierra as fa
as Yosemite sky purple of the most refined

Dry creek on whose happy bank
my cabin stands is subject to
sudden swellings & overflows in
the rainy winter season when
it becomes a majestic stream
almost a river, with serious &
confident gestures, curving about
its jutting banks & horseshoe bends
carrying fences & bridge timbers
& all careless logs &
houses within reach of
its ephemeral power
In the course of a
few hours after the
close of a rain it
will retire within its banks
to its narrow beaten path
leaving many flat smooth
fresh sheets of sand. I like to watch
the first writings upon these fresh
new made leaflets of Natures own making
One of these pages was made last
night & was already written upon when
I saw it this morning. It is

who is married to Ansel's son, Michael. Jeanne is a very outgoing, joyful, and smart woman. She ran the Ansel Adams Gallery in Yosemite for a while. The gallery belonged originally to Harry Best, Ansel's father-in-law, a landscape painter who had a concession for selling photographs and souvenirs along with his paintings. Ansel and his wife had a house in Yosemite and their children were raised there. Jeanne still has a cabin in Yosemite, so I called her up and talked to her about the picture I wanted to take. She said to come out and we would look around.

I had in mind the view of the valley in one of Ansel's most well-known pictures, *Clearing Winter Storm*. He made it in 1935, and I thought it was taken from the spot I had walked out to in the eighties, but I wasn't exactly sure. When Nick and I drove into the park, we stopped at a place called Tunnel View, which looks like the right spot. There are two parking lots at Tunnel View, which means that fewer people fall off the side of the road than they did before. There is always at least one photographer there, and usually about ten. It's a mecca. That first afternoon, someone with an 8 × 10 camera

and a darkroom in the back of his car was making tintypes. It was kind of wonderful. I took a couple of pictures, but there wasn't a cloud in the sky. What is extraordinary about *Clearing Winter Storm* is the clouds.

Jeanne Adams's cabin is an A-frame in Yosemite West, not far from the village where the gallery is. When we got there, I saw that there was a Polaroid on the wall of us at the workshop. We both looked really young. It was almost evening, and I suggested that we go to Glacier Point for the sunset. Glacier Point is the place where John Muir took Theodore Roosevelt to show him the valley in 1903. It has a kind of grand overview from the side, three thousand feet above the valley floor. We drove there, although it was the first of November and the road was supposed to be closed. There was a light dusting of snow. Then we went back to Jeanne's and lit a fire and

made dinner. I looked at the maps I had, and Jeanne had a couple of maps. We were trying to figure out where *Clearing Winter Storm* was made. There was Inspiration Point and Old Inspiration Point. And then there was Artist Point. It was confusing. Tunnel View is on a road that was completed in 1933, so it would have been available to Ansel, although if you study his picture, it seems like he was standing a little more to the right and higher up. Something is off. You can see further down the valley in Ansel's picture.

There were still no clouds the next morning. I mentioned this at breakfast, and Jeanne looked at me and said, "Annie, Ansel would wait two or three weeks for clouds." Then she said, "You know, those old-time landscape photographers, if you look closely at their pictures you can see that they took clouds from one place and used them over and over again." I cringed. That's something I do all the time in my digital portrait work. If I don't have the right sky, I'll add clouds. I was glad to hear about the early landscape photographers' borrowing clouds, but I felt very strongly that for this picture, it had to be straight. I wasn't going to mess around. It had to be the real thing.

We went to Tunnel View, and I shot the sunrise. The light wasn't good, but I thought we should look for the other views. Not that I had to be exactly where Ansel was, but it would be nice to know. At the parking lot across the road there was a sign that said "Inspiration Point, 1.2 miles," so we took some bottles of water and headed off. We weren't moving very fast, and we stopped to look at the view several times. After a while, we got to a place where an old road crossed the trail. Trees had fallen across it and you could still see a little asphalt. A sign pointed further up the trail to Inspiration Point. That part of the trail was fairly steep, and Jeanne was wearing what looked like slippers. She said that she had always wanted to walk the old road, which she thought went to Bridalveil Fall, and since I could see that it went down, that seemed like a good idea. I asked Nick to go back and get the car and drive to the falls and meet

THESE AND FOLLOWING PAGES: In 1860, Cameron and her family moved to Freshwater Bay, at the western end of the Isle of Wight. They bought two houses that they later combined into one, Dimbola Lodge. Their friend and neighbor, Alfred, Lord Tennyson, cleared trees to create a road from his house down to the sea. The road ran past the back wall of Dimbola Lodge. Tennyson, who was besieged by fans and sightseers, used a private gate when he visited. Cameron could see the gate from her bedroom window. She sometimes used the wall as the background for portraits.

Dimbola Lodge was at the center of a celebrated literary/artistic salon. Tennyson and Cameron usually dined together, often with twenty or thirty other people. They took daily walks over the downs above the Great Chalk Cliffs.

us there. Jeanne and I headed in that direction, crawling over and under logs. Not far along, there was a classic view of Yosemite. Pretty much the view in Ansel's picture, except that there were trees in the way. Jeanne said that it used to be worse, but that in recent years the Park Service had been quietly doing some tree cutting.

In the mid-1800s, when the valley was "discovered," the view was much more open. If you look at Albert Bierstadt's paintings of the valley floor or Carleton Watkins's photographs, you can see that there were many clearings and meadows. The Native Americans had been managing the vegetation for centuries. They burned off underbrush and cultivated oak trees. That way of life changed in 1851, when a militia bent on eliminating hostile Indians rode into Yosemite. Gold had been discovered in California a few years earlier, and miners and settlers had arrived in droves. The native inhabitants were pretty quickly shuttled off to reservations. In Rebecca Solnit's book *Savage Dreams,* she points out that one of the reasons the early white visitors to Yosemite described it as a garden was because it *was* a garden. After most of the native inhabitants were gone, sheepherders and farmers moved in. Grazing sheep and farming affected the landscape until early in the twentieth century. It took a long time for the forest to erase that history.

When we got back to Jeanne's house, someone checked the weather report, which said that nothing was going to change. There were to be no clouds that day. I don't usually pay any attention to weather reports, but it didn't look good, and in the interest of economizing our time, we decided to leave early and drive over to Carmel, where Jeanne and Michael live in Ansel's old house. It's where his darkroom is. Ansel built the house in the early sixties on a site just a mile from Edward Weston's house. It has a panoramic view of the coast and is hidden on a slope, although it is only a few hundred feet from Highway One. I photographed the darkroom and then went back to New York. A few days later, I got an email from Jeanne saying that she and Michael had gone to the park on the weekend and that the clouds were glorious.

For the next two or three months, I kept trying to find a day that I could pop back into Yosemite. Not that you can ever pop into Yosemite, especially in the middle of winter. If you even try to get in without chains, they give you a fine. But I finally did get back in January and, of course, there were no clouds. I was traveling with my sister Susan that time. We took a hotel room, and I went to the gift shop and bought a book called *Yosemite: Art of an American Icon.* The next day I made some pictures through the windshield of the car and took some views of roads. We went up to Tunnel View and there were no clouds, but I took pictures anyway.

It's one thing to live in Yosemite and run out the door whenever the weather becomes interesting. It's quite another to take a chance on the small window of a random visit. On the other hand, you might get lucky. About ten days before I had to turn this book over to the printer, I flew out to Yosemite again. I knew that it was a crazy thing to do, but things looked promising when we arrived at the Fresno airport. We threw our equipment into a van and raced toward the valley. There was a hail

storm and a lot of rain and for a while the road was socked in by a cloud. It was already late afternoon and I was afraid that we would miss the light. I wouldn't let anyone in the car talk about the weather. It took three hours to get to Tunnel View, but when we arrived, the valley was still filled with clouds and mist. I jumped out with my camera and found a place among the thirty or so other people who were crowded around taking pictures. There were tourists and several photography students. Matthias ran behind me with the tripod, but there was no time to set it up. I got about eight frames before the light changed and the clouds disappeared. They didn't come back.

———

John Muir wrote that when he first saw Yosemite, when he had just turned thirty, the mountains "seemed not clothed with light, but wholly composed of it, like the wall of some celestial city." He wrote about that moment more than twenty years later, in 1890, when he was making the case for protecting Yosemite by creating a national park. He no longer lived in the valley, but his experiences there had been so profound that it seemed that he had never left.

By the time Muir arrived in California, in 1868, he had heard enough about Yosemite that he set off almost immediately to see it for himself. He walked there, hiking south from Oakland and then through the coast range. This was not the standard route. Most visitors took a steamship to Stockton and a stagecoach to the valley rim and then rode into Yosemite on horses. Muir liked to hike. In this case, the hike was more than two hundred miles, but he wasn't daunted. He had already walked most of the way to Florida from his home in Wisconsin.

Muir grew up on a farm on an isolated stretch of the Wisconsin frontier. He spent his boyhood clearing land, threshing grain, digging wells, and splitting logs. When he was almost twenty-three, he enrolled in the University of Wisconsin. It was there that he was introduced to the science of botany and began collecting plant specimens. He also met a woman, Jeanne Carr, who shared his interest in plants and would be an important figure in his life. She was the wife of one of his professors. At Muir's urging, the Carrs moved to California shortly after he did.

Muir got a job overseeing a herd of sheep in Yosemite, and then he built a sawmill for James Hutchings, who owned a hotel in the valley. Muir lived in a little cabin near the mill. He slept in a hammock suspended from the ceiling, over a stream that ran through the floor. Later he lived in a sort of sleeping loft that he had built as an attachment to the top of one of the ends of the mill. It was there that he was visited by Ralph Waldo Emerson. Jeanne Carr had arranged the meeting. Emerson gamely climbed up to Muir's perch and looked at his plant collections and drawings. In Muir's account, Emerson is eager to go off on a camping trip with him and is held back by his overly solicitous traveling companions. "You are yourself a sequoia," he tells Emerson. "Stop and get acquainted with your big brethren." But after a week of conventional sight-seeing, Emerson rides off. As Muir watches from a grove of trees, Emerson stops at the

FOLLOWING PAGES: Ansel Adams moved to a house near the ocean in Carmel, California, in 1962. He worked in his state-of-the-art darkroom there during the last years of his life. The walls were painted black. He designed a big horizontal enlarger on wheels for large-format negatives. Two vertical enlargers for small-format negatives were along a wall across from a row of deep sinks. Adams was interested in the newest equipment. He wrote several books on photographic technique.

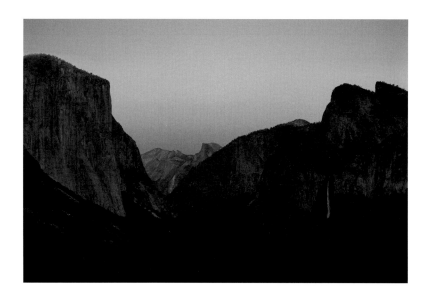

top of a ridge. "After all the rest of the party were over and out of sight, he turned his horse, took off his hat and waved me a last good-bye," Muir recalled. Later that year, Emerson wrote in his journal that Muir was "one of my men." He sent a letter encouraging him to come east.

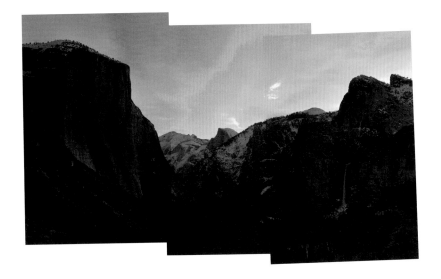

Ansel Adams visited the Yosemite Valley for the first time in 1916. He was fourteen years old and had just been given his first camera. From that moment on, Adams was devoted to Yosemite. The valley had restorative powers for him. He made thousands of photographs of Yosemite and was a committed lobbyist on its behalf. Ansel Adams's pictures are what most people think of when they think of Yosemite.

Muir began to read Emerson more thoroughly after he met him. He also read *Walden* and Thoreau's collected essays. But most of his energy went into studying science and mountaineering. Muir's goal was to explore and record Yosemite with scientific thoroughness. His first published essay was on the subject of glaciers. He was the foremost proponent of the then controversial theory that the valley had been formed by glacial movement.

Muir began spending the winters in town in 1873. He first stayed near the Carrs, who lived in Berkeley, where he became friends with the local intelligentsia. It was during these winters that he began to seriously develop writing as a career. He had supported himself with manual labor in the past, but now he would make a living describing his experiences. People who lived in cities were interested in his stories, and his beliefs about the value of the natural world meshed with the philosophy of a

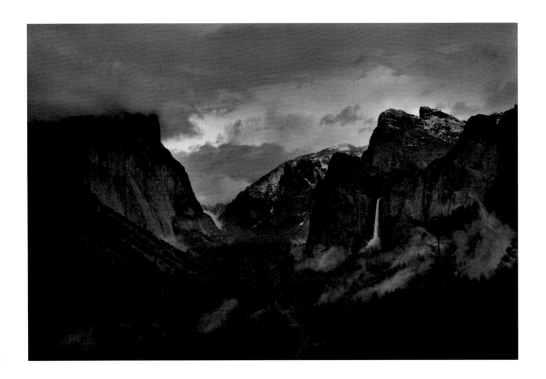

growing conservation movement. He was an honored guest in progressive homes. In one of those homes, near the town of Martinez, about twenty-five miles northeast of San Francisco, he met Louisa Strentzel, the daughter of a wealthy farmer. Jeanne Carr introduced them. They were married in 1880 and Muir took over the running of the Strentzel farm. He lived in Martinez from the time he got married until he died, in 1914. He turned the management of the farm over to his brother-in-law in 1891 and he took long trips, not back to Yosemite for any extended period, but to Alaska and up the Amazon and the Nile and around the world.

The day before I went to Yosemite with my sister Susan, I drove to what is now the John Muir National Historic Site in Martinez. I wasn't sure that I would find what I was looking for there. The John Muir story, for me, took place in Yosemite. When I went into the valley with Jeanne Adams, I worked hard to find out where Muir's cabin had been—the hut where he slept with the water gurgling under him. Jeanne said that there was a plaque somewhere but it might not be in the right place. The river had shifted in its bed several times. Who could say where it used to run? His plant

specimens and journals were more reliable as artifacts. Muir had left thousands of plant specimens. And he had kept journals wherever he was. They had been preserved.

On the National Park Service's website for the Martinez house, I had seen a photograph of a big leaf folded over. The leaf was so big that it didn't fit on the page it was attached to. There was something irreverent about it. Most of Muir's specimen pages, and certainly his journals, are constructed with extreme care. He paid great attention to detail. I asked about the big leaf when I got to Martinez, and the curators were really nice about trying to find it for me. They were all pretty young and had absorbed the current thinking that archives should be accessible. They took me down to the basement where there were filing cabinets full of specimens. There were four of them trying to find that leaf. It took a while. I had to come back the next day. I was supposed to go to the Muir collections at the University of the Pacific library in Stockton, but I called and told them I would come later. I got very involved with grasses and leaves in that basement in Martinez.

———

The Farnsworth House, the distillation of Mies van der Rohe's ideas about steel-and-glass buildings, is nestled in the woods. We got our first glimpse of it at dusk on a murky evening. We had an appointment to see the house in the morning and we hadn't planned on being in Chicago while it was still light, but we arrived ahead of schedule. The drive from the airport to the little town of Plano didn't take long, less than an hour. I was surprised that the landscape opened up into farmland so quickly. There were only occasional pockets of suburban sprawl. The house was fenced in, but Nick looked at Google Earth on his iPad and saw that there was a public park on the other side of the Fox River, which runs on the south side of the house. We drove there and walked down a trail to the water. We were standing right across from the house.

The Farnsworth House started out as a romance. Edith Farnsworth was a doctor from a prominent Chicago family. She met Mies van der Rohe in 1945 at a dinner party given by friends. Mies had immigrated to Chicago from Germany in 1938 and was the director of the school of architecture at the Illinois Institute of Technology. He was almost sixty and was acknowledged to be one of the masters of modernism, but he was just starting out on the American phase of his career. Dr. Farnsworth wanted to build a weekend house on seven acres of land she owned near Plano, and she asked someone at the Museum of Modern Art in New York to suggest an architect. They proposed Le Corbusier, Frank Lloyd Wright, and Mies. She chose Mies, perhaps because he was nearby but also because she found him attractive.

The Farnsworth/Mies relationship is a legendary story of an architect and his client. They began by spending time together on the site, picnicking on the riverbank and going over drawings. She sent him checks with little apologies about how money was inadequate for a project that was really about heart and soul. A few years later they were in court. He sued her for unpaid bills and she countersued, claiming that he

PRECEDING PAGES: Mies van der Rohe's Farnsworth House was completed in 1951. It is a one-room steel-and-glass house designed as a country retreat on the Fox River.

had overcharged her and was incompetent. The house was stiflingly hot in the summer, the floor-to-ceiling windows were covered in condensation during the winter, and the roof leaked. The case was settled in Mies's favor, although he got only half the money he asked for. Dr. Farnsworth continued to live in the house until 1971. She sold it when the county succeeded in taking some of her land and building a new highway and a bridge close to the house. It was no longer a secluded retreat. You could see the bridge and there was traffic noise. Dr. Farnsworth moved to Italy and spent the final years of her life translating poetry.

The house was bought by Peter Palumbo, a wealthy British developer and patron of the arts. He is a collector of houses and he didn't stay in it very often or for very long. It wasn't meant for domesticity. It's a minimalist glass box, one room, with a center structure that contains two bathrooms, a kitchen area, and a utility space. Mies wanted Dr. Farnsworth to use furniture that he designed and drapery that he selected, but by the time she moved in, she was so angry that she refused to cooperate. She even screened in the terrace. Lord Palumbo spent a great deal of money on restoration. He hired Mies's grandson, who rebuilt the roof, stripped and repainted the steelwork, replaced the glass panels, and put in electrical heating and air-conditioning. The furniture that Palumbo installed included a table from the German Pavilion of the 1929 Barcelona Exposition, the structure that established Mies's reputation.

The house is built on stilts. Mies was very careful to investigate the historical pattern of floods, and he raised the house more than five feet from the ground, which was two feet higher than any recorded flood. Unfortunately, flood levels began to increase dramatically in the 1950s. There was a bad flood soon after Dr. Farnsworth moved in, but nothing like what the Palumbos experienced. In July 1996, eighteen inches of rain fell in twenty-four hours and floodwaters broke two of the glass walls. The house was filled with mud and silt. Less than a year later, before restoration had been completed, there was another serious flood. The house continues to be flooded regularly to some extent. With absolutely no hard feelings toward the house, I wished that I could see it surrounded by water, like a houseboat.

We drove to the house in the morning and parked in an area that Lord Palumbo's landscape architect had created. Mies didn't want cars near the house itself, which is revealed as you walk across the backyard, through the trees. We were met outside by Whitney French and Justin Lyons, representatives of the preservationist trust that bought the house from Palumbo in 2003. One of the most important elements in Mies's siting of the house was a large maple tree that stood between the house and the river, making a kind of screen. The tree shaded the house in the summer. It had been dying for years, and Whitney and Justin said that they were going to have to cut it down soon after I left. They had taken cuttings and were growing saplings. They gave me a piece of bark as a souvenir.

I was left alone in the house, which is what it was designed for. You're in a place that is neither inside nor outside. The hand-polished plate glass creates a transparent

FOLLOWING PAGES: Old Faithful, the most famous geyser in Yellowstone National Park.

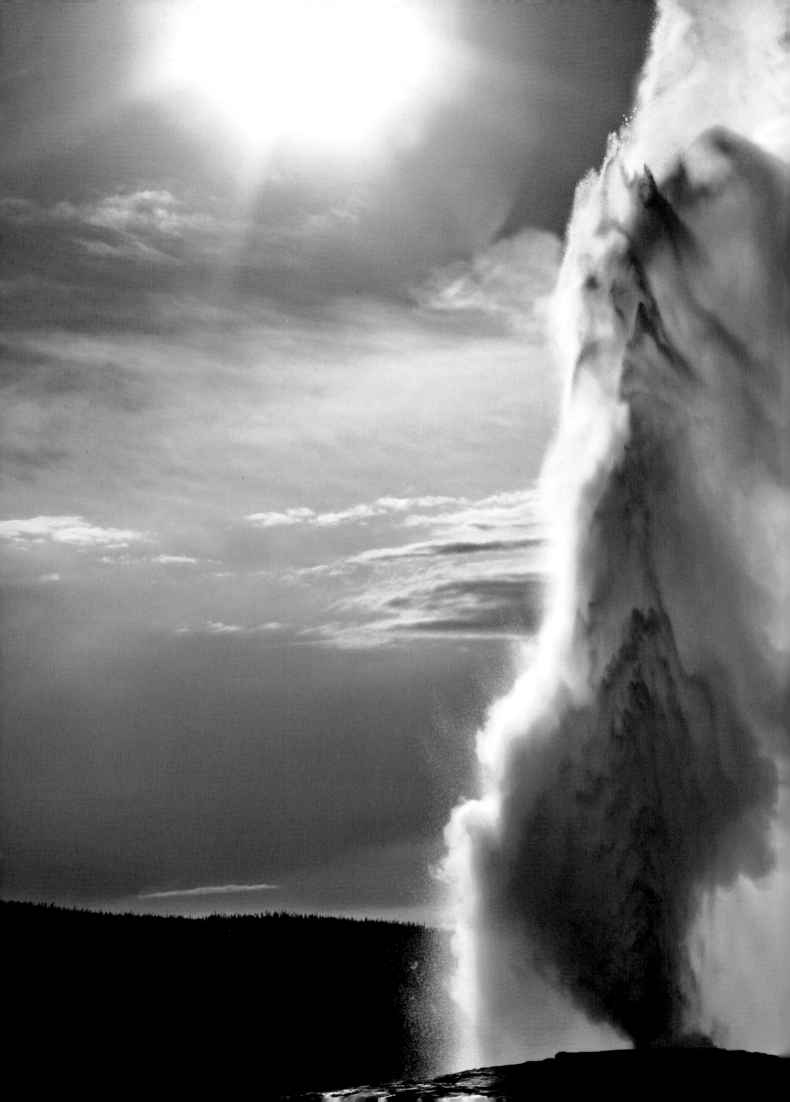

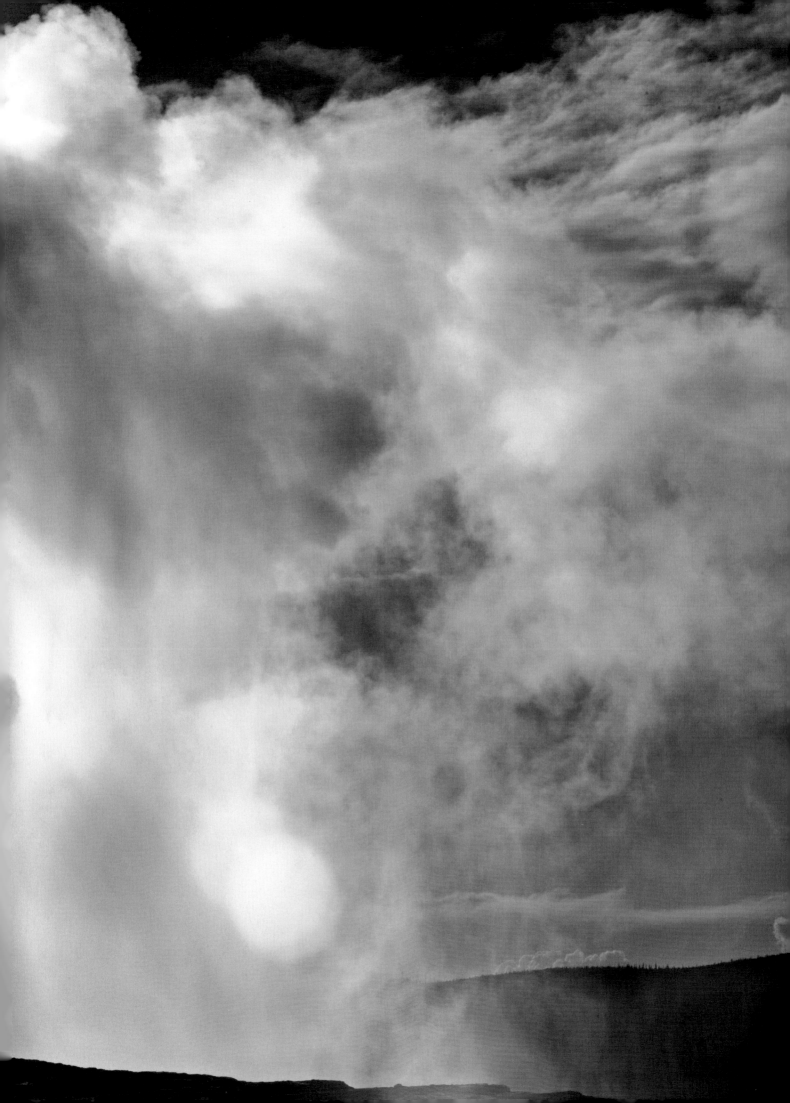

wall. The tempered glass that replaced the panes broken in the 1996 flood caused some reflection, but the other panes were beautifully clear. Mies had designed a system for the curtains, and if you knew how to open and close them you could almost create rooms, or the sense of rooms. If I lived there, I wouldn't have curtains.

There wasn't anything like this house when Mies designed it, and even though it was enormously influential, none of the houses built after it were so perfect. Farnsworth is the epitome of what Mies often said he aspired to: almost nothing.

———

The Spiral Jetty was always on my lists of places, even the lists I made with Susan. I had wanted to go there ever since I saw a show of Robert Smithson's work at the LA County Museum in the early nineties. They had slides that Smithson had made of a half-finished, dilapidated hotel in Mexico and a recording of him giving a lecture about the "de-architecturization" of the hotel site. It was a very funny send-up of 1960s art criticism. There were also photographs of the Spiral Jetty taken at the time it was constructed. Robert Smithson was dead when I saw the show in LA, and the Spiral Jetty was submerged, but years later, when I read that the water covering it was starting to recede, I cut out a photograph of the jetty and tacked it on my wall.

For a long time, the Spiral Jetty was known only through photographs, and not just because it had been obscured by water a few years after it was built. It is in a remote place—a desolate edge of the Great Salt Lake. Smithson assumed that not many people would find their way to see it, and he made a film about it that was shown in galleries and museums. The Spiral Jetty project for him included both the actual jetty and the film. Smithson died in a plane crash in 1973, just three years after the Spiral Jetty was completed. He was thirty-five. He and a photographer and their pilot were killed during a reconnaissance flight for an earthwork near Amarillo, Texas.

A few years ago, the Dia Art Foundation, the custodian of the Spiral Jetty, published a book that includes an essay by Bob Phillips, the Utah contractor who worked on the project with Smithson. Phillips was hired because he had experience building dikes for evaporating ponds. He was as surprised as everyone else when he found himself being talked into helping Smithson execute his bewildering plan. The appearance of a long-haired artist from New York in that part of Utah was itself confusing to most people. Phillips tried to discourage him. Smithson had obtained a twenty-year lease on the land and a permit to move rock, but Phillips explained that engineers were necessary and that earthmoving equipment would very likely sink into the ooze of the lake bed. Smithson returned with diagrams of what he wanted and a check that didn't bounce. The subject of engineers never came up again.

A five-man crew with two dump trucks and a bulldozer spent several days moving nearly seven thousand tons of rocks and soil into the configuration that Smithson had staked out in the shallow water. The equipment did sink into the ooze several times, but the crew figured out ways to get around logistical difficulties. "It was like an orchestra,"

Phillips writes, "with Robert Smithson as the conductor." Smithson oversaw the placement of every rock. When they were finished, they had a spiral with a little island at the end, rather like a question mark. A week or so later, Phillips got a call from Smithson saying he realized that it wasn't right and had to be fixed. Everybody went back for three more days of work, and the coils of the spiral became what we know now. "When it was done, I went out to look at it," Phillips said. "The feeling I got looking at it that second time, compared to what I got the first time . . . went from 'That's a good-looking dike I built" to "My word, that's sensational."

The rocks are black and the water is an eerie pink in the original photographs. The hue of the water was the main reason that Smithson chose the site. Bacteria and algae that thrive in saltwater create a color that he described as looking like tomato soup. When the water began receding, in about 1999, the rocks and the surrounding lake bed were covered in saline crystals. Everything was white. The appearance of the area fluctuates, but it will never be exactly like it was when Smithson was there.

Smithson's intentions for the future of the Spiral Jetty are a subject of endless debate. The Dia Foundation contends that natural changes, like water levels, are acceptable but man-made changes are not. They have, so far, successfully opposed exploratory oil-well drilling near the site. Dia wasn't involved in one of the strangest recent alterations to the surrounding salt flats. In 2005, two state agencies, trying to be helpful, carted away tons of what was referred to as "junk." This included a rusted military amphibious vehicle and the skeleton of a mobile home, the kind of wreckage in the landscape that drew Smithson to it.

It takes about forty minutes to fly from Salt Lake City to the Spiral Jetty in a helicopter, which is how we went there. We arrived around noon and landed on the edge of the lake. A couple who were on an art pilgrimage were sitting in their jeep. It was July and the water level was low, and we walked out to the end of the coil. I talked to the pilot about the best way to fly over the jetty. I told him to go in circles. Robert Smithson used a helicopter in his film. The noise of the motors is part of the soundtrack. The final sequence is shot from several hundred feet in the air, with the sun reflecting in the camera's lens. The jetty and the sun are part of a circle of light.

In an interview Smithson gave two months before his death, he talked about the interaction of people and places over time. "I don't think things go in cycles," he said. "I think things just change from one situation to the next. There's really no return."

———

My list of places turned out to be arbitrary. Some of them have always meant something to me and some of them I went to out of curiosity and some of them were along a path I stumbled onto. But all of them made an impression. From the beginning, when I watched my children stand mesmerized over Niagara Falls, this project was an exercise in renewal. Looking at history provided a way of going forward. I always knew that the Spiral Jetty would be the last picture. It's both an end and a beginning.

FOLLOWING PAGES:
Robert Smithson created the Spiral Jetty earthwork in 1970 on the northeastern shore of the Great Salt Lake in Utah. It was submerged for thirty years, but then the water level of the lake receded again.

229

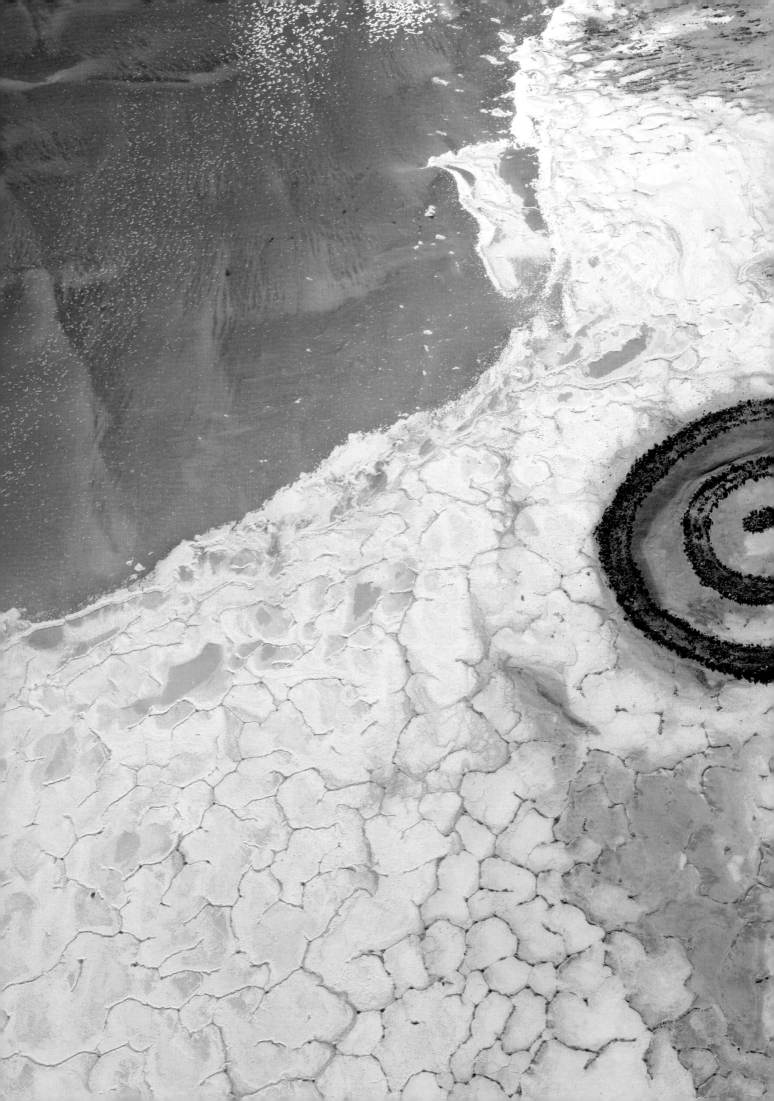

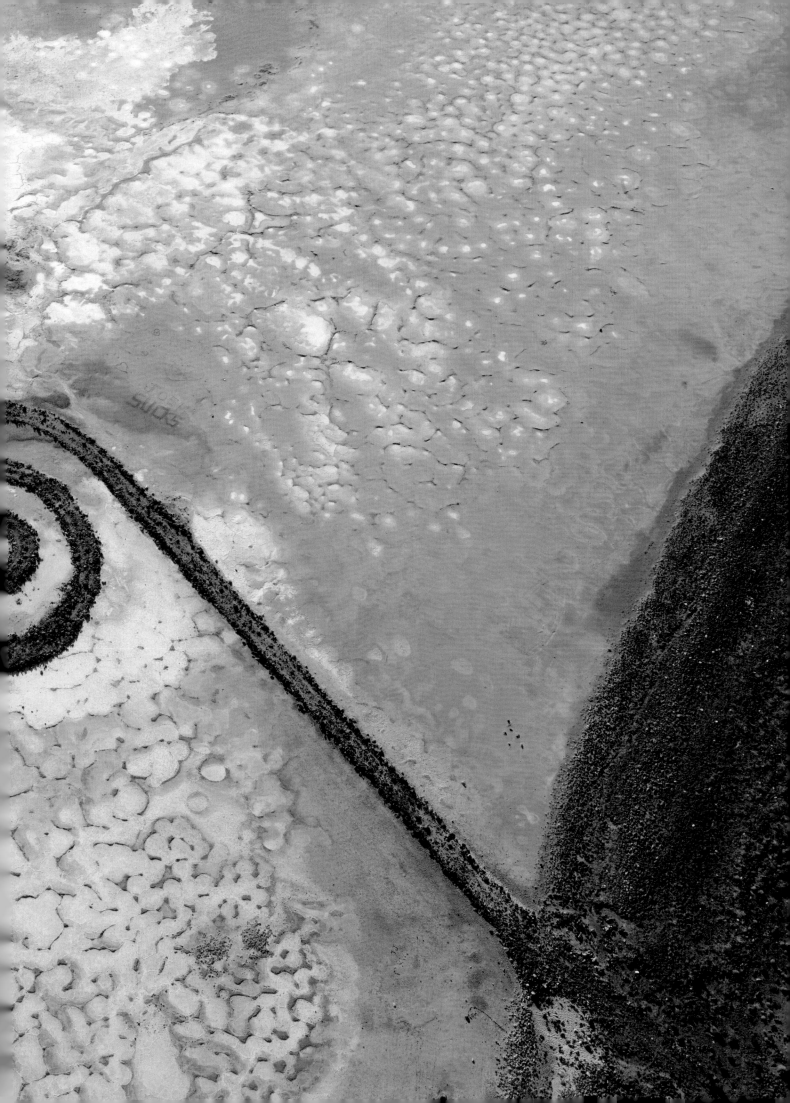

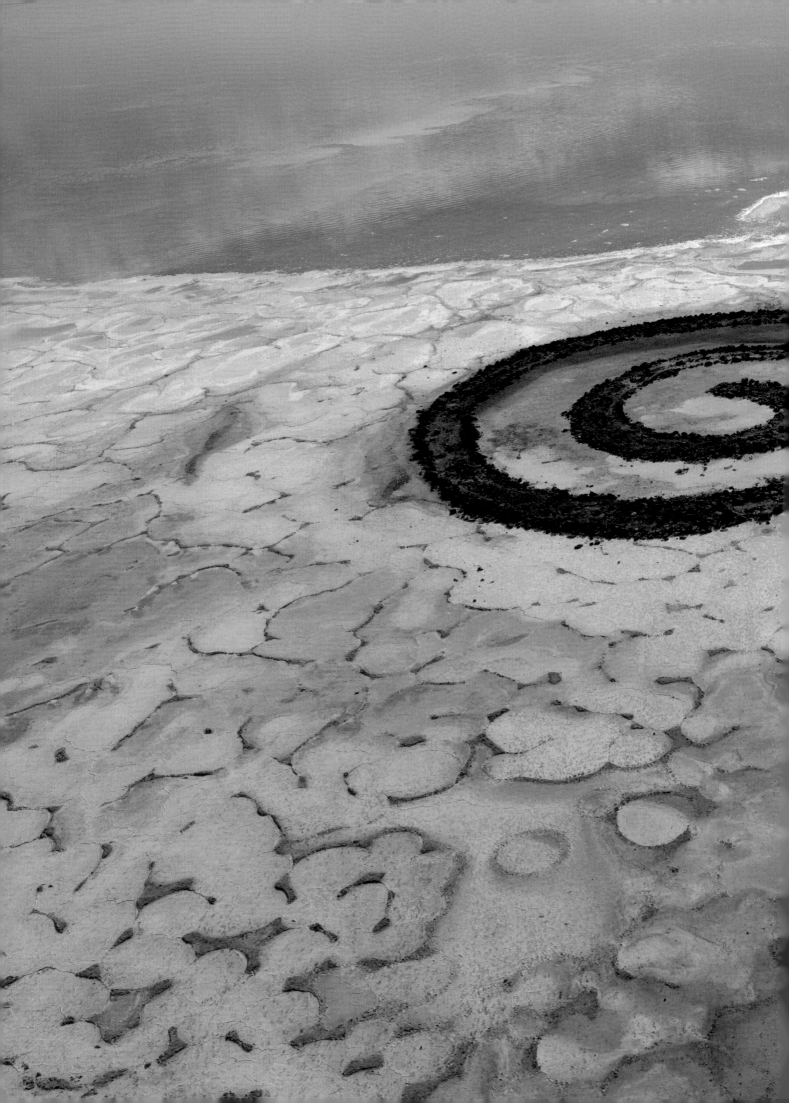

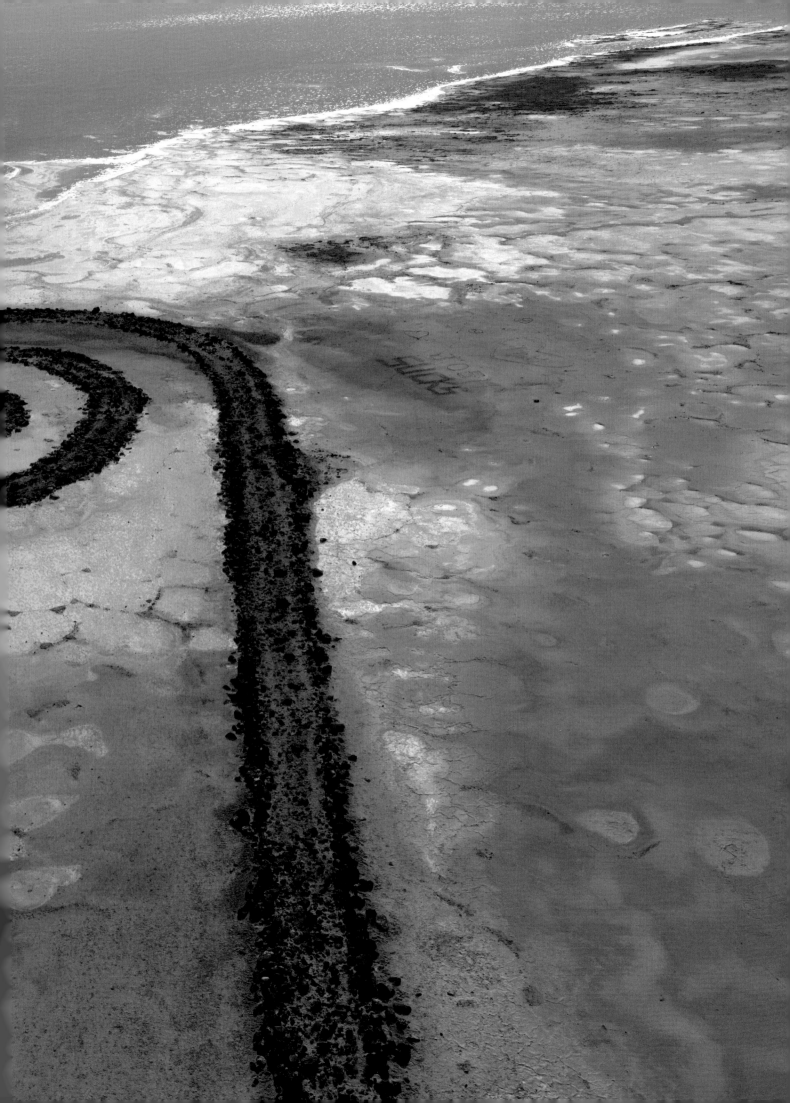

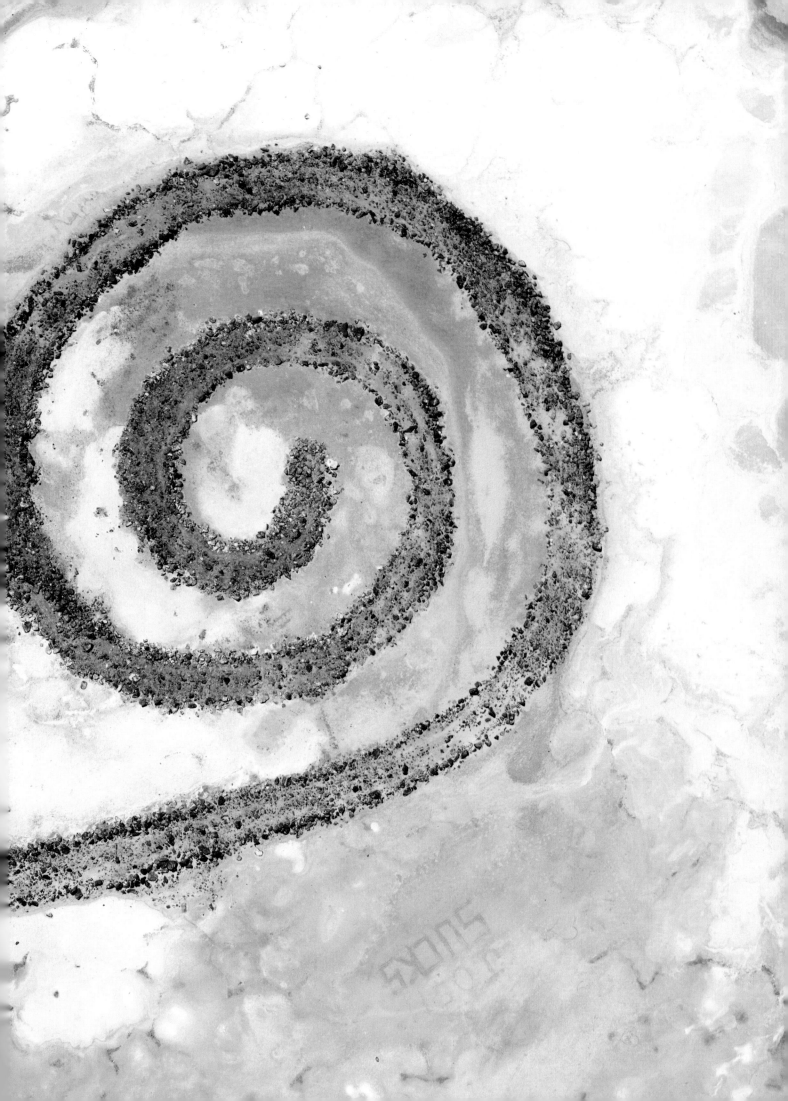

Chronology

The Places

Selected Bibliography

**APRIL 13, 1743** Thomas Jefferson is born in Shadwell, Virginia

**1768** Jefferson begins construction of Monticello

**APRIL 1775** The Revolutionary War begins with battles at Lexington and Concord, Massachusetts

**JUNE 1776** Jefferson writes the first draft of the Declaration of Independence

**NOVEMBER 29, 1799** Bronson Alcott is born on a farm in Connecticut

**SEPTEMBER 3, 1783** Treaty of Paris. Britain recognizes American independence and cedes to the
    United States all land between the Allegheny Mountains and the Mississippi River

**1801–1809** Thomas Jefferson is the third president of the United States

**APRIL 28, 1803** France and the United States sign treaties for the Louisiana Purchase. The U.S. gains
    820,000 square miles of land west of the Mississippi.

**MAY 25, 1803** Ralph Waldo Emerson is born in Boston

**1804–1806** Thomas Jefferson's personal secretary, Captain Meriwether Lewis, and Lieutenant William
    Clark lead an exploratory expedition to the Pacific coast

**FEBRUARY 12, 1809** Charles Darwin is born in Shropshire, England.
    Abraham Lincoln is born in Hardin County, Kentucky

**JUNE 11, 1815** Julia Margaret Cameron is born in Calcutta

**JULY 12, 1817** Henry David Thoreau is born in Concord

**OCTOBER 17, 1821** Alexander Gardner is born in Paisley, Scotland

**1823** Mathew Brady is born in Warren County, New York

**JULY 4, 1826** Thomas Jefferson dies at Monticello

**MAY 23, 1830** Bronson and Abigail Alcott are married

**DECEMBER 10, 1830** Emily Dickinson is born in Amherst, Massachusetts

**DECEMBER 1831–OCTOBER 1836** Darwin's voyage on the *Beagle*

**NOVEMBER 29, 1832** Louisa May Alcott is born in Germantown, Pennsylvania

**1834** Ralph Waldo Emerson moves to Concord

**SUMMER 1835** Bronson Alcott meets Emerson in Boston

**1837** Emerson meets Thoreau, who is just about to graduate from Harvard

**APRIL 21, 1838** John Muir is born in Dunbar, Scotland

**1838** Thoreau opens a small school on Main Street in Concord

**1838** Julia Margaret Cameron is married in Calcutta

**1839** Announcements of the invention of a process for fixing a photographic image on a metal plate
    (a daguerreotype) and another system, invented by William Fox Talbot, for producing an image on
    paper, what would become a calotype

**APRIL 1840** The Alcott family moves to Concord

**1842** Darwin buys Down House

**NOVEMBER 4, 1842** Abraham Lincoln marries Mary Todd

**JANUARY 1844** The Alcotts leave the utopian farm Fruitlands in failure

**APRIL 1844** Mathew Brady opens his "Daguerrian Miniature Gallery" in downtown New York

**1844** Lincoln buys a house in Springfield, Illinois

**JULY 4, 1845** Thoreau moves to Walden Pond

**JULY 1846** Thoreau is arrested for not paying a poll tax

**SEPTEMBER 6, 1847** Thoreau leaves the cabin in Walden Pond

**JANUARY 1848** Gold is discovered on the American River in California

**1848** Julia Margaret Cameron and her family leave India and take up residence in England

**MARCH 1849** Ten-year-old John Muir immigrates with his family to America

**APRIL 20, 1850** Daniel Chester French is born in Exeter, New Hampshire

**MARCH 1851** A volunteer militia of white men in search of hostile Indians rides into the Yosemite
    Valley. They find a landscape that has been carefully cultivated.

**AUGUST 1854** *Walden* is published

**MAY 6, 1856** Sigmund Freud is born in Freiberg, in the Austrian Empire

**MAY 24, 1856** John Brown and his men murder pro-slavery farmers in Kansas

**SPRING 1856** Alexander Gardner begins working in Mathew Brady's gallery in New York

**JULY 1, 1856** Austin Dickinson and Susan Gilbert are married

**JANUARY 26, 1858** Mathew Brady opens his Washington, D.C., gallery and studio

**JULY 1858** The Alcotts move into Orchard House

**1858–1862** Emily Dickinson writes the "Master" letters and poems

**1859** Darwin's *On the Origin of Species* is published

**OCTOBER 16, 1859** John Brown takes hostages at Harper's Ferry

**DECEMBER 2, 1859** John Brown is executed

**1860** Julia Margaret Cameron buys two houses on the Isle of Wight

**FEBRUARY 27, 1860** Lincoln makes an antislavery speech at Cooper Union in Manhattan. A Mathew Brady photograph commemorates the occasion.

**AUGUST 13, 1860** Annie Oakley is born in Woodland, Ohio

**MARCH 4, 1861** Lincoln's inauguration

**APRIL 12, 1861** Confederate batteries open fire on Fort Sumter in Charleston Harbor, South Carolina. The American Civil War begins.

**JULY 1861** Carleton Watkins photographs Yosemite with mammoth-plate negatives

**FEBRUARY 20, 1862** Lincoln's son, eleven-year-old Willie, dies

**MAY 6, 1862** Henry David Thoreau dies

**DECEMBER 1862–JANUARY 1863** Louisa May Alcott is a nurse in a Union military hospital in Washington, D.C.

**JANUARY 1, 1863** Emancipation Proclamation

**MAY 1863** Alexander Gardner opens his own photographic studio in Washington, D.C.

**JULY 1–3, 1863** The Battle of Gettysburg

**JULY 5, 1863** Alexander Gardner, Timothy O'Sullivan, and James Gibson arrive at the Gettysburg battlefield and begin photographing it

**NOVEMBER 19, 1863** Lincoln gives the Gettysburg Address at the dedication of the cemetery for Union soldiers

**CHRISTMAS 1863** Julia Margaret Cameron is given a camera

**JANUARY 1, 1864** Alfred Stieglitz is born in Hoboken, New Jersey

**JUNE 30, 1864** Lincoln signs a bill granting Yosemite to the State of California for public use for all time

**1864** Julia Margaret Cameron becomes a member of the Photographic Societies of London and Scotland and begins to exhibit photos publicly

**MARCH 4, 1865** Lincoln is inaugurated for a second term as president

**APRIL 9, 1865** Robert E. Lee surrenders at Appomattox

**APRIL 15, 1865** Lincoln dies from assassination wounds

**DECEMBER 6, 1865** The Thirteenth Amendment to the Constitution prohibits slavery

**MAY 1868** John Muir visits Yosemite for the first time

**SEPTEMBER 1868** *Little Women* is published

**1869** May Alcott gives sculpting tools to Daniel Chester French

**MAY 1871** Ralph Waldo Emerson meets John Muir in Yosemite

**JUNE 16, 1874** Emily Dickinson's father dies

**MARCH 1875** Congress buys more than 3,000 glass-plate negatives from Mathew Brady for $25,000

**1875** Julia Margaret Cameron and her husband leave the Isle of Wight and move to Ceylon

**1877** The Alcotts leave Orchard House and move to the house on Main Street that had belonged to the Thoreau family

**JANUARY 26, 1879** Julia Margaret Cameron dies in Ceylon

**MAY 30, 1879** Vanessa (Stephen) Bell is born in London

**JULY 15, 1879** The Concord School of Philosophy convenes at Orchard House

**APRIL 14, 1880** John Muir marries Louisa Strentzel and settles in Martinez, California

**NOVEMBER 1881** Mathew Brady's Washington studio is closed

**JANUARY 25, 1882** Virginia (Stephen) Woolf is born in London

**APRIL 19, 1882** Charles Darwin dies at Down House

**APRIL 27, 1882** Ralph Waldo Emerson dies at home in Concord

**SEPTEMBER 1882** Austin Dickinson and Mabel Loomis Todd begin affair

**DECEMBER 10, 1882** Alexander Gardner dies in Washington, D.C.

**1883** First Buffalo Bill's Wild West show

**MARCH 21, 1884** Annie Oakley meets Sitting Bull

**OCTOBER 11, 1884** Eleanor Roosevelt is born in New York

**JANUARY 21, 1885** Duncan Grant is born at his ancestral home, The Doune, in Scotland

**APRIL 1885** Annie Oakley joins Buffalo Bill's Wild West show

**MARCH 27, 1886** Mies van der Rohe is born in Aachen, Germany

**MAY 15, 1886**  Emily Dickinson dies in Amherst

**NOVEMBER 15, 1887**  Georgia O'Keeffe is born in Sun Prairie, Wisconsin

**MARCH 4, 1888**  Bronson Alcott dies in Boston

**MARCH 6, 1888**  Louisa May Alcott dies in Boston

**1889**  Paris Universal Exposition (Annie Oakley becomes world famous)

**1889**  Robert Underwood Johnson, editor of *Century* magazine, proposes the establishment of a national park incorporating Yosemite

**OCTOBER 1890**  Yosemite National Park is created

**NOVEMBER 1890**  *Poems* by Emily Dickinson, edited by Mabel Loomis Todd, is published

**MAY 1892**  The Sierra Club is founded. John Muir is president

**1893**  John Muir visits Concord

**MAY 11, 1894**  Martha Graham is born in Allegheny, Pennsylvania

**AUGUST 16, 1895**  Austin Dickinson dies in Amherst

**JANUARY 16, 1896**  Mathew Brady dies in New York

**FEBRUARY 27, 1897**  Marian Anderson is born in Philadelphia

**JULY 16, 1898**  Daniel Chester French moves into his studio at Chesterwood, in western Massachusetts

**FEBRUARY 20, 1902**  Ansel Adams is born in San Francisco

**MARCH 17, 1905**  Eleanor and Franklin Roosevelt are married

**JULY 1905**  Yosemite Valley is incorporated into the surrounding national park

**FALL 1905**  Georgia O'Keeffe studies at the Art Institute of Chicago

**JANUARY 2, 1908**  O'Keeffe meets Alfred Stieglitz

**AUGUST 10, 1912**  Virginia and Leonard Woolf are married

**MARCH 17, 1913**  Franklin Roosevelt becomes Assistant Secretary of the Navy

**AUGUST 4, 1914**  Germany invades Belgium. England declares war.

**DECEMBER 24, 1914**  John Muir dies in Los Angeles

**MARCH 1915**  Virginia Woolf's *The Voyage Out* is published

**JUNE 1916**  Ansel Adams visits Yosemite for the first time

**OCTOBER 1916**  Vanessa Bell moves her household to Charleston Farmhouse

**APRIL 1917**  Georgia O'Keeffe's first one-woman show, at Stieglitz's 291 gallery in New York

**APRIL 1917**  U.S. declares war on Germany

**SEPTEMBER 1918**  Eleanor Roosevelt discovers love letters of Lucy Mercer and FDR

**NOVEMBER 11, 1918**  World War I armistice

**MAY 3, 1919**  Pete Seeger is born in New York

**JULY 1919**  Leonard and Virginia Woolf buy Monks House

**APRIL 1920**  Ansel Adams arrives in Yosemite to serve as custodian of the Sierra Club's headquarters

**FEBRUARY 1921**  Nude photos of O'Keeffe are shown in a Stieglitz retrospective at the Anderson Galleries in New York

**AUGUST 1921**  FDR is stricken with polio

**MAY 30, 1922**  Dedication of Lincoln Memorial

**DECEMBER 11, 1924**  Georgia O'Keeffe and Alfred Stieglitz are married

**1925**  Val-Kill partnership is formed (Eleanor Roosevelt, Marion Dickerman, Nancy Cook)

**NOVEMBER 3, 1926**  Annie Oakley dies

**APRIL 17, 1927**  Ansel Adams makes *Monolith, the Face of Half Dome,* his first "visualized" image

**1928**  FDR is elected governor of New York

**MAY 1929**  Georgia O'Keeffe and Rebecca Strand go to New Mexico for four months. They stay with Mabel Dodge Luhan.

**SPRING 1930**  O'Keeffe returns to New Mexico. She moves out of the Luhan house and into the Sagebrush Inn in Taos. She brings back skulls and bones

**SPRING 1931**  O'Keeffe visits New Mexico again. She travels to the badlands of Abiquiu

**OCTOBER 7, 1931**  Daniel Chester French dies at Chesterwood

**1932**  Group f/64 formed in Bay Area (includes Ansel Adams, Imogen Cunningham, and Edward Weston)

**OCTOBER 14, 1932**  Mabel Loomis Todd dies

**NOVEMBER 1932**  FDR is elected president

**JUNE 1934**  Georgia O'Keeffe discovers Ghost Ranch

**JANUARY 1935**  Ansel Adams makes *Clearing Winter Storm*

**JANUARY 8, 1935** Elvis Presley is born in Tupelo, Mississippi

**JANUARY 18, 1935** *Freshwater,* Virginia Woolf's play about Julia Margaret Cameron on the Isle of Wight, is performed at Vanessa Bell's studio in London

**FEBRUARY 1936** Marian Anderson sings for the Roosevelts at the White House

**NOVEMBER 1936** Ansel Adams show at Stieglitz's American Place Gallery in New York City

**1938** Mies van der Rohe immigrates to the United States

**JANUARY 2, 1938** Robert Smithson is born in Passaic, New Jersey

**EASTER SUNDAY 1939** Marian Anderson sings on the steps of the Lincoln Memorial

**SEPTEMBER 1, 1939** Germany invades Poland

**SEPTEMBER 23, 1939** Sigmund Freud dies in London

**JULY 7, 1940** Marian Anderson buys Marianna Farms, near Danbury, Connecticut

**AUGUST 1940** Premiere of Martha Graham's *Letter to the World*

**OCTOBER 1940** Georgia O'Keeffe buys the house at Ghost Ranch

**MARCH 28, 1941** Virginia Woolf drowns in the River Ouse

**OCTOBER 31, 1941** Ansel Adams makes *Moonrise, Hernandez, New Mexico*

**DECEMBER 11, 1941** Germany and Italy declare war on the United States

**JULY 20, 1943** Pete Seeger and Toshi Ohta are married

**APRIL 12, 1945** Franklin Delano Roosevelt dies

**MAY 8, 1945** The Allies accept the unconditional surrender of the armed forces of Nazi Germany

**DECEMBER 31, 1945** Georgia O'Keeffe buys the Abiquiu house

**MAY 15, 1946** O'Keeffe is the first woman artist to have a major show at the Museum of Modern Art in New York

**JULY 13, 1946** Alfred Stieglitz dies in New York

**NOVEMBER 6, 1948** Elvis Presley and his parents move to Memphis

**1949** Pete Seeger buys land near Cold Spring, New York, and builds a log cabin for his family

**1949** Georgia O'Keeffe moves to New Mexico permanently

**1950** The Weavers (Pete Seeger, Lee Hays, Fred Hellerman, and Ronnie Gilbert) record Leadbelly's "Goodnight, Irene." It sells a million copies.

**1951** Mies van der Rohe completes work on Farnsworth House

**1952** Martha Graham moves into the Sixty-third Street studio in New York

**1955** *Poems of Emily Dickinson* in three volumes is published

**AUGUST 18, 1955** Pete Seeger testifies before the House Un-American Activities Committee. He is indicted for contempt of Congress and sentenced to a year in jail. The indictment is later dismissed on appeal.

**MARCH 1957** Elvis buys Graceland

**AUGUST 14, 1958** Elvis's mother, Gladys, dies in Memphis

**APRIL 7, 1961** Vanessa Bell dies at Charleston

**1962** Ansel Adams moves to Carmel

**NOVEMBER 7, 1962** Eleanor Roosevelt dies in New York

**1969** Martha Graham stops dancing

**AUGUST 14, 1969** Leonard Woolf dies at Monks House

**AUGUST 17, 1969** Mies van der Rohe dies in Chicago

**APRIL 1970** Robert Smithson completes the Spiral Jetty

**OCTOBER 1970** Georgia O'Keeffe retrospective at the Whitney Museum in New York

**1972** O'Keeffe completes her last unassisted oil painting

**JULY 20, 1973** Robert Smithson is killed in a plane crash near Amarillo, Texas

**AUGUST 16, 1977** Elvis Presley dies at Graceland

**OCTOBER 2, 1977** Elvis and his mother are reburied in the Meditation Garden at Graceland

**MAY 9, 1978** Duncan Grant dies at Aldermaston, Berkshire, England

**APRIL 22, 1984** Ansel Adams dies in Carmel, California

**MARCH 6, 1986** Georgia O'Keeffe dies in Santa Fe, New Mexico

**APRIL 1, 1991** Martha Graham dies in New York

**APRIL 8, 1993** Marian Anderson dies in Portland, Oregon

**1997** Georgia O'Keeffe Museum opens in Santa Fe

**JANUARY 18, 2009** Pete Seeger sings "This Land Is Your Land" on the steps of the Lincoln Memorial during the pre-inaugural concert for Barack Obama

**EMILY DICKINSON**
**Emily Dickinson Museum, Amherst, Massachusetts**
**Amherst Historical Society and Museum, Amherst, Massachusetts**
**Jones Library, Amherst, Massachusetts**
**Houghton Library, Harvard University, Cambridge, Massachusetts**

Patricia Lutz, Amherst Historical Society and Museum; Jane Wald, Emily Dickinson Museum; Tevis Kimball and Bonnie Isman, Jones Library; Leslie A. Morris and Susan Halpert, Houghton Library, Harvard University

*Emily Dickinson's Herbarium, A Facsimile Edition,*
 Harvard University Press, 2006
*The Life of Emily Dickinson,* Richard B. Sewall,
 Harvard University Press, 1994
*Lives Like Loaded Guns: Emily Dickinson and Her Family's Feuds,*
 Lyndall Gordon, Viking, 2010

**NIAGARA FALLS**
**Niagara Falls, New York, and Niagara Falls, Ontario, Canada**

**VIRGINIA WOOLF**
**Monks House, Lewes, East Sussex**
**Sissinghurst Castle, Biddenden Road, near Cranbrook, Kent**

Caroline Zoob, Monks House; Alessandra Holly, Adam Nicolson, and Jenny Rogers, Sissinghurst; Chris Rowlin, National Trust

*Virginia Woolf,* Hermione Lee, Knopf, 1997
*Downhill All the Way: An Autobiography of the Years 1919 to 1939,*
 Leonard Woolf, Harcourt, 1975
*The Journey Not the Arrival Matters: An Autobiography of the Years 1939
 to 1969,* Leonard Woolf, Harcourt, 1975

**CHARLESTON**
**Charleston Farmhouse, Firle, Lewes, East Sussex**

Sarah Bayes and Sophie Shaw

*Charleston: A Bloomsbury House and Garden,* Quentin Bell and Virginia
 Nicholson, Francis Lincoln Ltd., 1997
*Charleston: Past and Present,* Quentin Bell, Angelica Garnett, Henrietta
 Garnett, and Richard Shone, Harcourt, 1987

**SIGMUND FREUD**
**Freud Museum, 20 Maresfield Gardens, London**

Carol Seigel, Francisco da Silva, and Alex Bento

*Freud: A Life for Our Time,* Peter Gay, Norton, 1988
*20 Maresfield Gardens: A Guide to the Freud Museum,* Serpent's Tail, 1998
*Freud's Library: A Comprehensive Catalogue,* compiled and edited by
 J. Keith Davies and Gerhard Fichtner, The Freud Museum, 2006

**CHARLES DARWIN**
**Down House, Downe, Kent**
**Natural History Museum at Tring, Hertfordshire**

Michael Murray-Fennell, English Heritage; Cathy Power, Down House;
Dr. Joanne H. Cooper, Tory Harte, Katie Anderson, Juliet McConnell,
and James Stockton, Natural History Museum at Tring

*Charles Darwin: Vol. I, Voyaging,* Janet Browne,
 Princeton University Press, 1995
*Charles Darwin: Vol. II, The Power of Place,* Janet Browne,
 Princeton University Press, 2002
*Pilgrim on the Great Bird Continent,* Lyanda Lynn Haupt, Little, Brown, 2006
*Down House: The Home of Charles Darwin,* Tori Reeve, English Heritage, 2009

**ELEANOR ROOSEVELT**
**Val-Kill Cottage, Hyde Park, New York**

Frank Futral and Kevin R. Thomas, National Park Service

*Eleanor Roosevelt,* Vol. 1, 1884–1933, Blanche Wiesen Cook, Penguin, 1992
*Eleanor Roosevelt,* Vol. 2, 1933–1938, Blanche Wiesen Cook, Penguin, 1999
*No Ordinary Time: Franklin and Eleanor Roosevelt, The Home Front in World
 War II,* Doris Kearns Goodwin, Simon and Schuster, 1994
*Eleanor and Franklin,* Joseph P. Lash, Norton, 1971
*Eleanor: The Years Alone,* Joseph P. Lash, Norton, 1972

**MARIAN ANDERSON**
**Danbury Museum and Historical Society, Danbury, Conn.**

Brigid Guertin, Levi Newsome, and Diane Hassan

*My Lord, What a Morning,* Marian Anderson,
 University of Wisconsin Press, 1992
*Marian Anderson: A Singer's Journey,* Allan Keiler,
 University of Illinois Press, 2002
*The Sound of Freedom: Marian Anderson, the Lincoln Memorial, and the
 Concert That Awakened America,* Raymond Arsenault, Bloomsbury, 2009

**GETTYSBURG**
**Gettysburg National Military Park, Gettysburg, Pennsylvania**

Grace Reese, Greg Goodell, Bill Dowling, and Katie Lawhon, Gettysburg
National Military Park; Dru Anne Neil and Mandy Moore, Gettysburg
Foundation

*Gettysburg: A Journey in Time,* William A. Frassanito,
    Thomas Publications, 1975
*Early Photography at Gettysburg,* William A. Frassanito, Thomas
    Publications, 1995
*Gettysburg: Then and Now,* William A. Frassanito,
    Thomas Publications, 1996
*The Gettysburg Then and Now Companion,* William A. Frassanito,
    Thomas Publications, 1997
*Witness to an Era: The Life and Photographs of Alexander Gardner,*
    D. Mark Katz, Rutledge Hill Press, 1991
*Mathew Brady and the Image of History,* Mary Panzer,
    Smithsonian Books, 1997
*Hallowed Ground: A Walk at Gettysburg,* James M. McPherson,
    Crown, 2003
*The Complete Gettysburg Guide,* J. David Petruzzi, Savas Beatie, 2009
*The Gettysburg Gospel: The Lincoln Speech That Nobody Knows,*
    Gabor Boritt, Simon and Schuster, 2006
*Lincoln at Gettysburg: The Words That Remade America,* Garry Wills,
    Simon and Schuster, 1992

**ABRAHAM LINCOLN**
**Lincoln Memorial, National Mall, Washington, D.C.**
**Abraham Lincoln's Birthplace, Sinking Spring Farm,**
    **Hodgenville, Kentucky**
**Abraham Lincoln's Boyhood Home at Knob Creek, Hodgenville,**
    **Kentucky**
**Lincoln Boyhood National Memorial, Lincoln City, Indiana**
**Abraham Lincoln Presidential Library and Museum,**
    **Springfield, Illinois**
**Library of Congress, Washington, D.C.**
**Smithsonian National Museum of American History,**
    **Washington, D.C.**
**National Archives, College Park, Maryland**

Robbin Owen, National Park Service, Lincoln Memorial; Patti Reynolds
and Scott G. Shultz, National Park Service, Lincoln Birthplace; Mike
Capps, Kristi Brown, and Kendell Thompson, National Park Service,
Lincoln Boyhood National Memorial; James M. Cornelius, David
Blanchette, and Linda Norbut Suits, Abraham Lincoln Presidential Library
and Museum; Audrey Fischer, Deanna Marcum, Dianne van der Reyden,
Diane Vogt-O'Connor, Fenella France, Mary Oey, Andrew Robb, Maria
Nugent, Helena Zinkham, Carol Johnson, Jan Grenci, Abby Brack, Library
of Congress; Laura Duff and Harry R. Rubenstein, Smithsonian National
Museum of American History; Edward McCarter, Miriam Kleiman, Jeffrey
Reed, Sarah Shpargel, and Lauren Varga, National Archives; Daniel R.
Weinberg, Abraham Lincoln Book Shop, Chicago

*Lincoln,* David Herbert Donald, Simon and Schuster, 1995
*Abraham Lincoln,* James M. McPherson, Oxford University Press, 2009
*Team of Rivals: The Political Genius of Abraham Lincoln,*
    Doris Kearns Goodwin, Simon and Schuster, 2005
*Lincoln: An Illustrated Biography,* Philip B. Kunhardt, Jr.,
    Philip B. Kunhardt III, Peter W. Kunhardt, Knopf, 1992
*Looking for Lincoln: The Making of an American Icon,* Philip B. Kunhardt III,
    Peter W. Kunhardt, Peter W. Kunhardt, Jr., Knopf, 2008
*Lincoln's Photographs: A Complete Album,* Lloyd Ostendorf,
    Rockywood Press, 1998
*In Lincoln's Hand: His Original Manuscripts with Commentary by
    Distinguished Americans,* edited by Harold Holzer and Joshua Wolf
    Shenk, Bantam, 2009

**DANIEL CHESTER FRENCH**
**Chesterwood, Stockbridge, Massachusetts**

Donna Hassler, Anne L. Cathcart, Gerard Blache, Brian McElhiney, and
Lisa Reynolds

*Daniel Chester French: An American Sculptor,* Michael Richman, National
    Trust for Historic Preservation/Metropolitan Museum of Art, 1976
*Memories of a Sculptor's Wife,* Mary French, Houghton Mifflin, 1928
*Journey into Fame: The Life of Daniel Chester French,* Margaret French
    Cresson, Harvard University Press, 1947

**GEORGIA O'KEEFFE**
**Georgia O'Keeffe Museum and Research Center, Santa Fe,**
    **New Mexico**
**Ghost Ranch, New Mexico**
**Abiquiu House, Abiquiu, New Mexico**

Barbara Buhler Lynes, Robert Kret, Jackie S. Hall, Julie Gomez, and Gary
Smith, Georgia O'Keeffe Museum and Research Center; Linda Seebantz
and Agapita Judy Lopez, Abiquiu and Ghost Ranch

*Georgia O'Keeffe: A Life,* Roxana Robinson,
    University Press of New England, 1999
*Georgia O'Keeffe: A Portrait by Alfred Stieglitz,*
    Metropolitan Museum of Art, 1997
"The Rose in the Eye Looked Pretty Fine," Calvin Tomkins,
    *The New Yorker,* March 4, 1974
*Georgia O'Keeffe and New Mexico: A Sense of Place,* Barbara Buhler Lynes,
    Lesley Poling-Kempes, and Frederick W. Turner, Georgia O'Keeffe
    Museum/Princeton University Press, 2004
*O'Keeffe's O'Keeffes: The Artist's Collection,* Barbara Buhler Lynes with
    Russell Bowman, Thames and Hudson, 2001
*Georgia O'Keeffe: Art and Letters,* Jack Cowart and Juan Hamilton,
    National Gallery of Art/New York Graphic Society, 1987
*Image and Imagination: Georgia O'Keeffe,* John Loengard,
    Chronicle Books, 2007

**MARTHA GRAHAM**
**Martha Graham Center of Contemporary Dance warehouse,**
    **Yonkers, New York**

LaRue Allen, Anne Posluszny, Karen Young, and Arnie Apostol, Martha
Graham Center of Contemporary Dance; Lael Morgan and Nils Morgan,
Barbara Morgan Archive

*Martha Graham: Sixteen Dances in Photographs,* Barbara Morgan, Duell,
    Sloan & Pearce, 1941
*Blood Memory: An Autobiography,* Martha Graham, Doubleday, 1991
*Martha: The Life and Work of Martha Graham,* Agnes de Mille,
    Random House, 1991

**ELVIS PRESLEY**
**Graceland, Memphis, Tennessee**
**Elvis Presley Birthplace, Tupelo, Mississippi**

Lisa Marie Presley; Angie Marchese, Alicia Dean, Scott Williams, and
Kevin Kern, Graceland; Dick Guyton, Elvis Presley Birthplace

*Last Train to Memphis: The Rise of Elvis Presley,* Peter Guralnick,
    Little, Brown, 1994
*Careless Love: The Unmaking of Elvis Presley,* Peter Guralnick,
    Little, Brown, 1999
*Elvis by the Presleys,* edited by David Ritz, Crown, 2005

**THOMAS JEFFERSON**
**Monticello, Charlottesville, Virginia**

Peter J. Hatch, Ann H. Taylor, Lisa Stites, and Susan R. Stein

*Thomas Jefferson's Farm Book,* edited by Edwin Morris Betts, Thomas
    Jefferson Memorial Foundation, 1999
*Thomas Jefferson's Garden Book, 1766–1824,* annotated by Edwin Morris
    Betts, Thomas Jefferson Foundation, 2008
*Thomas Jefferson's Monticello,* Thomas Jefferson Foundation, 2002
*Founding Gardeners: The Revolutionary Generation, Nature, and the Shaping of
    the American Nation,* Andrea Wulf, Knopf, 2011
*American Sphinx: The Character of Thomas Jefferson,* Joseph J. Ellis,
    Vintage, 1998

**MERIWETHER LEWIS AND WILLIAM CLARK**
**Smithsonian National Museum of American History, Washington, D.C.**

Laura Duff and Harry R. Rubenstein

*Undaunted Courage: Meriwether Lewis, Thomas Jefferson, and the Opening of the American West,* Stephen E. Ambrose, Simon and Schuster, 1996
*Lewis and Clark: The Journey of the Corps of Discovery,* Dayton Duncan, Knopf, 2009

**ANNIE OAKLEY**
**Garst Museum and the Darke County Historical Society, Greenville, Ohio**

William Self and Barbara Self Malone; Bess Edwards, Annie Oakley Foundation; Clay Johnson, Penny Perry, and Brenda Arnett, Garst Museum and The Darke County Historical Society; Lynn J. Houze, Buffalo Bill Historical Center, Cody, Wyoming

*Annie Oakley,* Shirl Kasper, University of Oklahoma Press, 1992
*Bull's-eye: A Photobiography of Annie Oakley,* Sue Macy, National Geographic Society, 2001

**PETE SEEGER**
**Cold Spring, New York**

Pete and Toshi Seeger

*The Protest Singer: An Intimate Portrait of Pete Seeger,* Alec Wilkinson, Vintage, 2010
*Where Have All the Flowers Gone: A Singalong Memoir,* Pete Seeger, Norton, revised edition, 2009

**LOUISA MAY ALCOTT**
**Orchard House, Concord, Massachusetts**

Jan Turnquist, Orchard House; Nancy J. Barnard, H-K Designs

*Eden's Outcasts: The Story of Louisa May Alcott and Her Father,* John Matteson, Norton, 2007
*Bronson Alcott's Fruitlands,* compiled by Clara Endicott Sears, Fruitlands Museums / Applewood Books, 2004

**HENRY DAVID THOREAU**
**Walden Pond, Concord, Massachusetts**
**Concord Museum, Concord, Massachusetts**

David F. Wood, Concord Museum; Jennifer Ingram, Joseph M. Rotondo, Peter Davenport, Peter Hoffman, and John Faro, Massachusetts Department of Conservation and Recreation

*An Observant Eye: The Thoreau Collection at the Concord Museum,* David F. Wood, Concord Museum, 2006
*Henry Thoreau: A Life of the Mind,* Robert D. Richardson, Jr., University of California Press, 1986

**RALPH WALDO EMERSON**
**Ralph Waldo Emerson House, Concord, Massachusetts**

Bay Bancroft, Eliza Castañeda, and Marie Gordinier, Ralph Waldo Emerson Memorial Association

*Emerson: The Mind on Fire,* Robert D. Richardson, Jr., University of California Press, 1995
*Emerson Among the Eccentrics,* Carlos Baker, Penguin, 1996
*American Transcendentalism: A History,* Philip F. Gura, Hill and Wang, 2007

**JOHN MUIR**
**John Muir National Historic Site, Martinez, California**
**Holt-Atherton Special Collections, University of the Pacific, Stockton, California**

Ric Borjes, Tom Leatherman, and Isabel Jenkins Ziegler, John Muir National Historic Site; Shan Sutton, Holt-Atherton Special Collections

*A Passion for Nature: The Life of John Muir,* Donald Worster, Oxford University Press, 2008
*Nature's Beloved Son: Rediscovering John Muir's Botanical Legacy,* Bonnie J. Gisel, with images by Stephen J. Joseph, Heyday Books, 2008
*John Muir in Yosemite,* Shirley Sargent, Flying Spur Press, 2008

**JULIA MARGARET CAMERON**
**Dimbola Lodge, Freshwater Bay, Isle of Wight**
**National Media Museum, Bradford, West Yorkshire**
**Farringford, Isle of Wight**

Brian Hinton and John Holsburt, Dimbola Lodge; Ruth Kitchin, Brian Liddy, and Phil Oates, National Media Museum; Rebecca Fitzgerald, Farringford

*Julia Margaret Cameron: The Complete Photographs,* Julian Cox and Colin Ford, J. Paul Getty Museum, 2003
*Julia Margaret Cameron: A Critical Biography,* Colin Ford, J. Paul Getty Museum, 2003
*Victorian Photographs of Famous Men & Fair Women,* Julia Margaret Cameron, with introductions by Virginia Woolf and Roger Fry, edited by Tristram Powell, Godine, 1973
*Annals of My Glass House: Photographs by Julia Margaret Cameron,* Violet Hamilton, University of Washington Press, 1996
*Tennyson at Farringford,* Veronica Franklin Gould and Leonée Ormond, Tennyson House, 2009
*Immortal Faces: Julia Margaret Cameron on the Isle of Wight,* Brian Hinton, Isle of Wight County Press, 1992
*Pioneer Victorian Photographer: Julia Margaret Cameron, 1815–1879,* Brian Hinton, Julia Margaret Cameron Trust, 2008
*Freshwater: A Comedy,* Virginia Woolf, Harcourt, 1976

**ANSEL ADAMS**
**Ansel Adams home, Carmel, California**
**Yosemite National Park, California**

Jeanne Adams

*Ansel Adams: An Autobiography,* with Mary Street Alinder, Little, Brown, 1985
*Ansel Adams: A Biography,* Mary Street Alinder, Holt, 1996
*Savage Dreams: A Journey into the Landscape Wars of the American West,* Rebecca Solnit, University of California Press, 1999
*Yosemite's Yesterdays,* Vol. II, Hank Johnston, Flying Spur Press, 1991

**FARNSWORTH HOUSE**
**Farnsworth House, Plano, Illinois**

Justin Lyons and Whitney French

*Mies van der Rohe: A Critical Biography,* Franz Schulze, University of Chicago Press, 1985
*The Farnsworth House,* Franz Schulze, Lohan Associates, 1997
*Farnsworth House,* Maritz Vandenberg, Phaidon, 2003

**OLD FAITHFUL**
**Yellowstone National Park, Wyoming**

Karen L. McEneaney, National Park Service; Rick Hoeninghausen and Laura Love, Xanterra Parks and Resorts

**ROBERT SMITHSON**
**Spiral Jetty, Rozel Point, Great Salt Lake, Utah**

Mario Nicki, Classic Aviation; Paul Chapin, Million Air, Salt Lake City

*Robert Smithson: Spiral Jetty,* edited by Lynne Cooke and Karen Kelly, Dia Art Foundation / University of California Press, 2005
*Robert Smithson: The Collected Writings,* edited by Jack Flam, University of California Press, 1996
*Robert Smithson,* organized by Eugenie Tsai with Cornelia Butler, Museum of Contemporary Art, Los Angeles / University of California Press, 2004

The text is a collaboration with Sharon DeLano. We taped many conversations about the *Pilgrimage* project. She went with me on a few of the trips, but usually I would meet with her when I came back and we would talk about what I had seen and who I met and how I felt about a subject. She put the stories into a narrative and added historical information that we thought would illuminate the visual narrative. *Pilgrimage* was a very personal project for me, but it was entwined with the sometimes complicated histories of people with public lives.

A.L.

STUDIO 2011  Karen Mulligan • Suzanna Rees, Jennifer Greim, Matthew Currie, Jesse Blatt, Laura Cali, Hasan and Baha Gluhic • Martin O'Connor, Joseph McNulty
ADDITIONAL SUPPORT  Kathryn MacLeod • Mary Howard

CONDÉ NAST  S. I. Newhouse, Jr. • Graydon Carter • Anna Wintour
WYLIE AGENCY  Andrew Wylie • Jeffrey Posternak
RANDOM HOUSE  Gina Centrello • Kate Medina • William Takes • Thomas Perry • Lisa Feuer • Richard Elman Joelle Dieu, London King, Benjamin Dreyer, Janet Wygal, Beth Pearson
CONTI TIPOCOLOR  Roberto Conti • Ann Faughender, Laura Cuccoli, Alfredo Zanellato
ADAMSON EDITIONS  John Hughes, Wade Hornung, Colin Loughlin

EDITOR  **SHARON DELANO**
EDITORIAL AND PRODUCTION CONSULTANT  **MARK HOLBORN**
RESEARCH AND PRODUCTION  **BARBARA LEIBOVITZ HELLMAN**

PHOTOGRAPHER'S ASSISTANTS  **NICK ROGERS**
                          **MATTHIAS GAGGL**

DESIGN SUPERVISION  **MATTHEW CHRISLIP**
DIGITAL COLOR  **ALEXANDER VERHAVE**

DIGITAL COLOR AND PROOFS/PRINTS  **DAVID ADAMSON**

DESIGN  **JEFF STREEPER**